ART OF LATIN AMERICA

1900-1980

MARTA TRABA

Distributed by
The Johns Hopkins University Press
for the
Inter-American Development Bank

The opinions and views expressed in this publication are not necessarily those of the Inter-American Development Bank.

ART OF LATIN AMERICA: 1900 -1980

© Inter-American Development Bank, 1994

Distributed by
The Johns Hopkins University Press
2715 North Charles Street
Baltimore, Maryland 21218-4319

Library of Congress Catalog Card Number: 94-075175
ISBN: 0-940602-73-3
ISBN: 0-940602-71-7 (PBK)

Graphic design: Dolores Subiza

COVER: **ALEJANDRO OBREGÓN**. *THE WAKE*. 1956. OIL ON CANVAS, 140 X 175 CM. COLLECTION OF THE ART MUSEUM OF THE AMERICAS, OAS, WASHINGTON, D.C., U.S.A. PURCHASE FUND, 1957. PHOTOGRAPH BY MICHAEL GEISSINGER.

PREFATORY NOTE

The Inter-American Development Bank takes great pleasure in publishing Marta Traba's last work. While it was written a little over 10 years ago, its appearance in print is peculiarly timely. It comes at a moment when the significance of the role culture plays in development is acknowledged at the highest decision-making levels. Marta Traba was more than aware of the relationship, and at all times sought to situate art criticism within the proper economic, social, and political context.

It is this understanding that leads the Bank and other international organizations to lay ever greater stress upon the human aspect of development, viewed as sustainable, shared progress. In one of its reports, the recently created UNESCO World Commission on Culture and Development explains the emphasis it places on the importance of culture and art for human development by stating that without a cultural and spiritual rebirth there can be no economic rebirth. Unquestionably, new models for development must not be limited to technical concerns but must extend to include the contributions of thinkers, artists, community leaders, and educators.

Five centuries after the great encounter between the civilizations of the Old and New Worlds, Latin America can exhibit a rich variety of artistic expression, enjoying worldwide renown. The variety is precisely the challenge Marta Traba had to face in writing her book. As she herself asked, how is one to arrive at an overall view of the artistic product of more than two score countries, differing widely in tradition, culture, and language? Her task was to disentangle a confused web of disparate expression in an endeavor to establish a Latin American plastic identity.

Art of Latin America: 1900-1980 provides a broad overview of art activity in the southern portion of our hemisphere. In some cases it evidences a rethinking by the author of positions previously taken that had given rise to heated controversies. In furtherance of its commitment to culture, the Bank will make copies of this work available to universities and other teaching institutions throughout our hemisphere, particularly ones concerned with the arts. Marta Traba was one of the outstanding figures in the Latin American art world. This is the last testimony of her thought.

Enrique V. Iglesias
President
Inter-American Development Bank

TABLE OF CONTENTS

FOREWORD

THE METAPHYSICS OF LIGHT

This valuable study represents a valiant effort to present a view of Latin American art as a coherent whole, rather than a disjointed summary of artistic achievement in the individual countries of the area. It results from exhaustive research by the author into developments in art from 1900 to 1980—research that enabled her to paint a broad panorama in which theory is abundantly supported by fact.

Marta Traba could not conceive of art criticism in separation from the economic, political, and social reality of the region. In consequence, the present text describes the evolution of modern art in Latin America as conditioned by such factors—the relationship between life as it was lived in the several countries and their artistic accomplishments.

The principal theses of this study are as follows:

• The Mexican Muralist Movement was not merely a consequence of the Mexican Revolution, but reflected a new attitude toward art, awakened by modernist winds blowing from Europe.

• While the Mexican Muralists were at work, countries that had received large numbers of European immigrants—Argentina, Brazil, and Mexico, for example—became centers of lively experimentation in matters of form. Individual artists from still other countries, such as Lam, Reverón, and Torres-García, were active along similar lines, and eventually won international renown. In contrast, countries with a greater Indian population and which were less receptive to immigration—Colombia, Ecuador, and Peru, for instance—were more subject to the political influence of Mexican Muralism.

• From the 1950s on, artists engaged in experimentation with form (*i.e.* the avant-garde) are no longer conspicuous by their rarity in Latin America: their ranks have swollen to a chorus of about 50 figures who may be termed outstanding.

• In reaction to this conceptual avant-garde (which had powerful reasons for existence in developed countries), a number of Latin American artists brought about renewal in drawing and printmaking, forms of artistic expression that were modest in scope and permitted reproduction.

• The most conspicuous characteristic of Latin American art is its unvarying aim of communicating with the public by means of visual images.

The last days of dithyramb

Marta Traba was born in Buenos Aires on January 25, 1930. She and her brother Alberto were the children of Francisco Traba and Marta Tain, descendants of

Spanish immigrants. Marta attended public primary school and received her secondary education from the capital's Liceo Nacional. After obtaining a degree in letters from the Faculty of Philosophy of the National University, she began to work as an editorial assistant for the magazine *Ver y Estimar*, directed by the art critic Jorge Romero Brest. It was there that her first published articles appeared in 1948, during which year she took art courses at the Sorbonne and later at the Louvre Museum in Paris. She made trips to Budapest and Rome, and in 1950, while in France, she married the Colombian journalist Alberto Zalamea. Her first child, Gustavo, later to become a painter, was born in the following year. Returning to Buenos Aires, she there brought out her first book, *Historia natural de la alegría* (A Natural History of Merriment). She was a mere 20 years old. She went back to Europe to study art history in Rome, where her husband served as correspondent for the Bogotá newspaper *El Tiempo*.

It was then that she initiated her career as a critic and creative writer in all fields of arts and letters. Dithyramb's long reign over art criticism written in Latin America was about to come to an end.

The heat of invective

Marta Traba could be found in the forefront of all types of intellectual activity. She founded magazines, promoted colloquia, and gave courses and lectures. Impatient and vehement by nature, she was constantly stirring up arguments. She had but one rule of conduct: to tell the truth as she saw it, without reservations, concessions, or compromises of any kind. In expressing her aesthetic convictions, she aimed ever to instill community pride and to encourage creative artists. She felt this to be a personal obligation on her part. She never sought for approval. She hated the idea of giving up. Praise—even from her intimates and disciples—was repugnant to her. She would never take an easy way out and was fascinated by challenges to her pedagogical ability. The discussions in which she engaged led to a constant enlargement of her field of teaching. They strengthened her convictions, even with respect to the most everyday of matters, and her consciousness of advancing in the paths of knowledge. She was a great talker, and she wrote persuasively. The Argentine critic Damián Bayón said that Marta was at her best in the heat of invective. Her pamphlets and articles for periodicals poured forth as from an ever-erupting volcano. "She gave shelter to students wounded in the violent skirmishes of the period," her friend the poet Juan Gustavo Cobo Borda recalls. She gave birth to novels amid a whirlwind of participation in exhibitions in most of the countries of Latin America, to which word had come of the depth of her knowledge and the brilliance of the judgments she passed on new artists and their works, applauding them when they so deserved, while holding them to the highest of international standards. Dithyramb was a thing of the past.

An end to concessions

The present book exemplifies the exacting aesthetic standards Marta Traba set for herself and the accuracy of her appreciations. She is shrewd in her judgment of schools and received opinion. Arbitrary classifications are overriden by logical and coherent analysis. The reputations of established figures in art, literature, and politics are subjected to careful reexamination. The orthodoxy of acceptance is replaced by the skepticism of research and the reality of confrontations.

In her autobiographical novel *Las ceremonias del verano* (The Ceremonies of Summer), awarded the Havana "Casa de las Américas" Prize by a jury chaired by Alejo Carpentier, in the caustic observations of her *Homérica Latina*, in her study *Dos décadas vulnerables en las artes plásticas latinoamericanas* (Two Vulnerable Decades in Latin American Plastic Art), in her articles for learned reviews, in her introductions to exhibition catalogs, and in endless personal discussions, Marta noted that at a period in which European art evidenced a decline, Latin America was failing to make use of elements of its culture as instruments of revelation. "We are free because others pay us no attention," she wrote on several occasions, seeking to arouse both creative artists and political leaders from their slumbers.

The metaphysical role of light

In her book *En la zona del silencio* (In the Zone of Silence), Marta Traba wrote:

> In my analysis, my aim is less to persuade than to provoke a reaction, to tell the public: These images belong to you; take possession of them. They represent you; take them for a covering, as a witch gathers her cloak about her. They give you a meaning that goes beyond outward appearence; put faith in its symbolic significance. They exalt you; let the artist—the sole mortal capable of performing this act of reevaluation disinterestedly, without demagogic intent or lapses into rhetoric—let the artist elevate you to a higher realm, transformed in substance and being.

In an article writen in 1960 for the Bogotá magazine *Semana*, she described in lyric terms approaching poetry the wonder aroused in her by art:

> No matter how many galleries one may visit, filled though they may be with the most ingenious, the most dazzling, the most touching, and the most powerful of man's creations in painting, there is nothing to compare with the handling of light in the works of Jan Vermeer of Delft. Better than anyone before or since, Vermeer understood that light is not merely the definitive element in painting but that which imparts life to beings and objects in repose. This life has nothing to do with everyday existence, although outwardly it

reflects the simplest of things—those to be seen in Dutch interiors. It is life infused with light, life preserved in a light that is eternal. It was Vermeer who came closest to realizing the great ambition, common to all artists, of making his painted creations immortal. The girl pouring from a jug in the small painting in the Metropolitan Museum of Art and the girl pausing from her music in the still smaller canvas belonging to the Frick Collection reveal the metaphysical role performed by light. Light has captured their very essence, taking them by surprise, absorbed in themselves—creatures of air that once seen are never to be forgotten. It has raised them to the very peak of creative effort and sustains them there by its power, soaring over the heaven and hell of all other painting.

The utopia of identity

The foregoing quotations provide keys to Marta Traba's aesthetic approach. Her carefully orchestrated precepts marked a sharp, dissonant break with then-current critical practice. Even when spellbound by the art of Uccello, Piero della Francesca, and Mantegna, she preserved a critical attitude strictly in keeping with her conscience. In seeking to define those individual identities that, taken together, constitute a common identity, she was harsh in dealing with both mediocrity and injustice. In the introduction to this book she wrote: "However material be organized, whether for studies of limited scope or ones of a general nature, the critic must take into account social, economic, or political circumstances that may bring about a complete change in a country's art."

Making her way through the thicket of the area's social disturbances, cultural conflicts, abundant needs, and scanty satisfactions, she comes somewhat closer to the utopian goal of assigning an "identity" to Latin American art. She recognizes that for art to be honest it must exceed the bounds of art.

Throughout his creative career—and most emphatically in "Questioning the Enigma," delivered in the French Academy—the iconoclastic writer Eugène Ionesco has sustained that all art possessing real depth transcends the problems peculiar to its own mode of expression, whether it be painting or literature, music or architecture, and that a work of art such as a cathedral is expressive of an entire cosmology.

Joan of Arc

This book, written with the resolution characteristic of Marta Traba's spirit, vibrates with convictions that she never made any attempt to conceal—convictions that represent an attack on the bourgeois society in which she grew up and a challenge to the establishment in Colombia and other American countries in which she was active.

In a composite interview the Colombian painter Beatriz González constructed using selections from the many statements the critic made to the press, Marta Traba acknowledges that she took her hat off to good writers because of the prophetic qualities of their words. She then calls attention to the fact that she did not care for her fellow members of the middle class.

> I feel that the class from which I come is mean, stupid, and dishonest. Middle-class women are a caste of parasites who take to the streets in Chile to bang on the pots and pans they never scour in the kitchen, who play canasta in Colombia, who gossip as they sit under hair dryers in beauty parlors everywhere.

She adds:

> I don't like to get into fights, but I have to, because it is my duty. I would prefer to live in a just society and serve it with meekness, loyalty, and passion.... My incredible struggles are always against forces that could reduce me to dust.... I should like to go on being Joan of Arc, ever Joan of Arc.

In an essay written in 1982, after applauding gifts by American millionaires to museums in cities both large and small, and after lauding Nelson Rockefeller for dispelling the mystique of the unique by permitting reproduction in limited editions of works of art and objects of daily use to be found in his home, she expressed a few reservations in this last regard. "What magazines announce as objects of art are in fact aesthetic monstrosities: bronze animal groups, porcelain Harlequins and shepherdesses, images stamped out of gold and silver, and above all interminable variations on themes associated with the legendary American West—cowboys, bucking horses, horned bulls, rodeos, and Indians, all heavily rendered in bronze and marble.... The identification of art with material objects has been played up by the advertising media, to the point that everything becomes their prey. One of the latest examples is an ad in which a late-model automobile is skillfully centered in a ballet scene painted by Degas, where it apparently constitutes an object of admiration both to the instructor and to the ballerinas lined up at the barre."

Following this choleric outburst against the lifestyle of affluent society, she undertakes an almost tender defense of the culture of poverty. A page or two later, however, she admits that there is much to be said for an affluent society, noting the value given to open space in new urban construction in New York— space that gives the public the same freedom it enjoyed in the light-filled interiors of the Gothic cathedrals or the open-air reaches of the Roman Forum. "Everything has begun to move in Manhattan, thanks to the new architects. The lobby of the admirable Citicorp building gives the community ample living room, and

through its glass walls one can fully appreciate the other skyscrapers that have sprung up around it. Curved façades and diagonally placed walls create a dynamic interplay of reflections. The new tower of the Museum of Modern Art, designed by the Argentine architect César Pelli, seems severe until one looks to the back, where it is joined to the old building by superimposed transparent levels, similar in effect to the exposed escalators of the Place Beaubourg in Paris. The Trump Tower advances deceptively toward Fifth Avenue in terraces from which the skyscraper shoots up to the rear."

Reevaluation of Mexican Muralism

Marta Traba gave evidence of this characteristically metaphysical vision in all that she undertook—in her inspiring classroom presentations, in her exciting television appearances, in her writing, in the introductions to the exhibits she organized, in the creation of museums, in help rendered any publication she might establish or stimulate to further world understanding. She had an inborn capacity for appreciating painters, from the masters of the Renaissance to young practitioners of abstraction. She brought them all to public attention, at times by rude insistence, in constant combat with mediocrity.

When the Colombian painter Fernando Botero was 25, she wrote:

> It would not be wide of the mark to say that there are as many Fernando Boteros as the artist has had shows to date. This statement is not to be taken as disparagement. After all, Botero is only 25, and, as is normal with any good painter, he was not born with a style ready-made for use. He has been seeking for a style with the stubbornness, zeal, and effort of an explorer making his way through the jungle, seeking for a clearing in which he can set up camp—for how long he knows not. Up to the present Botero has been passionately searching for form, and the sudden turns that his search has taken, first in one direction and then in the opposite, leave the public disconcerted.

The sharpness of her perceptions, apparently based on a preestablished set of value judgments, derived from long acquaintance with art and artists of all times. Her language abounded in figures of speech, but she never indulged in empty rhetoric. Her pronouncements were the antithesis of dithyramb. When she asserted that Picasso's *Guernica* exhibited the most varied, intense, and powerful grays of our day, she was speaking with knowledge gained from acquaintance with the discreet use of grays in canvases by Velázquez and the white in the habits of monks painted by Zurbarán. It is with the same knowledge that in this book she passes judgment on Szyszlo, Figari, Reverón, Tamayo, Obregón, Lam, and Torres-García. And it is with the same boldness of spirit that she inveighs against the murals Portinari did for United Nations Headquarters in New York.

More than one enraged critic wanted to know who the upstart was who dared to come out against the Mexican Muralists at the 1965 Symposium of Latin American Intellectuals held at Chichén Itzá in Mexico. In the present study, however, after delving for roots and searching for spiritual ancestors, after examining social and political factors and weighing attitudes, she comes to this conclusion:

> In the considered and dispassionate reexamination of the Muralists now under way, there is general agreement that their work represents the most important movement in Latin American art of the early part of the century. It was the only one to make clear the need for something that went beyond easel painting, something capable of playing a role of social importance in emerging Latin American societies.

Human dignity

Marta Traba led an admirable existence—admirable both for the quality of her life and for the fact that it was dedicated to the cause of beauty and justice. She accepted her calling with a joy and enthusiasm that infused every act of daily living. She was ever a fighter, whether alone or in the company of her husbands— first Alberto Zalamea, from whom she was divorced in 1967, and then Ángel Rama, the Uruguayan critic with whom she came to the United States in 1979 to lecture by invitation at Middlebury College, Harvard University, the universities of Maryland and Vermont, and the Massachusetts Institute of Technology. By that time she stood in the forefront of art criticism in Latin America and the Caribbean. Attracted to narration, she published in Mexico *Conversación al sur* (Conversation in the South), in which she came to the defense of human dignity in response to the severities of the military in Chile and Uruguay.

In 1983 the Art Museum of the Americas, located at the headquarters of the Organization of American States in Washington, D.C., undertook a project financed in part by the U.S. National Endowment for the Humanities. It involved an interpretive installation of the Museum's permanent collection, the aim being to present the art of Latin America in cultural context. Marta Traba was engaged to serve as guest curator for the project, and in amplification thereof she produced a text on developments in Latin American art during the course of the twentieth century. Regrettably she did not live to see the results of her labors, which were carried to conclusion with enthusiasm by her collaborators. In 1985 the OAS reinaugurated its permanent collection with an exhibition that illustrated the quality of its holdings, the complexity of the art scene in Latin America, and the contributions made by individual artists from throughout the region, all in accordance with the highest of professional standards.

Since Marta Traba had delivered only a first draft of her study to the Museum, publication could be undertaken only after editing, a task rendered unusually difficult without input from the author. The Art Museum of the Americas

toiled over the text for five years, at the end of which the budgetary situation of the institution did not permit publication. For another five years the OAS sought financial backing from outside, endeavoring to resolve problems relative to non-commercial distribution of the text. Finally, following discussions between representatives of the Organization of American States and the Inter-American Development Bank, the latter undertook to publish the work, with the intention of distributing copies to interested institutions and individuals, thereby contributing to a better appreciation of the achievement of representatives of Ibero-America and the Caribbean in the field of visual arts—the goal to which Marta Traba was so passionately dedicated.

A flame in the wind

Marta Traba and Angel Rama were pursuing their task of promoting better understanding of the significance of Latin American art at leading cultural institutions of the United States, when one day the Reagan administration decided to deny the couple residency. The present writer, at the time President of Colombia, intervened on their behalf. Marta related the incident in an article entitled "Testimonio," published in January 1983 by the Bogotá magazine *Semana*.

> When he learned the United States government had denied us resident visa status and that we were faced with deportation, the President twice telephoned our house in Washington, offering us a place to stay and work. He asked me, "Would you like Colombian citizenship?" Without thinking twice I said "Yes."

She received Colombian citizenship. In Colombia she did 20 television programs, she gave lectures, she took part in discussions and exhibitions. As always she sounded like an erupting volcano, but her analyses were increasingly profound, her expression clearer, her judgments more precise. In March 1983 she and her husband took up residence in Paris, but she continued to work for Colombian television. The government of Colombia was organizing a symposium of Latin American intellectuals, to be held in Bogotá to consider what the future held for the region with the coming of a new century. Marta Traba and Angel Rama were to be guests of honor. Then November 27, 1983, the airplane in which they were flying to Bogotá crashed against a hill outside Barajas Airport in Madrid, Spain. As a poem by the Colombian Porfirio Barba Jacob puts it: "She was a flame in the wind—and the wind blew it out."

Santafé de Bogotá
February 1994

Belisario Betancur
Ex-president of Colombia

ACKNOWLEDGMENTS

Publication of this work by Marta Traba brings to conclusion a task undertaken in 1983 by a group of individuals associated with the Art Museum of the Americas, under a grant from the U.S. National Endowment for the Humanities. It is not surprising, nor is it mere coincidence, that some of those individuals are still engaged in the study and promotion of art of Latin America and the Caribbean, though now as staff members of the IDB's Office of External Relations—clear evidence of the coordination in effort that characterizes the component agencies of the inter-American system.

Three persons merit special recognition: Maria Leyva, Curator of the Permanent Collection of the OAS Art Museum of the Americas; Félix Angel, previously Curator of Temporary Exhibitions at the Museum and now Consultant to the Cultural Center of the IDB; and Rogelio Novey, formerly Advisor to the Assistant Secretary General of the OAS and Interim Director of the Museum and now Chief of Conferences and Cultural Activities of the Bank's Office of External Relations. They have accompanied the development of this project since its beginning.

The late Susana De Clerck, Susana Ramsburg, and Ralph Edward Dimmick shared the difficult task of revising and editing the original manuscript without assistance from the author, who had been the victim of a tragic accident shortly following its completion. Dimmick was responsible for the English translation of the text published in the catalogue of the OAS Museum; he is also responsible for the translation that appears in this volume.

Acknowledgment should also be made of two other members of the original working group: Angel Hurtado, at the time chief of the audiovisual program of the OAS Museum, and Ana María Escallón, researcher. It was Hurtado who brought the existence of Marta Traba's manuscript to the attention of Ana María Coronel de Rodríguez, the Director of the IDB Cultural Center. A scholar who provided inspiration and guidance for the project in its early stages was Professor Stanton Catlin, of the University of Syracuse. Backing for the project was supplied by Alejandro Orfila and Valerie McComie, at the time respectively Secretary General and Assistant Secretary General of the OAS.

Finally, thanks are extended to Bélgica Rodríguez, Director of the OAS Museum, who made the manuscript available to the IDB's Office of External Relations, which has been responsible for the final revision and publication of this work.

Muni Figueres de Jiménez
External Relations Advisor
Inter-American Development Bank

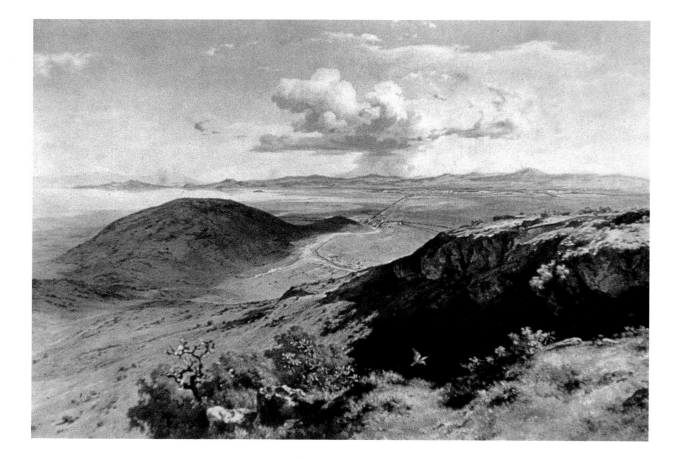

INTRODUCTION I

THE DIFFICULTY OF VIEWING AS A WHOLE THE PRODUCT OF MORE THAN a score of countries, representing a variety of cultures, traditions, and language areas, presents an all but insurmountable obstacle to writing a history of modern art in Latin America. This may explain why, up to now, such a text does not exist. Without one, however, Latin American art cannot be properly placed within the context of the twentieth century. It should not be viewed as a mere appendage of such firmly established cultures as those of Europe and the United States, but as an autonomous creative effort, mirroring a community that has been struggling since the late 1800s to assert and define a culture of its own.

A review of the existing bibliographic material, ranging from newspaper articles to studies of considerable length, shows a variety of approaches to the subject. First, there is a considerable number of monographs on individual artists. For the most part these do not fall into the category of criticism based on modern techniques of analysis and evaluation, but consist rather of biographical details and literary panegyrics.[1] Next in quantity are histories of modern art devoted to a single country. These are of several types. Some are systematic studies, covering all trends. Alfredo Boulton's volume on Venezuela is a good example.[2] Others are little more than compilations of notes of various types ranging over a broad spectrum of artistic activity.[3] In still others, the critic concentrates on a single aspect of this development.[4] Works of more inclusive character are those that deal with cultural areas, examined in terms of pre-Hispanic traditions and influences received from abroad,[5] and studies in which countries are grouped by geographical areas.[6] A problem common to all derives from the difficulty of establishing uniform guidelines for value judgments. Standards are different for each country and in most cases are determined by purely local conditions, often of a transitory nature.

The erratic character of criticism derives in part from the fact that it is a relatively new professional activity in Latin America. In societies that have known little more than a century of republican existence, one cannot work on the basis of long-established and generally received cultural values. The history is

● JOSE MARIA VELASCO. *THE VALLEY OF MEXICO.* COLLECTION OF THE NATIONAL ART MUSEUM OF MEXICO, MEXICO CITY. PHOTOGRAPH COURTESY OF THE ART MUSEUM OF THE AMERICAS ARCHIVE, OAS, WASHINGTON, D.C., U.S.A.

one of violent breaks with the past, of affirmations followed by denials, of alternating confidence and skepticism with respect to powers of expression.

However material be organized, whether for studies of limited scope or ones of a general nature, the critic must take into account social, economic, or political circumstances which may bring about a complete change in a country's art.

Sometimes the circumstances are purely economic. It was the establishment of the Royal Tobacco Factory in Cuba that brought artists to that island early in the nineteenth century. They came to design ornamental paper cigar bands, but they were also responsible for the appearance of a remarkable output of popular prints strongly critical of the established order. In addition, in 1818 the Academy of San Alejandro was founded in Havana to provide the rising moneyed class with art modeled on that of Europe. As a result of these two factors, the art scene in Cuba was altogether different from that in other Latin American countries during the nineteenth century. Though rich and varied, it did not favor the introduction of modern trends in art, which, critics say, did not assert themselves until about 1925.[7]

The political event with the greatest influence on the modern art of a Latin American nation was the Mexican agrarian revolution. Even such outstanding figures as Diego Rivera, David Alfaro Siqueiros, and José Clemente Orozco—all of whom were European-trained—would probably have developed along quite different lines had they not been invited in 1921 by the Secretary of Public Education, José Vasconcelos, to do murals for the country's principal public buildings. Their compositions—which reflected both personal inclination and political indoctrination—were by-products of the Mexican Revolution. When imitated by artists in other countries, where conditions were not the same, the results were often unfortunately artificial.

Sometimes change came about through the sudden appearance of an avant-garde group seeking to revolutionize artistic standards, as was the case with the Montparnasse Group[8] in Chile in 1925. In other instances change was hastened by conflicts between groups, and by public discussions, such as those that took place in Buenos Aires between writers from Florida and Boedo, small towns in the environs of the capital. In most cases new trends in art were first advocated in the avant-garde, nationalistically inspired literary magazines that began to appear in the late 1920s and early '30s, for there tended to be a close alliance between plastic artists and poets and other writers. Thus the work of Amelia Peláez was promoted in the Cuban magazine *Revista de Avance*; the Buenos Aires publication *Martín Fierro* lent support to Xul Solar; the Peruvian review *Amauta* championed Torres-García; and Baldomero Sanín Cano joined battle in Bogotá in 1925 in defense of Andrés de Santa María *(pp. 9, 10)*. These are but a few examples of the writer-artist relationship that existed before modern art succeeded in asserting itself in Latin America.

If we take 1925 as the dividing line between old and new, we note that in each case the appearance of modern art was conditioned by the politico-social

circumstances of the individual country. Nothing could be farther from Siqueiros' texts on aesthetics[9] than the writings of Mário de Andrade and the group associated with São Paulo's 1922 Modern Art Week.[10] In the 1920s, the Chilean poet Vicente Huidobro, who sought to "internationalize Chile," and the Peruvian writer Juan Carlos Mariátegui, who advocated "Peruvianizing Peru," took stands that were not merely different but positively antagonistic; their artistic counterparts were, respectively, Roberto Matta and José Sabogal.

The varying roads to political and economic development that the countries were taking at this same time tended to draw them apart, as did their search for national identity. The latter led to a revived interest in folkways and an effort to define cultural boundaries, with consequent balkanizing effects. The worst of these consists in the fact that it is impossible to establish that line of continuity that is the sole solid foundation for cultural development, for all that it may appear to take place "by leaps and bounds," as Walter Benjamin wrote. As a result of the desire each country felt to possess a more individual type of modern art than that boasted by its neighbors, there was a break with the common heritage in which all had hitherto shared: the struggles for independence in the nineteenth century; the colonial regime that preceded; pre-Hispanic Indian cultures (both strong and weak); the influx of Blacks from Africa; crossbreeding between natives and newcomers. Rather than being viewed as a basis for cultural continuity, racial integration is even today a highly controversial issue.[11]

The appearance of modern art in Latin America should not be seen as a mere side effect of its development first in Europe and then in the United States. Neither should it be seen as a simple transfer to Latin America of the new perspectives and techniques that had been generated by the profound changes undergone by the societies responsible for the Industrial Revolution. If we date the beginnings of modern Latin American art from the mid '20s, 50 years after the first Impressionist exhibition in Paris (1874), it is obvious that Latin America took half a century to accept the idea that art is of value in and of itself, and not as a mere representation of reality.

It is important to understand that, if Latin America was a late bloomer in the field of modern art, it was because those fifty years were needed to prepare for what was to come. The background against which the development took place was not that of French Impressionism or Naturalism, or any of the "isms" current in Europe from 1905 to 1930, but the genre painting that artists of the late nineteenth century turned out in response to the bourgeois, provincial tastes of a society that was totally removed from the explosive growth of industry and cities in Europe and the United States.

An important place in this background was occupied by foreigners—not the eighteenth-century travelers who meticulously sketched the landscapes of the New World and the appearance and customs of the inhabitants—but academic painters of distinction. Mexico was one of the main centers of attraction. Baron Jean-Louis Gros, who lived there in the years 1832-36, depicted the central valley long before José María Velasco (1840-1912) *(p. xvi)*. The most summary criti-

cal analysis shows the difference between Gros' faultless academic style and Velasco's "learned constructions" with their "historical, philosophic, and folkloric overtones," to use terms employed by the Mexican critic Justino Fernández.[12] And it was an Englishman, Daniel T. Egerton, who was responsible for dramatic views of Popocatépetl. The German Johann Mauritz Rugendas (1802-1858), and later the Englishman Thomas S. Somerscales (1842-1927), devoted long hours to views of the Bay of Valparaiso, and had no equal in evoking the wild, cold South Pacific. The Frenchman Raymond Monvoisin (1790-1870) arrived in Chile in 1843. The Academy of Painting, founded in 1848, was headed first by the Italian Alessandro Cicarelli (1810-1874); he was succeeded as director by the German Ernst Kirchbach (1832-1880). They and Anthony Smith (1832-1877), the tireless observer of the Cordillera, were the first Chilean painters.

By the middle of the nineteenth century foreigners were active in all parts of Latin America. Trained in the academic manner and adhering to all the established rules, they painted with great technical proficiency, and with increasing emphasis on landscape, as the Cuban critic Adelaide de Juan has observed.[13] Since many of these painters were teachers, and since almost all the schools of fine arts were of their creation, one might conclude that it was they who taught painting and sculpture to every Latin American artist active at the end of the century. The conclusion is too simplistic, however. In the period between 1870 and 1920—when one can identify about 500 artists of some degree of interest—there was constant movement back and forth between Europe and Latin America. The foreign academics and landscapists established in Latin America practiced and taught different genres of painting. During the second half of the century, the two most in demand were historical paintings and portraits. Newly established national institutions sought enhancement in tableaux of heroes engaged in bold deeds. For their part, members of the moneyed classes that began to assert themselves following the wars of independence took pleasure in their own likenesses and in pictures devoted to mythological or biblical subjects, possession of which was supposed to convey a certain social standing.

While landscape constitutes the outstanding feature of the scenes of the Paraguayan War painted by Cándido López (Argentine, 1840-1902), in itself it was of no interest to either of the patrons mentioned above. With very few exceptions, such as the previously mentioned José María Velasco, landscape did not come into its own until the twentieth century, when it had an extraordinary flowering, concentrated, however, in a few favorite areas—notably Mexico, Colombia, and Brazil. In 1978 the State Art Museum of São Paulo presented an exhibit of 54 landscape artists active in the first two decades of the present century.

Two points are to be noted in regard to this flowering of landscape. First there were a large number of paintings in which landscape served merely as a backdrop—scenes of women washing clothes in streams, laborers working in the fields, and so on—all rather neutral from the descriptive viewpoint. There is no great difference between the washerwomen Andrés de Santa María painted in

Colombia and the manioc millers painted by Modesto Brocos y Gomez (1852-1936) in Brazil.

Second, with the exceptions of Joaquín Clausell (1866-1935) in Mexico and Armando Reverón (1889-1954) in Venezuela, the landscapists copied the Impressionists in capturing subjects rapidly and in producing color effects in which pigments are blended by the eye. They became tardy Postimpressionists who remained at all times within the established bounds as regarded genre and technique. No change or progress can be observed at any point. The Argentine Fernando Fader (1882-1935), who exhibited at the Costa Bazaar in Buenos Aires in 1905, is a typical example.

Postimpressionist landscape painting did not therefore imply the appearance in Latin American art of the idea of painting for its own sake. It indulged in no more than a timid alteration of reality, which continued to be the artist's point of departure. Comparing *Sketches of the Savannah*, painted by the Colombian Roberto Páramo in 1910, with *The River*, executed by his compatriot Andrés de Santa María in 1920, one notes that the latter is markedly more concerned with color values and the manner of applying paint to canvas, but the aim of both is to reproduce reality, transfigured though it may be by poetry or energy.

Reverón, in Venezuela, went beyond the limit which Rafael Monasterios (1884-1961) never exceeded: one crossed the threshold into modern art or one did not. If the Postimpressionist landscapists were not strictly speaking modern, neither were they the romantics their nineteenth-century United States colleagues had been. From the time of Thomas Cole till the turn of the century, the Luminists and members of the Hudson River School never ceased to breathe the romantic spirit. It went well with the discovery of nature by writers such as Thoreau, Emerson, and Whitman, and expressed a longing for wide-open spaces and awesome vistas contrasting with the bleak spectacles of the advancing industrial era. The Postimpressionists were quite unacquainted with the romantic spirit of the foreign landscapists of the earlier generation. They engaged in diffuse realism, as void of heroism as of social protest.

Paralleling them in the nascent century were a few—no more than a dozen—artists who practiced the type of social painting acceptable in the Paris salons, typified by the gentle humility of the peasants in Millet's *Angelus*. It was a type of genre painting that served in France to illustrate serialized novels such as Hugo's *Les Misérables*. It was picked up by a few artists whose emphasis was on the anecdotic. The episodes soon became clichés: *The Sick Boy*, painted by the Venezuelan Arturo Michelena *(p. 7)*, is brother to *The Sick Girl* of the Chilean Pedro Lira *(p. 7)*. Cuban beggars as depicted in popular prints are cousins of *The Orphans* painted by the Chilean Julio Fossa Calderón. *The Soup of the Poor* and *Breadless and Out of Work* (1885), painted by the Argentines Reinaldo Giudice and Ernesto de la Cárcova, are fit companions to the hungry and jobless in the gloomy renditions of the Venezuelan Cristóbal Rojas *(p. 7)*. It is no coincidence that a majority of these artists lived in Paris and painted for the salons there in the years from 1885 to 1890. Contrasting with this operatically programmed realism (which in Eu-

rope reflected the terrible overcrowding of the industrial centers) were less pretentious but more successfully realized works turned out in Latin America. In 1911 the Argentine Antonio Alice (1886-1943) won the prize for painting at the first National Salon in Buenos Aires with his *Portrait of the Painter Decoroso Bonifanti*. He, the Brazilian Eliseu d'Angelo Visconti (1867-1944), and the Colombian Alfonso González Camargo (1883-1941) asserted themselves as Intimists, and set the tone for an unpretentious type of painting whose significance is increasingly recognized as time goes by.

While the journey the Venezuelan Jacinto Inciarte made to Rome about 1883 belongs to the history of the nineteenth century, around 1890 a large number of painters of present concern began to make the pilgrimage to the fountainheads of art instruction, particularly the School of Fine Arts in Paris and the Academy of San Fernando in Madrid. After 1900 these travelers, less conscious of being neophytes, began to shed the timidity evinced by those of two decades earlier. In 1915, after admiring some 600 Goyas at the Buen Retiro Museum in Madrid, Reverón felt he had been in Europe long enough and returned to Venezuela for good, taking up a hermit-like existence in the little "castle" he built on the beach at Macuto.

The Colombian Andrés de Santa María (1860-1945) and the Uruguayan Pedro Figari (1861-1938) went to the other extreme, doing almost the whole of their work in Europe. Figari's compatriot Joaquín Torres-García (1874-1949) spent 43 years in the Old World before returning to Montevideo in 1934. The Mexican Rufino Tamayo emphasized his divergence from the muralists by constant journeying between Mexico City, Paris, and New York in the years from 1926 to 1938. After his trip to France and Italy in 1912, the Argentine Emilio Pettoruti (b. 1892) divided his existence between the Old World and the New until his death in Paris in 1971.

I have purposely mentioned some of the exceptional artists who, rising above their environments, took it upon themselves to introduce modern art into Latin America. They are recognized as forerunners of the art to come, owing to the exceptional quality and innovative character of their work. They were, however, the product of the same milieu as their less-talented colleagues, they received the same poor academic instruction, they struggled with similar problems, and they encountered the same lack of understanding on the part of a conservative and unreceptive public. One should recall that until their arrival in Europe they had had almost no contact with modern art. In celebration of the centennial of Argentine independence in 1910, an exhibition of paintings was staged at the old Argentine Pavilion in Buenos Aires. It featured Spanish artists such as Nonell, Mir, Rusiñol, and Anglada Camarasa and Frenchmen such as Renoir, Bonnard, Monet, and Vuillard. (Picassos had first been presented in Buenos Aires at the Witcomb Gallery in 1904.) But Buenos Aires was an exception —a flourishing cosmopolitan center riding on a wave of prosperity. In contrast, despite the power of its closely knit cultural elite, São Paulo had no contact with works of the famous School of Paris until Tarsila do Amaral (1890-1973) took to frequenting

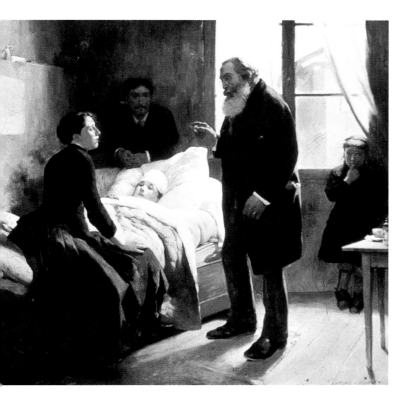

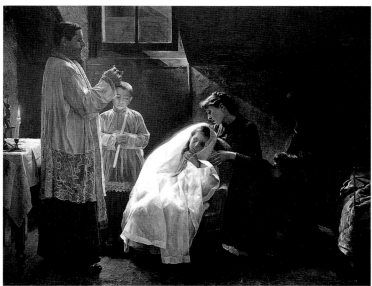

• **ARTURO MICHELENA**. *THE SICK BOY*. 1886. NATIONAL ART GALLERY, CARACAS, VENEZUELA. (UPPER LEFT). **CRISTOBAL ROJAS**. *THE LAST FIRST COMMUNION*. 1888. NATIONAL ART GALLERY, CARACAS, VENEZUELA (UPPER RIGHT). **PEDRO LIRA** *THE SICK GIRL* (BELOW). PHOTOGRAPHS COURTESY OF THE ART MUSEUM OF THE AMERICAS ARCHIVE, OAS, WASHINGTON, D.C., U.S.A.

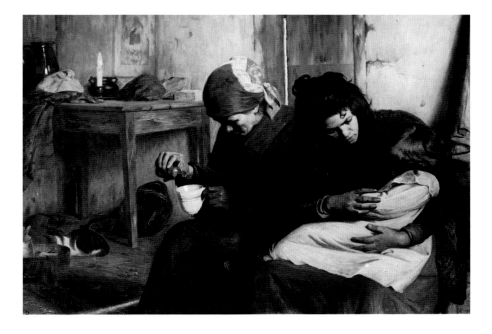

the studio of André Lhote.[14] While snobbery had the beneficial effect of keeping the Buenos Aires elite up to date, this did not prevent the public that acclaimed the exhibit of the Japanese artist Foujita at the Müller Gallery in 1932 from repudiating and mocking Pettoruti and Xul Solar. It is easy to imagine the artistic stagnation of the first two decades of the century in what we might call "closed-door" countries in view of their unreceptiveness to immigration—those of the Andean area, Central America, and certain parts of the Caribbean. Genre painting reigned supreme; the public refused to accept anything other than literal reproduction of visible reality. Sometimes the merest of accidents had a profound effect on an artist's career. Jaime Sabartés, a friend of Picasso, set up a tailor shop in Guatemala City in 1907, and it was there that the young Carlos Mérida saw for the first time a few examples of modern painting. This chance encounter proved decisive for the development of one of the most original of the pioneers of modern Latin American art. Wifredo Lam's visit to Picasso's Paris studio in 1930 was to bear fruit 12 years later in an impressive series of Picasso-like pictures of women of the tropics. Individual talent and chance were two factors of significance in the implantation of modern art in Latin America.

The slow, laborious process of gaining access to modern art meant that until 1925 artists did not feel free to depart from representation of reality. It also meant, however, that Latin America skipped over the period of "isms" in European art. Fauvism, German and Scandinavian Expressionism, Russian Constructivism, De Stijl, Dada, and Pointillism all were without direct or indirect effect on Latin American artists. The innovations that became known and were timidly accepted fell in the areas of Impressionism—already in a second phase—and Cubism. With respect to the latter, reservations must be made similar to those expressed in the case of the former. The analytic and synthetic aspects of French Cubism, the use of planes, and the decorative manifestations found no reflection in Latin America. Instead we find a process of "Cubification" of still-recognizable forms, combined in rather elementary fashion. It was not a matter of chance that the European artist most closely followed in Latin America was André Lhote, a now-forgotten painter of second rank, who engaged in the same sort of second-hand modernism. The break with Postimpressionist landscape painting came about through "Cubification" more in the manner of Cézanne than in that of Picasso. During the '30s it found its best expression in a dry, literal realism, deriving from enthusiasm for the Mexican muralists, the most important influence being that of Diego Rivera. Portraits painted in Argentina by Raquel Forner, Demetrio Urruchúa, and Lino Eneas Spilimbergo; in Colombia by Ignacio Gómez Jaramillo; and in Cuba by Jorge Arche, and working-class scenes painted by the Argentine Antonio Berni or the Mexican Antonio Ruiz are all characterized by the same directness of expression and synthesis of elements in a well-combined whole. One might call it Diego Rivera seen in the light of Cubism. There were variations of course. An artist like the Argentine Luis Centurión took a more aesthetic approach to "Cubification," and the Brazilian Emiliano di Cavalcanti practiced it with exuberant exaggeration.

● ANDRES DE SANTA MARIA. *COUNTRY CONCERT.* UNDATED. OIL ON CANVAS, 16 X 21 CM. ANTIOQUIA MUSEUM, MEDELLÍN, COLOMBIA. GIFT OF HELENA OSPINA DE OSPINA, 1955. PHOTOGRAPH FURNISHED BY THE ANTIOQUIA MUSEUM.

In this introductory period one must also recognize the power exerted by Surrealism. Mexico provided a natural home for the movement and many of its outstanding figures gravitated there. The Frenchmen Antonin Artaud and André Breton appeared there in 1936 and 1938 respectively. One also notes the presence of the Peruvian César Moro, the German Wolfgang Paalen, and, during World War II, two women painters, Remedios Varo of Spain and Leonora Carrington of England. All served to reinforce a century-old native tradition running from José Guadalupe Posada through Julio Ruelas and Frida Kahlo to Francisco Toledo.[15] At the other end of the continent, in Argentina, Surrealism was practiced as an intellectual exercise, in accordance with orthodox European principles. Juan Batlle Planas was the unquestioned leader of the movement, and Aldo Pellegrini its official critic.[16] Strange to say, these exceptions aside, though

Latin America has been described as a "Surrealist continent," the theories of the European Surrealists and their "planned fantasies" had no repercussion there whatever. As we shall see, modern Latin American art derives in large part from the myths and magical beliefs that circulate in a majority of the countries, and has far deeper meaning than the limited fantasizing of a René Magritte or a Paul Delvaux. The importance of this element lies in the fact that it gives a "tone" to Latin American art that comes close to expressing the "identity" to which it aspires. An identity that embraces both group and individual tendencies in Latin American art is undoubtedly a utopian ideal. It is not to be achieved by theorizing, but must derive from the works of art themselves. The way to the goal is a tortuous one, but it is not lacking in adequate guideposts.

Notes

[1] Interpretation from the literary viewpoint is well exemplified by *Tamayo* (Mexico City: Universidad Nacional Autónoma de México, 1958); from the angle of philosophical analysis, by Juan Flo's *Torres-García*, published in Montevideo; from the research angle, Barbara Duncan's *Torres-García*, published in the United States; from the viewpoint of the sociology of art, by Rita Eder's *Gironella* (Mexico City: Instituto de Investigaciones Estéticas de México).

[2] Alfredo Boulton: *Historia abreviada del arte en Venezuela* (Caracas: Monte Avila).

[3] Good examples are Juan Calzadilla's *El ojo que pasa* (Caracas: Monte Avila, 1969) and Juan García Ponce's *La aparición de lo invisible* (Mexico City, 1968).

[4] Cayetano Córdova Iturburu: *La pintura argentina del siglo XX*, Buenos Aires, 1958.

[5] Marta Traba: *Dos décadas vulnerables en las artes plásticas latinoamericanas, 1950-1970* (Mexico City: Siglo XXI, 1973).

[6] Damián Bayón: *Aventura plástica de Hispanoamérica* (Mexico City: Fondo de Cultura Económica, 1974).

[7] Adelaida de Juan: *Pintura cubana* (Mexico City: Universidad Nacional Autónoma de México, 1980).

[8] The group adopted this name as a sign of renewal and rebellion. Most of its members had lived in Paris and were influenced by the new ideas in fashion there. According to the *Revista de Educación de Chile* (1928), when these artists reached Santiago they issued a manifesto and held a number of group shows. The principal characteristics of the Montparnasse Group and its epigones were: a lack of strict plastic style, a desire to transfer their own subjective reactions to canvas, and an indubitable lyric spirit. See Antonio R. Romera, *Historia de la pintura chilena* (Santiago de Chile: Zig-Zag, 1960).

[9] David Alfaro Siqueiros: *No hay más ruta que la nuestra* (Mexico City, 1945). A compilation of ten articles by the author.

[10] Marta Rosetti Batista *et al.*: *Brasil; 1° Tempo modernista, 1917-1929, Documentação* (São Paulo: Universidade de São Paulo, 1972).

[11] See in this regard the controversy between the Argentine writer Julio Cortázar and the Peruvian José María Arguedas concerning Arguedas's criticism of cosmopolitan writers in *Amarú*.

[12] Justino Fernández: *El arte del siglo XIX en México* (Mexico City: Universidad Nacional Autónoma de México, 1967).

[13] Adelaida de Juan, *op. cit.*

[14] Aracy A. Amaral: *Tarsila, sua obra e seu tempo*, 2 vols. (São Paulo: Editora Perspectiva/ Universidade de São Paulo, 1975).

[15] Ida Rodríguez Prampolini: *El surrealismo y el arte fantástico de México* (Mexico City: Universidad Nacional Autónoma de México, 1969).

[16] Aldo Pellegrini: *Panorama de la pintura argentina contemporánea* (Buenos Aires: Paidós, 1967).

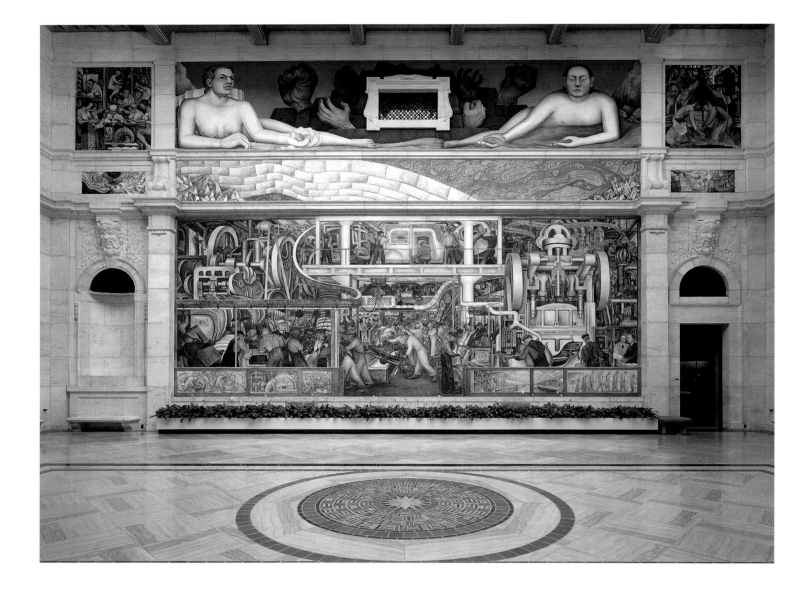

MEXICAN MURALISM: ACCOMPLISHMENT AND IMPACT

||

MORE THAN SIX DECADES HAVE PASSED SINCE THE WALLS OF PUBLIC buildings in Mexico were first emblazoned with the works of the country's great muralists. Those compositions can now be viewed in perspective and discussed objectively, without the impassioned argument that they provoked until the early 1950s—an argument that was revived all but posthumously in 1970 by the construction of David Alfaro Siqueiros' Cultural Polyforum in Mexico City.

It is generally agreed that the Mexican School had its roots in the 1910 revolution, but the statement is now qualified to some extent. The Mexican critic Jorge Alberto Manrique writes: "To view the Mexican School of Muralists solely as a product of the revolution that began in 1910 is a misinterpretation of which propaganda has taken maximum advantage."[1] He points out that the social upheaval coincided with the revolution in poetry that occurred everywhere between 1920 and 1930. The Mexican writer Octavio Paz expresses a similar view: "Mexican mural painting springs not only from the change in social consciousness represented by the Mexican Revolution but also from the change in aesthetic perception that constitutes the European artistic revolution of the twentieth century."[2] At a colloquium held at the National University of Mexico's Institute of Aesthetic Research November 7-10, 1979, the attempt was made to reevaluate a number of concepts in current usage. One of them was the term "the big three," applied to Rivera _(pp. 12, 17, 18, 19)_, Siqueiros _(pp. 21, 22)_, and Orozco _(pp. 24, 25, 26)_. In this regard the critic Berta Taracena writes: "It is important to note that at this juncture it is no longer possible to speak of a 'Mexican School'—a term frequently used in a pejorative sense—with regard either to the Muralists or to other painters of the period. The expression has gradually given way to the

● **DIEGO RIVERA**. _DETROIT INDUSTRY._ MURAL ON THE SOUTH WALL OF THE CENTRAL COURT OF THE DETROIT INSTITUTE OF ARTS, MICHIGAN, U.S.A. FRESCOES EXECUTED 1931-33. DETROIT INSTITUTE OF ARTS. ACQUISITION OF THE SOCIETY OF FOUNDERS WITH FUNDS DONATED BY EDSEL B. FORD. PHOTOGRAPH BY DIRK BAKKER FURNISHED BY THE DETROIT INSTITUTE OF ARTS.

more general aesthetic concept of 'Mexicanism,' which defies all attempts at definition, owing to the complexity of its origins." In the considered and dispassionate reexamination of the Muralists now under way, there is general agreement that their work represents the most important movement in Latin American art of the early part of the century. It was the only one to make clear the need for something that went beyond easel painting, something capable of playing a role of social importance in emerging Latin American societies. As nationalistic tendencies came to the fore in the '20s and '30s, there was great debate of the prime obligation to establish a bond between art and society, particularly when the society in question was culturally deficient and lacked access to information that would make clear its role as the protagonist of history. The theoretical discussions found reflection in the work of a number of exceptional artists. The Mexican Muralists were vigorous in putting the idea into practice, expressing it with a conviction and sweep that no one has been able to duplicate since. The violence of the reaction to the Muralists when they moved clearly into the political arena is better understood when one recalls that at the same time efforts were being made in Latin America to introduce a type of art that was truly twentieth-century in character, in clear opposition to nineteenth-century models. A number of artists were seeking on an individual basis to evolve an aesthetic language suited both to the world of their day and to national peculiarities, rejecting passive acceptance of European models.

Today one has no difficulty in recognizing the debt owed by the Mexican Muralists to the new European art of their time. This applies particularly to Diego Rivera. During his years of apprenticeship in Europe he produced Cubist compositions in the manner of still lifes by Juan Gris, Braque, and Picasso. His color combinations were, however, highly original, and doubtless owe something to Mexican folk art. While Siqueiros and Orozco lacked Rivera's European experience, they nonetheless profited from the new freedom in the treatment of form that derived from Expressionism and from the spirit of experimentation that had taken the place of slavish adherence to academic precepts. Around 1907 "Dr. Atl" (Gerardo Murillo, 1875-1964) painted 12 gesso panels for the House of the People in Paris. He used pigment mixed with resin, producing a pastel-like effect. His Italo-French training influenced to some extent his panoramic concept of space—a concept similar to that of the Muralists.

The moving forces behind the work of the Muralists were thus two. First there was the Mexican Revolution and the concurrent discovery of the spirit, the inherent worth, and the deep-rooted culture of the Mexican people, all of which had been obscured by the Europeanizing tendencies of the long period (1876-80, 1884-1911) of Porfirio Diaz's presidency. Second, there were the new tendencies abroad in the Old World, polarized around the right "to dare everything," as Paul Gauguin put it. But other forces were also at work—ones of a more immediate and local nature. One notes for example the influence exerted by the extraordinary printmaker José Guadalupe Posada (1852-1913) *(p. 15)*, to which must be added that of two other great figures: Manuel Manilla (1830-1895) and Gabriel Vicente Gahona (1828-1899). In reality, one should take into consider-

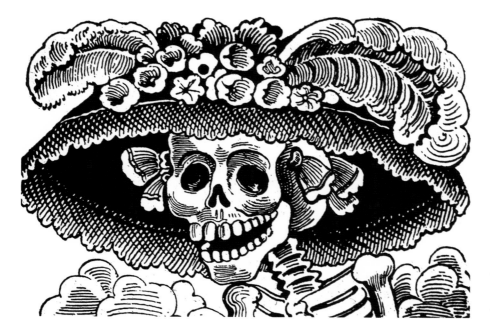

ation the whole mass of penny-press satirical graphics. Aimed at the general public, they constituted the most vigorous social criticism to be found in Latin America.

It was a Frenchman, Jean Charlot (1898-1979), the Muralists' "fellow-traveler," who discovered Posada's work in a printshop belonging to Blas Vanegas Arroyo, the son of Posada's printer Antonio Vanegas. Taking from folk art the figure of the skeleton, Posada portrayed as death's-heads members of the opulent society that flourished under Porfirio Díaz. Their presence in scenes of injustice and atrocity symbolizes the leveling effect of death, the theme so popular in late medieval art. In his fresco *Dream of a Sunday Afternoon in the Alameda*, Rivera painted himself as a child in a monumental tableau. A skull-headed woman leads him by one hand and gives the other to José Guadalupe Posada. The critic Luis Cardoza y Aragón has called this a tribute to "the universal figure of the Mexican Revolution."

In the course of 30 years, Posada authored about 15,000 prints. He arrived on the scene when lithographs of satiric intent had become important factors in Mexican public life. Lithography was introduced to Mexico by an Italian, Claudio Linati, who opened up a printshop in 1826. By 1900, 10 years before Porfirio Díaz was to celebrate the centennial of Mexican independence and the modernization of the country with unbelievable pomp, no less than 37 printshops were functioning in Mexico City. In the years from 1847 to 1913, lithography of satiric intent flourished mightily. In 1847 Gabriel Vicente Gahona brought out in Yucatan *Don Bullebulle*, a ferocious take-off of society and manners, including

people in life's humblest stations. Posada worked for 25 different penny-press sheets at one and the same time. Rivera had his prints reissued in 1922, at which time Siqueiros and Xavier Guerrero began publication of *El Machete*, which was to last till 1938. At the turn of the century the Mexican satirical press was represented not only by penny sheets but also by periodicals, the most successful of which were *El Argos, La Patria, El Ahuizote, El Hijo del Ahuizote* (in whose issues for 1911 and 1912 early drawings by Orozco appear), *Fray Gerundio, El Fandango, La Risa del Popular, Gaceta Popular, El Diablito Rojo, El Diablito Bromista, La Araña,* and *La Guacamaya.* Political criticism is the aim of all, but form derives primarily from the Mexican ballad, featuring the adventures and misfortunes of heroes, bandits, and victims of tragedies that had evoked popular interest. It exhibits a fondness for exaggeration and bloodshed, for dividing the world between the innocent and their persecutors, and above all for action. The emphasis on detailed description of episodes, the sharp division between good and evil, and the excessive indulgence in melodrama carried over into the work of the Muralists. Save for occasional excursions into symbolism or prophecy, their compositions consist in narratives of gigantic proportions. The ballad, transmitted orally or by the penny press, gave continuity and consistency to the Muralist movement.

In Mexico the relationship between printmakers, Muralists, and folk art runs deep; it has roots in colonial art and in that of the the pre-Hispanic period. Triumphing over 35 years of dictatorship by Porfirio Díaz, the folk ballad, with the needs and tastes to which it gives expression, found reincarnation in the great narrative cycles of Diego Rivera (1886-1957), David Alfaro Siqueiros (1896-1974), and José Clemente Orozco (1883-1949). It also finds expression in the *Tribute to Zapata* painted by Rufino Tamayo (1899-1991) *(p. 29).*[3]

The monumental mural work of Rivera, Siqueiros, and Orozco has been the object of extensive study. The lengthy bibliography includes letters, autobiographies, and other writings by the artists themselves. Every text on modern Latin American art must review that work in order to explain its prestige and extensive repercussion. We shall follow the traditional order in dealing with the three.

In his *Zapatista Landscape* (1915), his *Portrait of Angelina* (1917), and the still lifes he painted in Paris in 1916, Rivera showed himself surprisingly independent of the Cubist masters who then dominated the art scene. While *Roses in a Vase* (ca. 1914) partakes of some of the liberties that characterize Juan Gris' work, it exhibits none of the monochromatic refinement of the ocher compositions Georges Braque was painting in 1914 and 1915, nor does one observe the play of spaces and planes to be found in Picasso's still lifes of the same period. The violence and sensuality of the color effects and the realistic details that crop up unexpectedly make for a heterodox Cubism of exceptional qualities.

A scant year after his return to Mexico, however, Rivera was painting in terms of the post-revolutionary situation. In 1921 he did *Creation* for the National Preparatory School, using encaustic, "putting the paint right on the wall, so that dollars can't unglue it." His first great works, however, are the murals he did for the Secretariat of Public Education. Covering 1585 square meters, they are overwhelming in effect. Rivera makes a strategic use of space, taking advantage of

● **DIEGO RIVERA**. *ZAPATISTA LAND-SCAPE: THE GUERRILLA*. 1915. OIL ON CANVAS, 144 X 123 CM. NA-TIONAL ART MUSEUM, MEXICO CITY. PHOTOGRAPH BY DIRK BAKKER FUR-NISHED BY THE DETROIT INSTITUTE OF ARTS, DETROIT, MICHIGAN, U.S.A.

overhangs, recesses, and staircase landings. One does not so much "read" as "experience" the mural: one rises from a landscape of low-lying jungles, ports filled with boats and thronged with women, up the sides of mountains. Legends—that of Xochipilli on the first landing—bring the narrative to a temporary halt, but constitute no real break. At the second level one witnesses the birth of socialism, with the end of capitalism and the burial of the worker. Rivera had clearly learned from Giotto how a composition is structured.

The murals painted for the National School of Agriculture in Chapingo in 1927 are of a different order. In the central panel one sees Mother Earth, with plants springing from the bodies of martyrs. As the critic Oliver Debroise has observed, one must let oneself be carried off into the world of dreams to appreciate this properly. Seeking to appeal both to the educated and to the public at large, the Muralists constantly vacillated between mere description and symbolism. The use of a system of symbols constitutes a highly complex plastic language, which can be deciphered only by the initiate. It takes a scholarly minded artist to make successful use of this manner of expression. In Orozco's case it constitutes an ontological statement, in that of Siqueiros it serves the end of political and ideological propaganda. To come back to Rivera, the murals at Chapingo provide a primer of elementary symbols. The closed fist represents the germination of revolution; the partly open hand signifies its flowering; the fully open hand, its

fruit. The earth lies in bondage to capitalists, the military, and the clergy. Good
and bad government are depicted as in the Sienese frescoes of the fourteenth cen-
tury. The hammer and sickle appear in the center of the vault.

While Rivera was painting at Chapingo, Mexico was rocked by a new
wave of violence—the War of the Cristeros.[4] In 1928 Obregón was reelected only
to be assassinated. Calles, who succeeded to the presidency, put a stop to the
spread of the *ejidos*, settled relations with the United States, and came to new
agreements with the great landholders.

The frescoes and grisailles Rivera did for the Cortés Palace in Cuernavaca
were commissioned by Dwight Morrow, then the American Ambassador in
Mexico. Their verve and preciseness of outline reflect the influence of Uccello.
The battle between the Aztecs and the Spaniards and the taking of Cuernavaca
are portrayed by Rivera in the best Renaissance spirit. The equestrian figure of
Zapata in the panel devoted to exploitation and insurrection is nothing less than
a masterpiece. Between 1929 and 1935 Rivera executed monumental frescoes in
the stairwells and entrance hall of the National Palace, works which according to
the critic Antonio Rodríguez show Rivera's "exceptional feeling for architec-
ture." Pre-Columbian Mexico, the Spanish conquest, the struggles for indepen-
dence, the war with the United States, the 1910 Revolution with Zapata's cry for
"land and liberty," the history of class struggle, present-day Mexico, and Mexico

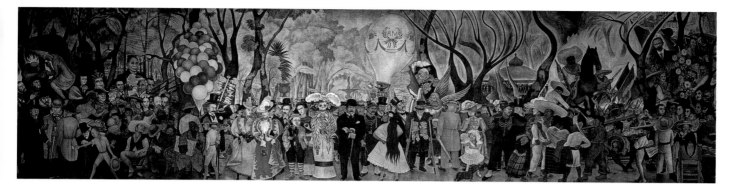

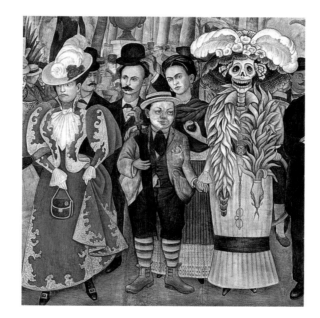

● **DIEGO RIVERA**. *DREAM OF A SUN-DAY AFTERNOON IN THE ALAMEDA*. 1947-48, FRESCO IN THE HOTEL DEL PRADO, MEXICO CITY, 4.80 X 15 M. PHOTOGRAPH BY DIRK BAKKER, CONTRIBUTED BY THE DETROIT INSTITUTE OF ARTS, DETROIT, MICHIGAN, U.S.A.

of the future—all are depicted in fresco in the Italian manner, painted on quick-drying wet plaster. There are, however, a few slight departures from tradition. For example, cactus juice was used instead of water to dissolve the pigments, with the result that some of the colors have oxidized. The narrative technique recalls the films of Cecil B. De Mille, with their sweeping movements of masses and their organized confusion. It is history turned into pageant and staged for ready comprehension on the part of the public.

While Rivera was painting murals for the Palace of Fine Arts (1935) and the frescoes on movable frames for the Hotel Reforma (1939), Lázaro Cárdenas was President of Mexico. This was the period of Mexico's expropriation of landed estates and the holdings of foreign oil companies. It coincided ideologically and politically with the nationalist movements that were sweeping all parts

of Latin America. Ten years later (1948) Rivera painted for the Hotel del Prado the composition that the critic Justino Fernández has termed his masterpiece, *Dream of a Sunday Afternoon in the Alameda*. Here, as we have already noted, Rivera makes a return to descriptive material derived from the folk ballad.

Between 1930 and 1933 Rivera did a number of important works in the United States. The mural at the California School of Fine Arts in San Francisco (1930-1931) is clear and well balanced. In a satiric touch, Rivera has depicted himself from behind, seated on the scaffolding. The murals for the Detroit Institute of Arts (1932-33) mark a return to spatial complexity and to the cinematographic handling of masses. Of the 27 panels, the two largest (north and south) are of unequalled baroque opulence. The key figures appear amid a wild jungle of machinery. The Detroit murals were commissioned by Edsel B. Ford and refer in large part to the manufacture of automobiles. Certain small panels, such as the one with the personification of the worker, show a resemblance to the tubular compositions of Fernand Léger, and also to the puritanically geometric work of Charles Demuth and Charles Sheeler, the two principal American offshoots of European Cubism. The murals Rivera executed for Rockefeller Center in New York in 1933 and the 21 paintings on subjects from U.S. history, executed as frescoes on movable frames for the New Workers School in New York, suffered a series of politically motivated misfortunes, causing Rivera to adopt even more radical positions. One should note that throughout these years, and almost until his death, Rivera never ceased to practice easel painting, principally in the form of frontal views of children,[5] in which he alternated between two-dimensional and three-dimensional effects, sometimes combining them with unexpected results.

Diego Rivera died in 1957, five years after the presidency of Miguel Alemán, who had brought about a rapid modernization of the country, a broadening of the middle class, and the consolidation of the PRI—the Institutionalized Revolutionary Party.

In 1945 David Alfaro Siqueiros gathered together a series of newspaper articles and published them in book form, under the title *No hay más ruta que la nuestra* (Ours Is the Only Way).[6] This phrase, which became the most celebrated slogan of the Muralist movement, appeared in the article "La pintura moderna mexicana." Siqueiros held that modern Mexican painting was the cultural equivalent of the Mexican Revolution. It merited economic support from the state and the political and financial backing of all existing or future entities representative of the people. The path it had taken was the only one that could be followed, "the one which, in a future much nearer than one might think, all artists of all countries—including the Paris-based and their adherents—will have to take beyond the shadow of a doubt. There is no other! Could anyone dare to deny it after even the most superficial analysis of the present world art scene? Are there signs of any other path? The movements in Paris, which were all that counted up to yesterday, are now meaningless."

In "Vigencia del movimiento plástico mexicano contemporáneo" (Validity of the Contemporary Mexican Art Movement), which the critic Raquel Tibol included in *Textos de David Alfaro Siqueiros*,[7] Siqueiros wrote in 1966: "As for free-

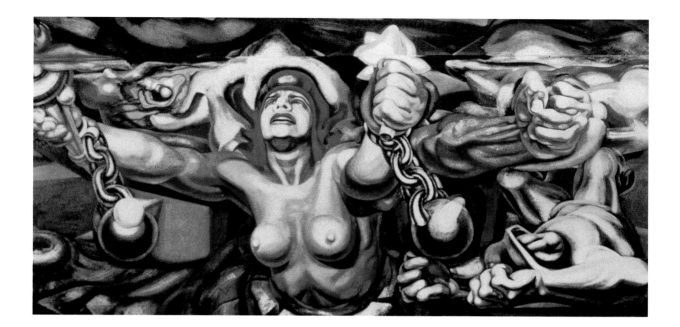

dom of artistic creation, we did not nor do we claim that anyone should be forced to follow our artistic line. To assert the contrary would be a calumnious falsehood." Taking a realistic view of the intervening 20 years, the painter seems to recognize that Mexican art had rejected the Muralist formula and had taken three different directions—those of Surrealism, Neofigurative representation, and Geometric Abstraction.

Siqueiros' belligerent personality was undoubtedly responsible for much of the controversy surrounding the work of the Muralists. He joined the army of Madero before that president's assassination in 1913. He took a leading role in the establishment in 1922 of the Union of Technicians, Painters, and Sculptors, and shortly afterward he began publication of the polemical periodical *El Machete*. For half a century, until the inauguration of his Polyforum, he was in the eye of the storm—a storm which he himself provoked. "Our movement," he wrote, "runs contrary to that of the European avant-garde. We deny the fundamental principles of formalism and art for art's sake." He also attacked "the lamentable archaeological revivals (Indianism, primitivism, Americanism) so fashionable among us—revivals that are leading us to short-lived stylizations." He lent strong support to new technical media (exposed cement, air brushes, compressors, synthetic lacquers, sand mixtures, photomontages), in the use of which he showed himself a pioneer. He declared the traditional fresco techniques used by his companions to be obsolete. He attacked Orozco for being weak and romantic, and Carlos Mérida for practicing a hybrid form of art. Siqueiros' capacity for polemic was inexhaustible, but he was incapable of defining politico-national art in coherent, persuasive terms.

● DAVID ALFARO SIQUEIROS. *THE NEW DEMOCRACY*. 1944. MURAL IN PYROXYLIN. PHOTOGRAPH COURTESY OF THE ART MUSEUM OF THE AMERICAS ARCHIVE, OAS, WASHINGTON, D.C., U.S.A.

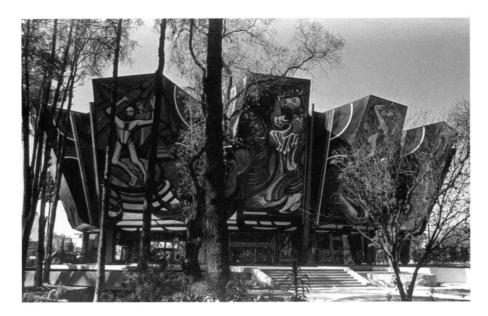

These contradictions can also be noted in his compositions, executed not only in Mexico but in other parts of the world. In 1922 he returned from Europe, where he had met Rivera, and at once began to produce "art that is figurative and realistic—in other words modern." In the 10 years between his murals for the National Preparatory School (1922) and his reappearance as a creative artist in Los Angeles in 1932, he busied himself as a journalist and a trade-unionist. He traveled to Moscow; he was a militant activist in Buenos Aires and Montevideo, encouraging the organization of artists in national trade unions. The frescoes he did on cement in Los Angeles and his use of an electric spray gun for large-scale air-brush work made a deep impression on inquiring young U.S. artists. He proposed working on the basis of photographs in Buenos Aires in 1933, and in 1935 he engaged in a long public discussion with Rivera on the chemistry of plastics. In 1936 he opened his celebrated experimental workshop in New York. It was there that Jackson Pollock came to know and admire him, and that "accidental effect" was proposed as the principal element in new painting. Siqueiros fought in the Spanish Civil War, attaining the rank of major. Returning to Mexico in 1939, he painted the mural *Fascism on Trial* for the Mexican Electricians' Union. Of greater interest are the murals he did in Chillán, Chile. In *Death to the Invader* (260 square meters), he discovered that "the most extraordinary element in mural painting is the mobility provided by architecture and varying viewpoints." Visiting Cuba in 1943 he executed some small wall and ceiling paintings entitled *Allegory of Racial Equality in Cuba*. In Mexico a year afterward he painted *Cuauhtémoc versus the Myth*. Here he found sources of strength in historical allegory and the use of new materials. These two sources he also exploited in *The New Democracy*, done for the Palace of Fine Arts in 1945, and *Patricians and Patricides*, a 300-square-meter compo-

sition executed in pyroxylin, vinylite, and silicones. It is based on photographs, and in it he made use of the air brush. Other vast compositions of a similar nature are *The Fight against Cancer*, done for the Medical Center of the Mexican Social Security Institute; a work on the life and accomplishments of Ignacio Allende, done for San Miguel de Allende; and one for the Mexican National Museum of History in Chapultepec Park.

An exhibit organized by the Museum of Modern Art of Mexico, shown in 1947 at the Museum of Modern Art in New York, provided a particularly significant view of his sketches and experiments.[8] At present historians and critics are in agreement in avoiding judgment on the aesthetic or creative value of his work, which is of a problematic nature and difficult to place. According to the critic Raquel Tibol, his theme is the expression of life force in man and his rapidly expanding and advancing world. *Humanity's Earthly March toward the Cosmos*, the centerpiece of the Polyforum, shows clearly the difference between Siqueiros and Rivera. The latter set identifiable masses in motion, whereas Siqueiros made of mass an indiscernible force. His allegory has something of the impact of poster art, differing from that of Rivera, whose symbols tend to be heavy-set and static.

Siqueiros' involvement in a variety of activities outside the realm of painting kept him at a certain distance from the Muralist movement. Setting himself up as judge, he criticized Orozco in an article published in 1944. "Your ideas and your work," he wrote, "represent the iconoclastic, antimythical, and consequently lyrical period of our common effort. They evidence your extraordinary capacity for plastic expression, unexampled in the contemporary world. With almost mathematical precision they reveal the ideological errors into which many important men born of the revolution have fallen in the course of their political activities. They shared the unbounded faith of your early days, your first doubts, your ultimate tremendous skepticism and anguished fits of remorse for the mystique of the past. It is an attitude that in reality reflects a romantic weakness for considering human frailties as necessary evils of the movements in which men find themselves engaged."[9]

Four years earlier José Clemente Orozco had put the finishing touches on his master works, done for the city of Guadalajara. His paintings cover the cupola of the university auditorium, the main walls of the entrance to the government palace, and the whole interior of the Cabañas Hospice, which may be termed the Sistine Chapel of Mexican mural painting. Orozco worked under a number of foreign Expressionist influences, the most remote of them being that of the Russian Andrei Rublyov. The symmetrical plan of the Hospice, with three vast blank wall areas on either side of the nave and a central dome flanked by another pair of blank areas, provided Orozco with a perfect setting for telling a story. The artist made use of portraiture (Cervantes, El Greco, Hernán Cortés, Philip II), allegory (the banal, the unknown, the tragic; science, religion, despotism), symbolism (dictatorship, demagoguery, suffering humanity, the mechanization of the masses), realistic perspective (warriors, monks, friars), and the incarnation of myths. The energy radiated by this body of work bears little relation to the forward sweep of Siqueiros' masses and Rivera's carefully planned ensembles. The

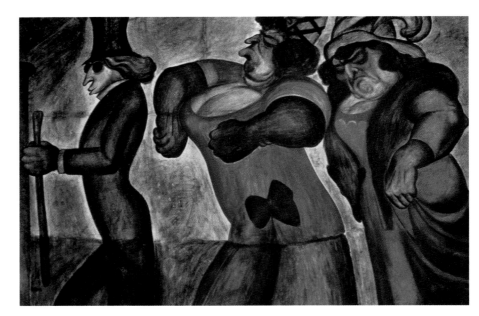

• **JOSE CLEMENTE OROZCO**. DETAIL OF THE MURAL *SOCIAL JUSTICE* (FORCES OF REACTION), NATIONAL PREPARATORY SCHOOL, MEXICO CITY. 1923-24. PHOTOGRAPH COURTESY OF THE ART MUSEUM OF THE AMERICAS ARCHIVE, OAS, WASHINGTON, D.C., U.S.A.

fury of the four horsemen of the Apocalypse and outcry against injustice inflame Orozco's universe, culminating, in the best baroque tradition, in the vault of the dome, where man receives the gift of fire. The drama changes tone; it becomes reflective and philosophic, setting forth man's quest, through life, struggle, and death, for his ultimate destiny. This tragic sense of life, conveyed in strongly Expressionistic terms, was first evidenced in Orozco's 1923 murals for the National Preparatory School. *The Trench*, with its bold diagonal slash, is a masterpiece rhythmically in accord with the strictest principles of Italian Mannerism. Sketches made by Orozco before 1915, now in the Carrillo Gil Collection, show the artist in a caustically critical light. *The Lecture* (ca. 1913) looks back to Goya and forward to José Luis Cuevas. Its richly expressive, rapid strokes give a clear idea of the artist's gift for satire.

In the years 1930-34, like Siqueiros and Rivera, Orozco spent a memorable period in the United States. In 1930 and 1931 he did a set of murals for the dining hall of Pomona College in Claremont, California, and about the same time another group, featuring political leaders from throughout the world, for the New School for Social Research in New York. Among the leaders, the figure of Lenin appears in the section on geometric research. Culminating his work in the United States are the murals Orozco did for Dartmouth College. In these he showed a capacity similar to that of Rivera and Siqueiros for painting a broad historical panorama of civilization, situating the first and second comings of Quetzalcoatl amid scenes of the native American world, the civilization that succeeded it, and the industrial age, and fusing modern sacrifices with that of Christ. The brushwork produces a Byzantine effect; the fresco technique employed is essentially traditional.

In 1934 Orozco returned to Mexico to execute an apocalyptic *Catharsis* for the Palace of Fine Arts in the capital and to finish the work he had begun in Guadalajara. This series was executed in a fresco technique in which lime and sand were applied to a concrete vault. Orozco continued thinking in grandly allegoric terms as can be seen from the murals he did for the Supreme Court Building in Mexico City (1941), the chapel of the Hospital de Jesús (1942-44), and the Turf Club (1945). An allegory of the nation covers 380 square meters at the National Normal School. In 1948 Orozco created an extraordinary mural, *Juárez and His Times*, for the National Museum of History at Chapultepec; this was executed in a mixture of powdered marble, cement, and lime on a steel backing. In 1949, the year of his death, he returned to Guadalajara to paint Hidalgo issuing his decree abolishing slavery. Sentences written before Orozco began his murals for the National Preparatory School give a clear idea of his aesthetic views. "Like a cloud or a tree," he wrote, "the true work of art bears absolutely no relationship to morality or immorality, to good or evil, to wisdom or ignorance, to vice or virtue.... The sole feeling it should arouse and transmit is that which derives from the scientifically structured, coldly abstract, plastic phenomenon. Whatever cannot be reduced to a plastic equation, expressive of the laws of me-

• **JOSE CLEMENTE OROZCO**. *FOL-
LOWERS OF ZAPATA*. 1935. LITHO-
GRAPH, 20/130, 32.5 X 40 CM. COL-
LECTION OF THE INTER-AMERICAN
DEVELOPMENT BANK, WASHING-
TON, D.C., U.S.A.

chanics, is a subterfuge masking impotence. It is literature, politics, philosophy, or what you will, but it is not painting. When art loses its purity, it becomes denatured and degenerates. It turns into a abomination, and at last it disappears." The critic Berta Taracena writes: "A reevaluation of Orozco is in order...for Orozco is an artist whose Mexicanism can be assigned a place in a line extending into our time from the pre-Hispanic era."

Both by their painting and by their public acts, the three artists we have been discussing exerted a strong pressure on art in Mexico. As Mexican critics have recognized, whereas in other countries there were a number of artists who facilitated access to the European avant-garde, Mexico was to all intents and purposes closed to such influence. Except for Surrealism, which constitutes a local tradition—witness the works produced by Julio Ruelas at the end of the nineteenth century—no tendency other than that exemplified by the Muralists was permissible. As a result of this pressure, Rufino Tamayo left the country, and, while Carlos Mérida was protected to some extent by the fact that he was Guatemalan, he nonetheless suffered personal alienation. Another result of the pressure exerted by the Muralists was the all-but-total dominance of "Mexicanism." Art was infused with a strongly nationalistic spirit; in subject matter there was great emphasis on folk material.

While a number of Mexican artists born during the twentieth century executed murals, none with the exception of Juan O'Gorman *(p. 27)* was in the same class with the three just discussed. O'Gorman's activity as a muralist dates from 1932, when he did some Mexican landscapes for the library in Azcapotzalco. Next came his surprising frescoes for the Plateresque church of San Agustín in Pátzcuaro. His art reached its culmination in his decoration of the

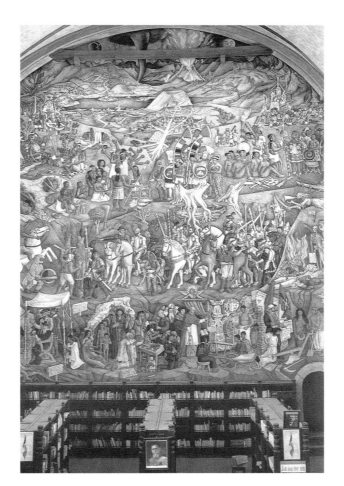

● **JUAN O'GORMAN**. MURAL IN THE GERTRUDIS BOCANEGRA LIBRARY, FORMER CHURCH OF SAN AGUSTÍN, PÁTZCUARO, MICHOACÁN, MEXICO. PHOTOGRAPH COURTESY OF THE ART MUSEUM OF THE AMERICAS ARCHIVE, OAS, WASHINGTON, D.C., U.S.A.

exterior walls of the university library in Mexico City (1952). Extending over 3,700 square meters, the murals make use of 12 different types of Mexican stone, coming from all parts of the country. The colors, ranging from the red rock of Guerrero to the pale green stone of Oaxaca, are unfading. Siqueiros protested violently against these murals, calling them "archaic," "backward-looking," and "static." He reproached O'Gorman for accentuating the complex descriptiveness of his indoor murals, particularly those at Pátzcuaro and the one entitled *The History of Aviation*, turning walls into an "illustrated tapestry." In rebuttal, O'Gorman deplored the work Siqueiros had done for the University City as incomprehensible and totally unrelated to the architecture of the buildings in question. The 1952 quarrel between Siqueiros and O'Gorman made two things clearly evident: First, the intransigence of the Muralists, as a school, with respect to any signs of heterodoxy, and, second, the artistic isolation and paralysis that were the ultimate result of that intransigence. One must consider that by 1950 modern art was a well-established presence in other parts of Latin America.

Undoubtedly O'Gorman's complex compositions (the *Tribute to Gaudí, The History of Aviation*, and, late in his career, the series of *Imaginary Flowers*) betray influences quite different from those of the "big three" Muralists—*art nouveau* and Surrealism, particularly as practiced by the German Escher. There is also lively evidence that he had a more learned and refined understanding than his colleagues of the kitsch aspects of folk art and the rich iconography of votive offerings. When he dedicated a work to a hero of the Revolution, as in the case of the *Tribute to Francisco Madero* done for Chapultepec Castle, he portrays both historical personages and representatives of the people with a delicacy that renders them quite different from the short, chubby figures in Rivera's compositions. The work blossoms with streamers and banners and terminates in a fantastic castle over which floats a balloon in a Germanic sky straight out of Altdorfer.

José Chávez Morado (b. 1909) painted three notable murals for the Hidalgo State Educational Complex in Santa Julia, and also had a hand in the exterior decoration of the University City in the Mexican capital in 1952. The murals Jorge González Camarena (1908-1980) did for the Guardiola Building in Mexico City are highly dramatic and not to be mistaken for the work of any other. In their regard the critic Antonio Rodríguez has said that the figure of Christ is "one of the most terrifying and spectacular in world art." González's *St. George and Imperialism* is a clever updating in which St. George appears as a soldier of the Mexican Revolution, killing the dragon with a shot from a revolver. The name of Alfredo Zalce (b. 1908) is associated primarily with graphics, but in 1930, working in collaboration with Chabela Villaseñor, he did a mural in colored cement—a technique unusual for the period—for the country school at Ayotla. In 1936 he worked with Leopoldo Méndez, Fernando Gamboa, and Pablo O'Higgins on a series of murals, the theme of which was the Popular Front, for the Government Printing Office. He surpassed his previous accomplishments in 1948 in his murals for the stairwell of the Michoacán Museum, the Chamber of Deputies, and the Government Palace in Morelia.

Fermín Revueltas (1901-1935) began as a Muralist in 1922 at the National Preparatory School, but thereafter pursued a path more his own, concerning himself with color vibrations and the energy conveyed by open spaces. One should mention among the driving forces of the Muralist movement Dr. Atl, and among faithful fellow-travelers Jean Charlot and Xavier Guerrero (1896-1974). The number of artists involved in mural painting bespeaks the power of the movement. It was indeed a national endeavor. When toward the end of the 1930s many artists returned to easel painting, they continued to occupy themselves with folk life and social themes. The aim was clearly descriptive, the spirit was one of social protest.

Some of the exhibitions of the period were of considerable interest. In 1937 the Gallery of Mexican Art sponsored the first group show devoted to easel painting. The effect was surprisingly uniform. Tamayo, Siqueiros, Montenegro, Rivera, Fernández Ledesma, and Cantú each contributed a figure painting, generally frontal and static. Only Tamayo's exuberant *Portrait of Olga* is enlivened by a personal touch of license. Even Carlos Mérida's oil *The Window*—a bright rect-

● **RUFINO TAMAYO**. *PORTRAIT OF OLGA TAMAYO*. 1935. OIL ON CANVAS, 113 X 78.8 CM. COLLECTION OF BERNARD LEWIN, LOS ANGELES, CALIFORNIA, U.S.A. PHOTOGRAPH FURNISHED AND REPRODUCTION AUTHORIZED BY THE OLGA AND RUFINO TAMAYO FOUNDATION, MEXICO CITY.

angle against a dark background—has the same frontal character and repose. There were four tableaux. Julio Castellanos (1905-1947), who had done openly militant murals on the theme "Heaven and Hell" for the Melchor Ocampo School in Coyoacán in 1933, contributed a *Dialogue*, with emphasis on plastic effects. Jesús Guerrero Galván (1910-1973) provided a monstruous *Nana*. *The Strike*, by Antonio M. Ruiz (1897-1964), is a cold example of "social art," concerned with the lowest class of city dwellers, the artist's usual subject. One of the rare cases in which he turned from this material resulted in his most famous painting, *Malinche's Dream*, generally classed as Surrealistic. José Clemente Orozco's *The Pulquería* is an admirable Expressionist work; the name of the bar—"Delirium"— well applies to the frightful aspect of the personages depicted. Also included in this key exhibition was a work by an "outsider," Carlos Orozco Romero (b. 1898), showing a human figure split in two. Magically beautiful in effect, it foreshadows the important Surrealist paintings he was to present at the Inés Amor Gallery in 1941.

The exhibition of Contemporary Mexican Painters put on at the art gallery of the Mexican National University in 1938 provides a backstage glimpse into the problems that the hegemony of Muralism posed for personal expression. The writer José Gorostiza prefaced it in a style highly challenging for the time. He asserted that what interested him in the works on view was their "close relationship to the abstract qualities of poetry." He went on to say that, mindful of the ends it pursued, Mexican art would be well advised to seek to graft itself into the development of artistic thought in the western world. With great critical intuition, Gorostiza ventured a definition: "Considered in itself, present-day painting is a form of primitivism. From the viewpoint of classic art, however, it represents a revolution. The whole of modern art should be understood, in C.J. Jung's fortunate expression, as *creative destruction*. Its worth can be calculated only teleologically, in terms of its future." Among the pictures included in the exhibition, not even Siqueiros's *Little Bull* shows any of the polemic spirit of mural painting. Indeed, the figures in *Little Bull* have much in common with the *Hunters of the Stratosphere* by Carlos Mérida (1891-1984). Federico Cantú (b. 1908), Jesús Guerrero Galván (1910-1973), María Izquierdo (1906-1955), and Agustín Lazo (1910-1971) showed themselves artists of substance, painting in a realistic, three-dimensional style. The *Portrait of the Painter Mario Alonso* by Roberto Montenegro (1887-1968) and the *Portrait of Chabela* by Orozco Romero follow the strongly nationalistic and realistic "hard line" favored throughout Latin America in the '30s. Julio Castellanos and Frida Kahlo represent the Mexican Surrealist trend, to be studied in the next chapter. The latter's admirable composition *Four Mexico City Dwellers* is characterized by a bold individualism, impossible to classify. There was apparently no problem regarding the two sculptors who were invited to participate in the exhibition, Luis Ortiz Monasterio (b. 1906) and Germán Cueto (1893-1975), though their work is poles apart, the former being a realist and the latter a Geometric Abstractionist.

Twenty years later Mexican art was solidly established in Europe, thanks to the impressive showing it made at the Venice Biennial of 1950. A defensive position, of justification of its existence, was nonetheless taken in the official exhibit of Mexican art that toured France in 1958. "The Mexican artist is a militant combatant," Miguel Salas Anzures wrote; "Art is always a message of hope transmitted from man to man," Jaime Torres Bodet declared. Totally unaffected by the hot competition between European movements in matters of form, Mexico chose to be represented by a group of proud, silent, fetish-like images: *The Protest* by Francisco Dosamantes (b. 1911), *The Indian Annunciation* by Raúl Anguiano (b. 1915), *The Bone* by Miguel Covarrubias (1904-1957), *Repose* by Ricardo Martínez (b. 1918), *Prometheus* by Orozco, *The Devil* by Trinidad Osorio (b. 1929), and *Indian Girl Bathing* by Diego Rivera. Equally remote in time and space from the European art scene were the landscapes included in the exhibit: views of Cuajimalpa by Dr. Atl and San Juan Ixtayopan by Francisco Goitia (1882-1960), *The Church of Los Remedios* by O'Gorman, and *The Cart* by Xavier Guerrero. Only the solidly structured landscapes of Angelina Beloff (1897-1967) and Olga Costa (b. 1913) show any influence of Cubism. Joaquín Clausell (1866-1935) had an

Impressionist intuition remarkable for Latin America; nevertheless his painting *The Baths of King Netzahualcóyotl* exhibits a rigidity characteristic of Mexican iconography. The permissible touch of Surrealism was provided by *Dreams in the Woods* by Leonora Carrington, *The Eclipse* by Orozco Romero, *The Fish* painted by Juan Soriano, and the mystical atmosphere exuded by Rufino Tamayo's *Slumbering Melodies* and Cordelia Urueta's *The Arrival*. The general effect of the exhibition was not diminished by these exceptions, and it was reinforced by the unanimity of social approach evidenced in the work of the graphic artists included in the show.

In 1980, while Pablo O'Higgins (1904-1983) was finishing a mural on foreign invasions of Mexico for the diocesan museum of Monterrey, Arturo García Bustos (b. 1926) was painting the history of Oaxaca in the government palace in that city. Siqueiros did not put the finishing touches on his Polyforum until 1974, the year of his death. Mexican Muralism and its derivatives thus continued to flourish, impervious to currents of change coming from abroad. It likewise triumphed over dissident movements at home. Surrealism was acceptable, but the idea of art void of social and historical content, purely aesthetic in func-

tion, which Mathias Goeritz introduced upon his arrival in Mexico in 1949, was decried in the most insulting of terms.

"The years 1920-1940 were marked by the appearance in Latin America of a considerable number of artists of first rank," writes the critic Jorge Alberto Manrique. "For the first time work was being produced that meant something on the world scene. Several of these artists are undoubtedly to be numbered among the great creative figures of the century. It is readily apparent, however, that in no other country was there a group of painters so substantial and cohesive as the Mexican Muralist School. Nowhere else were positions so firmly taken or was there such assurance with regard to accepted values. The group feeling, the consciousness of constituting a school, gave a certain coherence to the movement, but in the long run it proved an obstacle to communication with abroad."[10]

Implicit in this statement are the problems that Mexican Muralism posed for painting in the rest of Latin America. It presented a monolithic front to viewers from abroad. It found its justification in the Mexican Revolution and received financial support from the state. Conditions similarly favorable to large-scale production of mural art were not to be found elsewhere. Artists in other countries received occasional contracts for murals—Portinari *(pp. 31, 36)* in Brazil, Venturelli in Chile, Pedro Nel Gómez in Colombia, Berdía in Uruguay. Sometimes government officials offered verbal support to painters, as was the case with the writer Jorge Zalamea when he served as Minister of Education of Colombia during the first term of President Alfonso López Pumarejo (1934-38). Occasionally magazines such as the Peruvian José Carlos Mariátegui's *Amauta* expressed enthusiasm for mural painting as a social form of art. One must also remember, however, that the thirties—the period in which Mexican mural painting became known abroad—were the period of the worldwide depression that followed the stockmarket crash of 1929. Amid the pressures of dealing with the crisis, little attention could be assigned to art.

The influence of the Mexican Muralists was exerted in a number of ways. Of the big three, Siqueiros was the one who had the most contact with the rest of Latin America, owing both to his own mural activity there and to the zeal with which he attempted to establish in other countries artists' trade unions similar to the one in Mexico. The strongest influence on form, however, was that of Diego Rivera. The Rivera model, based on a substructure of cylinders and spheres, exerted an influence on many socially oriented artists of Latin America, from Darío Suro in the Dominican Republic to Antonio Berni *(p.41)* in Argentina. In addition to its use in murals, it fostered realistic social portraiture, a genre which enlisted the services of a majority of painters, sculptors, and engravers active around 1940.

If the '30s were a period of impoverishment for nearly all of Latin America, they also constituted a period in which the area was called to face the challenges of modern times. Attempts were made to achieve economic independence through industrialization. A working class appeared, bringing new problems and pressures, and the middle classes took on a more populist character. While the conditions that brought about the Mexican Revolution did not occur

elsewhere, there were a number of popular movements aimed at obtaining a share of political power, a circumstance that gave room for painting of political intent, generally related to the establishment or consolidation of local socialist or communist parties.

The updating of art continued its course. Despite the artists' union's claims of having eliminated aesthetic concerns, one can see in the background of Mexican art the influence of Cézanne and Soutine, as well as Giotto and Piero della Francesca. In other parts of Latin America a derivative type of social art affected the painted image. Sometimes the model was Rivera, sometimes Lhote, sometimes the Picasso of *Guernica* (1937). In its concern with conveying clear messages to the masses, art tended toward formula, losing much of the spirit of experimentation that would have permitted it to develop new forms of expression. Nevertheless, the break with the nineteenth century was a fact.

Social art derived from, or influenced by, Mexican Muralism is exemplified by the work of the following individual artists or groups.

The Brazilian Cândido Portinari (1903-1962) was nineteen in 1922 when Modern Art Week was staged in São Paulo. The spirit of the Brazilian movement was the antithesis of that which inspired the Mexican muralists. (It should be remembered that 1922 was the same year that Secretary of Public Education José Vasconcelos put the walls of Mexican public buildings at those artists' disposal.) Given the Brazilian concern for aesthetics and experimentation,

Portinari's work looms up in relative isolation among his compatriots, though from the time of the murals he began for the Ministry of Education in Rio de Janeiro in 1936 he was held to be his country's leading painter. The critic Mário Pedrosa writes: "His attraction to mural painting responds to something deeply rooted in his nature, of much more significance than occasional commissions or other external circumstances." The plastic qualities of the frescoes in the Ministry of Education—simplified forms, cold tonalities, figures choreographed in groups set apart by color zones—are accentuated in the panel *The First Mass in Brazil*, which Portinari did for the building Oscar Niemeyer designed for the Boavista Bank. Pedrosa considers this to be the summa of Portinari's art, showing "what he can do, what he can't, and what he shouldn't." He began to free himself from the contradictory influences of Picasso and Postcubist abstraction in 1941, when he undertook his frescoes for the Hispanic Foundation in the Library of Congress in Washington, D.C. These constitute the best of his work in the popular vein; his line acquires a baroque freedom, and he favors well-rounded form. In 1949, however, when he painted in tempera a gigantic canvas for the preparatory school in Cataguases (another building of Niemeyer design), the components were once again rigorously structured: figures were organized by groups and use was made of multiple perspective. Portinari was to develop this manner still further in the murals *War and Peace* which he executed for United Nations headquarters in New York, beginning in 1952. Complementing Portinari's murals are his easel paintings and drawings. These constitute a vast body of work, the best of which are undoubtedly the lyric scenes of rural life in his native Brodósqui and the peasant family groups—in which dead or starving children figure prominently—that he did in the '40s.

Emiliano di Cavalcanti (1897-1976), an eclectic in matters of form, shared Portinari's social concerns, but in his case it was more a matter of feeling than a consciously programmed expression of conviction. Di Cavalcanti summed up the elements of his art thus: "I get my love of color and rhythm and my typically Brazilian sensuality from the Rio Carnival; the narrative aspects of my work, suggestive of the novels of Machado de Assis, reflect the city's São Cristóvão quarter; my political concerns derive from what I learned during the events of May; and I inherit my spirit of adventure from my ancestors who settled in the northeastern states of Paraíba and Pernambuco." Based on folk themes, his painting is sensual, rich in atmosphere, and vibrant with color, and shows a fascination with black and mulatto women.

There is a strong contrast between Di Cavalcanti's work and the austere, somber painting of Carlos Prado (b. 1908), who during the '30s depicted with simple directness the wretched existence of São Paulo street dwellers. It contrasts also with the cow-dotted landscapes of Campos de Jordão painted between 1935 and 1943 by Lasar Segall (1891-1957). Born in Lithuania, he became a citizen of Brazil in 1924 and is a figure of capital importance in Brazilian modern art. Mário Pedrosa is right, however, in saying that Segall was not a truly Brazilian painter, for his most significant work—compositions such as *Pogrom, Immigrants on Shipboard, War, Concentration Camp,* and *The Condemned*—deal with European

• **HECTOR POLEO.** *ANDEAN FAMILY.* 1944. OIL ON CANVAS 70 X 58.5 CM. COLLECTION OF THE ART MUSEUM OF THE AMERICAS, OAS, WASHINGTON, D.C., U.S.A. GIFT OF IBM, 1969. PHOTOGRAPH BY ANGEL HURTADO.

themes. The loneliness and poverty of life in the Brazilian countryside did not escape his keen eye, however, and he did a striking series of drawings of the prostitutes in São Paulo's red-light district. In all these works he showed himself an Expressionist of admirable qualities.

Socio-political art in Brazil is closely related to domestic developments in that country. In the years from 1917 to 1920 the lower classes of the larger cities were stirred by anarchist agitation. In 1924 a column led by the communist Luis Carlos Prestes began a two-and-a-half-year march, during which it traversed the most poverty-stricken zones of the country, opening the eyes of the people to the evils of the landed-proprietor system. Those evils provoked the "Revolt of the Lieutenants"[11] in 1922, echoes of which can be seen in the populist policies of Getúlio Vargas, aimed at social improvement and national development, which were incorporated into the constitution of 1934. During this period, artists were torn between the aesthetic nationalism triggered by Modern Art Week (see the following chapter) and the demands of social justice that found expression in the works of Portinari and Di Cavalcanti.

In areas with a strong Indian tradition, Mexican Muralism had a strong catalytic effect. The Indian, who for centuries had been exploited and oppressed, became the protagonist of a self-styled "indigenist" movement. Independence of European aesthetics tended to be a matter of new models for subjects.

José Sabogal (Peru, 1888-1956) *(p.37)* had his first exhibit in Lima in 1919, three years before traveling to Mexico, where he established contact with Orozco and Rivera. Sabogal fervently insisted that he was "painting Indians," trying—not very successfully—to explain that the word "indigenist" reflected racist attitudes and nostalgia for the Inca past. However, since the nationalist tide in Peru favored acceptance of the term, he eventually agreed to be known as a "cultural indigenist," thus disclaiming the reactionary implications of the unqualified designation. For 10 years (1933-43) Sabogal served as director of the School of Fine Arts in Lima, active both as a painter and as a theorist, setting his work off from that of the Mexican Muralists by demonstrating a lively interest in the folk arts of his own country. Other Peruvian painters took the same route, among them Apurímak (*i.e.,* Alejandro González, b. 1900), Enrique Camino Brent (1909-1960), Julia Codesido (1892-1979), and Sérvulo Gutiérrez (1914-1961), who upon his return to Lima in 1940 painted a splendid symbolic work entitled *The Andes.* The Peruvian critic Mirko Lauer would add to these names that of a painter from the province of Cajamarca, Mario Urteaga (1875-1957), of whom he says: "He emphasized the encounter between the Indian and the country and between the Indian and painting, showing that the Indian cannot be correctly depicted save in the world of his exploiters."

• **JOSE SABOGAL.** *HUANCA IN-DIAN.* 1930. WOODCUT, 33 X 26.5 CM. COLLECTION OF THE ART MU-SEUM OF THE AMERICAS. OAS, WASHINGTON, D.C., U.S.A. ANONY-MOUS GIFT, 1976.

All this painting can be understood only as a product of the 1920s, when strikes by urban workers and peasant movements benefited from the anti-oligarchic coup d'état of Augusto Bernardino Leguía (president, 1919-1930). At the same time (1926) in the pages of the review *Amauta,* José Carlos Mariátegui was calling for "the Peruvianizing of Peru," saying: "We cannot accept as new a type of art that brings us nothing but a new technique. To do so would be to take for real the most misleading of present-day mirages. No aesthetic can reduce artistic labor to a mere matter of technique.... An artistic revolution is not satisfied with victories in matters of form." A few significant dates should be noted: 1927, appearance in Cuzco of the group known as "Resurgimiento" (Resurgence); 1928, founding of APRA (the Revolutionary Alliance of the Peoples of America), whose leader Raúl Haya de la Torre proposed a type of revolutionary nationalism in which state capitalism would serve as an alternative to Mariátegui's socialism; 1929, establishment of the General Confederation of Workers. These happenings help one to understand the impact "painting Indians" had in Peru and the enthusiasm it aroused there, notwithstanding the fact that Sabogal, the movement's advocate, was an artist of no more than second rank.

• **CUNDO BERMUDEZ**. *THE BAL-
CONY*. 1941. OIL ON CANVAS, 73.7
X 58.7 CM. MUSEUM OF MODERN
ART, NEW YORK, U.S.A. GIFT OF
EDGAR KAUFMANN, JR. PHOTO-
GRAPH FURNISHED BY THE MUSEUM
OF MODERN ART.

Paraguay enjoyed a brief liberal respite under President José P. Guggiari (1928-32), but this was followed by the Chaco War, which began in 1932. Given this perspective, it is understandable that aesthetic concerns should have been swept aside by the tide of political events, and that nationalism was therefore slow to make an appearance in art. The awakening came about with the initiation on February 17, 1936, of a movement that took its name of "Febrerismo" from that month. It made an attempt—fruitless in the event—to promote thought along critical and progressive lines. Amid this unstimulating atmosphere, the painter and graphic artist Andrés Guevara (1903-1964) produced work that reveals the unbelievable poverty of the environment. He was active until 1954, the year in which the New Art Group was founded. In the 1940s Paraguay had a population of more than a million. Forty percent spoke only Guaraní; 75 percent of the males were illiterate. Olga Blinder (b. 1921), deeply aware of this situation, denounced it in "indigenist" works of a stylized, static character.

In other countries of the Indian block, development of "indigenist" art expressive of social criticism was unthinkable. In Bolivia, for example, only in

1952 was an end put to the feudal regime of the mine-owning oligarchy. The solitary artist of note was the sculptress Marina Núñez del Prado (b. 1910) who, living in New York from 1940 to 1950, carved figures symbolic of the high plateau country from which she came.

Two countries stand out by reason of the complexity of their relationships with Mexican Muralism: Ecuador and Colombia. Ecuador lent the strongest and most consistent support to the renewed interest in painting on Indian themes. Writing of the impact of the Mexican Revolution, the Ecuadorian critic Wilson Hallo stated: "Owing to the similarities between Mexican and Ecuadorian problems, artists such as Pedro León, Rendón Seminario, and Camilo Egas developed a concern for treating economic and social development in painting, or, in a few cases, in sculpture." Interacting with the Mexican influence was that of three foreign painters, two of whom—Lloyd Wolf and Jan Schreuder—took up residence in Quito, whereas the third, Hans Michaelson, settled in Guayaquil. Their art at times was polemic to the point of ferocity. A still further factor to be reckoned with was the presence of Víctor Mideros (1888-1972). A recognized master, in 1917 he was the prize winner in the Mariano Aguilera Contest. Before

traveling abroad he painted local landscapes and Indian fiesta scenes. In Europe he became a convert to mysticism, and upon his return to Quito he did a huge painting of Our Lady of Mercies. Another artist independent of Mexican influence was Ciro Pazmiño (b. 1897). He did a number of paintings, but he specialized in designing stained-glass windows for public buildings in Quito, an activity in which Mideros also engaged. From 1924 to 1927 Pazmiño was director of the National Center for Fine Arts. For the "indigenist" generation born between 1900 and 1920, the paintings of Mideros and Pazmiño's windows provided a national counterweight to the influence of Mexican Muralism.

When the May Salon of Ecuadorian Writers and Artists was inaugurated in 1939, Camilo Egas (1897-1962) had already introduced the Indian into Ecuadorian art, in broad canvases in which magnified and idealized human figures stand out in a broadly rhythmic setting. *The Harvest* provides a good example of his style. Three of the painters who participated in the 1939 Salon were to become leading exponents of art on "indigenist" themes: Oswaldo Guayasamín *(p. 46)*, Eduardo Kingman, and Diógenes Paredes. Between 1940, the year in which José Velasco Ibarra, who had been the leading political figure in the country since 1933, was exiled to Buenos Aires, and 1945, the year in which the famous "Hunger March" took place, Ecuadorian "indigenist" painting took definite shape. The outstanding figure was Eduardo Kingman (b. 1913) *(p. 45)*. In 1939-40 he worked on the Ecuadorian Pavilion at the New York World's Fair, and in 1940 he produced a series of paintings on themes relating to the Spanish Civil War. In 1942 he exhibited at the Capiscara Gallery, the movement's unofficial headquarters, *Los abagos*, a painting monumental in spirit, in which the suffering of the Indians is conveyed with epic sweep and a strong sense of rhythm. The same qualities can be noted in *The Stretchers*, in which the encounter between enslaved Indians and an overseer mounted on an enormous horse and brandishing a whip is rendered with great vividness. In these compositions, in Diógenes Paredes' (b. 1915) *Earthenware Jugs*, in which the figure of the Indian assumes massive proportions, and *Dancers of Saquisilí* by Bolívar Franco Mena (b. 1913) one can see the influence of Diego Rivera's well-rounded subjects. Originality, however, derives from the monumental tone of the compositions and their markedly rhythmic character. Paredes, the founder of a trade union named for David Alfaro Siqueiros, was awarded first prize by the National House of Culture in 1945.

Oswaldo Guayasamín (b. 1919) embarked upon a path different from that of his companions, finding inspiration in the devices used by Picasso in *Guernica*. He produced in 1945 the first of his great cycles, the 103 paintings known as *Huacayñan* (the Trail of Tears). In 1948 he received the National Prize for Painting and thereafter was considered the leading figure in Ecuadorian art. His social painting reached its high point between 1952 and 1967, in the series *The Age of Wrath*, based on themes taken from Frantz Fanon's book *The Wretched of the Earth*. By that time, however—just as in Mexico—the standard line taken by Ecuadorian "indigenist" art had been rejected by the following generation, as represented by Villacís, Tábara, Viteri, and others, whose concern with matters

of form was to be the main theme of the '60s. Rounding out the picture of Ecua-
dorian "indigenist" art, let us note the lively works of Pedro León Donoso (b.
1894), the caricatures of Galo Galecio (b. 1912), and the "antibourgeois" art of
José Enrique Guerrero, which in some stages of his career exhibited a solid
Postcubist structure.

It is more difficult to summarize the influence of Mexican Muralism on
Colombia. Strictly speaking, the only artist to show himself a direct disciple of
the Mexicans was Alipio Jaramillo (b. 1913)—who had worked in Brazil and
Chile with Siqueiros—in the paintings he did in Duco on masonite. At the urg-
ing of Jorge Zalamea, then Minister of Education, Ignacio Gómez Jaramillo
(1910-1971), Luis Alberto Acuña (b. 1904) *(p. 33)* and Jorge Elías Triana (b.
1921) went to Mexico in 1936, but none of them practiced "indigenist" art,
though Acuña had long painted men and women of the people using a technique
similar to Pointillism, and Gómez Jaramillo, who won the National Prize both in
1940 and in 1944, did striking tropical landscapes. According to such critics as
Walter Engels and Germán Rubiano, it was the group of painters, sculptors, po-
ets, and prose writers known collectively as "Bachués" who got modern art off to
a start in Colombia. They were most active in the '40s though Ignacio Gómez
Jaramillo's *Violence in the Jungle* dates from 1954 and not until 1961 did Acuña
have his first retrospective in Bogotá. In that exhibit he presented 40 paintings
dating from as far back as 1931 and 11 sculptures done in 1961. Until the ap-

• **ANTONIO BERNI**. *NEW CHICAGO
ATHLETIC CLUB*. 1937. OIL ON CAN-
VAS, 184.3 X 300.3 CM. MUSEUM OF
MODERN ART, NEW YORK, U.S.A. IN-
TER-AMERICAN FUND. PHOTO-
GRAPH FURNISHED BY THE MUSEUM
OF MODERN ART.

pearance of the Bachués Colombian art had remained faithful to the precepts of the nineteenth century.

1931 was marked by what the sociologist Antonio García has termed "the end of the republic of the gentry." (This was three years after the banana strike and the subsequent acts of repression narrated by Gabriel García Márquez in *One Hundred Years of Solitude*.) With the coming of the Liberals to power under Enrique Olaya Herrera, the dominance of the moneyed classes in government, and the modernization produced by post-crisis substitution of domestic products for imports, the way was gradually opened for the introduction of modern art. Nonetheless, it was Ricardo Gómez Campuzano (1893-1982), a landscapist in the nineteenth-century manner, who won First Prize at the National Salon in 1931, whereas Andrés de Santa María (1860-1945), who was exhibiting at the Bogotá School of Fine Arts, had to be defended in a campaign vigorously waged on his behalf by Baldomero Sanín Cano and Max Grillo.

The great Colombian muralist was Pedro Nel Gómez (b. 1899), who in 1935 entered into a contract with the local authorities in Medellín to execute 10 huge panels for the Municipal Building. These were followed by frescoes for a number of other public buildings, both in Medellín and in Bogotá. Nel Gómez's career as a fresco artist can be compared only to that of the Mexican Muralists, but neither in form nor in matters of technique did he show any resemblance to them. He did a number of cycles—on the history of gold work, the village and the family, violence in Colombia, and myths relating to the appearance of life on earth. Despite the monumental character of his frescoes, he never lost his taste for watercolor technique. As a result his work is pictorial rather than descriptive. This is apparent in his modeling of detail, freedom of brushwork, and careful color shading in small areas.

The Liberal period continued under the presidency of Alfonso López Pumarejo (1934-38). Progressive measures were taken. The first agrarian reform law was passed in 1936, and that same year the Confederation of Colombia Workers was founded. This cycle did not end until the assassination of the populist leader Jorge Eliécer Gaitán in 1948. The social interest of the Bachués seem to have been kept under good control. Sculptors such as Ramón Barba (1894-1964), José Horacio Betancourt (1920-1959), José Domingo Rodríguez (1895-1965), and Rómulo Rozo (1899-1964)[12] took as their subjects men and women of the people. However, neither they nor their painter colleagues exhibited any signs of revolt. Only occasionally, and late in their careers, did painters such as Luis Alberto Acuña, Gómez Jaramillo, Gonzalo Ariza (b. 1912), Sergio Trujillo (b. 1911), and Carlos Correa (b. 1912) turn to executing murals. Trujillo did one for the School of Chemistry of the National University, for example, and in 1960 Acuña did an *Apotheosis of the Spanish Language*. All were primarily easel painters, who sought to impart a taste for modern art to the moneyed-class public via works such as Carlos Correa's *Annunciation*, exhibited at the National Salon in 1942. The group's basic realism is best seen in portraits done in the 1940s *(e.g.,* Jorge Ruiz Linares' [b. 1922] *Portrait of Eduardo Mendoza Varela* [1945] and Ignacio Gómez Jaramillo's *Double Portrait* of 1949). Neocubism, Neopointillism,

• **MIGUEL DIOMEDE**. *STILL LIFE*. 1958. OIL ON CANVAS, 27 X 41 CM. COLLECTION OF THE ART MUSEUM OF THE AMERICAS, OAS, WASHINGTON, D.C., U.S.A. PURCHASE FUND, 1959. PHOTOGRAPH BY ANGEL HURTADO.

and Neo-Cézannism distinguish these works from ones such as *In the Park* by Eugenio Zerda (1878-1945) or the landscapes of Jesús María Zamora (1875-1949), two holdovers from the nineteenth century.

This cautious advance toward modernism, within the limits of ready comprehensibility prescribed by Mexican Muralism, can also be noted in the work of politicized artists in Argentina and Chile during the 1940s.

There was some precedent for the treatment of popular themes in Argentina. Winner of the Grand Prize and Gold Medal at the Centennial Exposition, Cesáreo Bernaldo de Quirós (1881-1968) painted grandiose baroque narratives peopled with creole types. Benito Quinquela Martín (1890-1977) won popularity with his landscapes, scenes of the Riachuelo district of Buenos Aires, and depictions of workers in the port area known as the Boca. Eugenio Daneri (1881-1970) treated the same material in a more sober fashion, with greater pictorial sophistication. All three were descriptive painters, but whereas each of the first two indulged in his own form of idealization, the third was content to show daily life as it really is.

The following generation included painters such as Alfredo Gramajo Gutiérrez (1893-1961), Gustavo Cochet (1894-1979), Lino Eneas Spilimbergo (1896-1964), Ramón Gómez Cornet (1898-1964), Enrique Policastro (1898-1971), Horacio Gerardo March (1899-1978), Miguel Diomede (1902-1974) *(p. 43)*, Onofrio Pacenza (1904-1971), Antonio Berni (1905-1981), and Juan Carlos Castagnino (1908-1972), and sculptors such as José Fioravanti (1896-1977), Alfredo Bigatti (1898-1964), Rogelio Yrurtia (1879-1950), Agustín Riganelli (1890- 1949), José Alonso (b. 1911), and Luis Falcini (1889-1973). They engaged in thinly disguised realism, unlike painters such as Enrique de

Larrañaga (1900-1956), who won first prize at the National Salon in 1936, and Miguel Carlos Victorica (1884-1955), in whose work one can see the influence of Soutine.

In politics, 1931 marked the beginning of what Argentine historians call "the decade of infamy."[13]

As for art, Antonio Berni, later to undergo the influence of the Mexican School, was painting pictures that were clearly Surrealist in inspiration, such as *Obsession with the Mystery of Noonday*. Gómez Cornet's 1921 exhibit of native types preceded by three years the appearance of the nationalist group that went by the name of Martín Fierro. Its declarations about "our land" and "the Argentine spirit" had artistic repercussion in the battles over the works of Xul Solar and Emilio Pettoruti, as will be seen in the next chapter.

By 1940 Berni was the standard-bearer of the new realism. He was considered " a painter of principle." Although he had worked with Siqueiros on murals in Buenos Aires, the panel Berni did for the Theater of the People in 1941 is of a geometric character, quite the opposite of the Mexican artist's style. Large-scale oils such as *Jujuy* (1938), *The New Chicago Athletic Club*, *The Native Band* (1939) or the monumental *Farmers* show Berni's preference for the well-rounded, sharply outlined figures of Diego Rivera. In *Sunday Sun* (1941) Berni's work shows more of a resemblance to the cityscapes of March and Pacenza—the intentionally commonplace scenes of "neighborhood art." The tendency continued in his murals for the Galerías Pacífico (Buenos Aires, 1946), and culminated in the '60s with two great series of works on folk themes: a cycle on the shanty-dweller Juanito Laguna, done in a combination of painting and collage, and a set of prints dedicated to the seamstress Ramona Montiel. The portraits Berni painted during this period show much resemblance to those done by Gómez Cornet, Daneri, Spilimbergo, and Raquel Forner, and even to the *Portrait of María Rosa* included by Pettoruti in a Postcubist still life of the same name (1941), the hyperrealism of which is worthy of Fortunato Lacámera (1887-1951).

In 1942, after painting dramatic scenes of the Spanish Civil War, Raquel Forner (b. 1902) was awarded first prize at the National Salon. The persistence of Argentine art in the minor line of easel painting resulted in a whole gallery of realistic, frontal portraits with round, wide-open eyes, the effect of which is almost Surrealistic in the work of Demetrio Urruchúa (1902-1978). *Figure in Profile* (1947) is a good example of his product. A few works, such as Diomede's exquisite still lifes, might be classed as "chamber pieces." Most artists—painters, sculptors, engravers—were no more than solid craftsmen. One would have to call this the proto-modern era of Argentine art. When European influences, such as that of Lhote on Spilimbergo or of Anglada Camarasa on Raúl Mazza, appear, they are greatly toned down, to accord with prevailing taste. The real forward leap was to be taken in the mid forties, toward Geometric Abstraction on the one hand and Surrealism on the other.

In 1952, as part of Perón's second five-year plan, the National Museum of Fine Arts organized and exhibited the biggest show of Argentine art up to that date: 519 works, representing 271 different artists. Presiding over the whole were

two enormous (and anonymous) portraits of the president and his wife, Eva Duarte de Perón. In his preface to the catalogue of the exhibit, Juan Zocchi, the director of the Museum, wrote: "We are living the drama of being 'Argentine' or 'American' without having roots in the aboriginal past. Argentina is like Robinson Crusoe: it has had to do everything for itself, working in isolation, surrounded by international waters. From the viewpoint of our present national makeup, the aboriginal past is dead."

We might categorize the Chileans born around 1900 as "minor realists," much like their Argentine counterparts. Among them were Dora Puelma (1892-1972), María Tupper (1898-1965), Marta Villanueva (b. 1900), Carlos Ossandon (1900-1977), Héctor Banderas (b. 1903), and Inés Puyó (b. 1906). Modern tendencies are to be noted only in the form of variations in brush strokes and discreet alterations of reality. Painting with ulterior intentions can be found only in the work of Marco Bontá (1898-1974). From 1931 to 1945 he taught mural painting and the craft of stained glass at the School of Applied Arts in Santiago. His career took the opposite direction from that of Laureano Guevara (1889-1968), one of the Montparnasse group, founded in 1928, which was to bring the break with the past. Bontá, like Venturelli, dedicated himself entirely to landscape, into which he introduced types to be found among the people—peasants, and individuals living on the margin of society. The sole artist openly influenced by Mexican Muralism was José Venturelli (b. 1924). Norberto Berdía (1900-1983) presents a similar case in Uruguay. Both practiced a late type of Muralism, based on reality,

● **OSWALDO GUAYASAMIN**. *THE WHITE COFFIN*. PHOTOGRAPH COURTESY OF THE ART MUSEUM OF THE AMERICAS ARCHIVE, OAS, WASHINGTON, D.C., U.S.A.

but whereas Berdía evolved toward an almost abstract kind of figure painting Venturelli remained a realist throughout his work. Venturelli executed a number of murals in Chile: one for the Alliance of Intellectuals for the Defense of Culture in 1943, and one for the University of Chile in 1950. From 1953 to 1956 he lived in China and painted murals in Beijing. Of a later date are ones he did in Havana.

Norberto Berdía worked with Siqueiros when the Mexican visited Uruguay in 1933, but it was only after a sojourn in Mexico in 1945, at which time he studied with Federico Cantú (b. 1908), that he painted a series of murals in Uruguay—for the offices of the newspaper *El País* and the School of Architecture in Montevideo, and for the Hotel San Rafael in Punta del Este. Berdía took up residence for a while in Mexico; he later traveled through Peru, Paraguay, and Ecuador. He produced stylized versions of national types in a Cubistic manner, derived from his master André Lhote. Berdía's pictures differ from the ornamental syntheses of native motifs turned out by his contemporary Ricardo Aguerre (1897-1967)—*Washerwomen in Portugal*, for example. Luis Mazzey (1895-1983) and Carlos González (b. 1905) shared Berdía's interest in scenes from the life of the people, peasants, and lower-class types, often incorporating them into landscapes. There is not so much as a breath of social protest in their *History of Trade in Uruguay* and *Work Done by the National Fuel, Alcohol, and Portland Cement Administration*, murals less than 20 square meters in area, in which they show the lower classes at work.

These are "narrative murals" in the Mexican manner, but without Mexican fire. Such picture-stories of railroads, mining, agriculture, and communications media are to be found throughout Latin America.

The Uruguayan artist with the keenest critical eye and the most highly developed social consciousness was Rafael Barradas (1890-1929). This can be clearly seen from the sketches and caricatures he did in Montevideo before making a definite departure for Europe in 1912. He took up residence in Spain, concentrating on his cycle known as *The Magnificent*. The strength of these works derives from the magnification of popular types and poetical effects achieved through distortion. Nostalgia for his native city inspired his *Scenes of Life in Montevideo*, in which his capacity for satire was once again demonstrated.

From 1937 to 1941, when he returned to Venezuela, Héctor Poleo (b. 1918) *(p.35)* constituted an exception in the ranks of his contemporaries. He came home to depict types found among the people in paintings suggestive of Mexican influence, though, as the critic Lira Espejo observes, that influence is more apparent than real. The dictatorship exercised off and on by Juan Vicente Gómez from 1908 to 1935 does not explain the lack of interest in social themes exhibited by the country's painters. A more plausible explanation is one of an economic nature. 1909 saw the beginning of the oil boom, and with the granting of large numbers of concessions to foreigners Venezuela found itself overrun by

immigrants who intermarried with both the Negroes and mulattoes of the coastal areas and the Indians of the Andes. In 1928 there was a student uprising against Gómez, and the years 1931-1936 saw the beginnings of what were to develop into the two political parties, Acción Democrática and COPEI, that were later to alternate in power, more smoothly than in Colombia. The social structure remained archaic and land-based, however, and the dictator ran the country like a feudal estate.

In 1912 the Fine Arts Circle was founded in Caracas, and this stimulated activity by a number of landscapists. Among them were Rafael Monasterios (1884-1961), Manuel Cabré (b. 1890), Federico Brandt (1878-1932), Elisa Elvira Zuloaga (1900-1980), Edmundo Monsanto (1890-1947), Próspero Martínez (1885-1966), César Prieto (1882-1976), Tomás Golding (b. 1909), and Pedro Arpel González (1901-1981). Until 1919, the year in which the Circle was dissolved, landscape dominated the art scene. Three foreign artists who took up residence in Venezuela had considerable influence on local artists. They were Emilio Boggio (1857-1920), Samys Muntzer (Romanian, 1869-1958), and Nicholas Ferdinandov (Russian, 1886-1925). Landscapists, they made their presence strongly felt in Caracas in the years from 1919 to 1921.

The greatest of Venezuelan painters, Armando Reverón (1889-1954), was likewise essentially a landscapist. Referring to the period in which the Circle existed, the Venezuelan critic Enrique Planchart wrote in 1948: "Our painters lived in an isolation comparable to that to which Plato assigned poets in his *Republic*. Contact with the public came about only through a government commission or an occasional acquisition by a member of a very limited minority." With the end of the Gómez dictatorship in 1935, the country burst from its provincial calm into a race for modernization unparalleled in the rest of Latin America. A rich government and a wealthy minority had no use for "art with a message." Given these circumstances, after a brief fling at Surrealism Héctor Poleo turned to figurative painting of a decorative nature. During the '40s Francisco de Narváez (1905-1982) engaged in strongly ethnic painting and sculpture, with emphasis on typically creole models. Later he turned to nonfigurative work. Artists who dared to introduce representatives of the people and other popular elements into landscape were few in number: Pedro León Castro (born in Puerto Rico in 1913), César Rengifo (1915-1980), and Gabriel Bracho (b. 1915). The first two broke the idyllic calm of the Circle with depictions of human misery. Bracho painted violently Expressionist views of Mount Avila. In no cases were the artists' intentions fully realized.

Central America and the Caribbean should have constituted Mexican Muralism's natural zone of influence. Not only do they lie close at hand, but a succession of dictatorships and coups d'état produced conditions favoring art of social protest. National liberation movements generally involved a number of social classes, however, and periods of development under legally elected governments were too brief to result in artistic production of importance. There were individual exceptions. We have already mentioned Darío Suro (b. 1917) in the Dominican Republic. The Puerto Rican Lorenzo Homar, (b. 1913) contacted

Reginald Marsh in New York in 1931, and in 1951 went to work for the Division of Community Education back home in Puerto Rico, where Luis Muñoz Marín's populist government was interested in promoting art that would have impact on the public. The Guatemalan Enrique de León Cabrera (b. 1915) joined the group known as "Los Tepeus" in 1933; he enlivened his landscapes with scenes from the life of the people. The mystic implications of the work of the Haitians Philomé Obin (b. 1892) and Hector Hyppolite (1894-1948) reflect the deep-running roots of their country's culture. Francisco Amighetti (b. 1907) produced prints of great vigor in Costa Rica. The Salvadoran Luis Alfredo Cáceres (1908-1952) did a long series of narrative paintings in a style that was part primitive and part Postcubist. José Antonio Velásquez (1906-1983) painted marvelous views of his home village, San Antonio de Oriente, in Honduras. Rodrigo Peñalba (1908-1979) *(p.47)* reestablished contact with Nicaraguan reality and went on to become the master of the rising generation. His 1949 *Rites of Witchcraft among the Indians of Masaya* is a good example of his work. None of the artists mentioned, however, produced a body of socio-political work in the Mexican manner.

Cuba is the sole exception in the area. In 1927 a new magazine, *Revista de Avance*, appeared. Its principal writers were Juan Marinello, Jorge Mañach, and Martín Casanovas, and for three years it promoted public discussion of "the virgin background of America" and "universal aspects of creole culture." In 1930 Marinello wrote in *Revista de Avance*: "The search for native elements and the indigenist manner of expression characteristic of much of present-day Latin American art have found no echo among us, owing to our lack of an Indian population and of such literary or artistic monuments as the now-extinct aborigenes might have produced. While the theme of the Negro is worldwide in character, in Cuba it has special significance. The participation of the Negro in Cuban life...provides matter for thought and hope."

In works of Mario Carreño (b. 1913) such as *Scenes of Havana* (1940) one finds realism but little social aggressiveness. So too with *Houses with Figures* by Emilio Sánchez (b. 1921), *The Confrontation* by José Joaquín Tejada (1867-1943), and *Cuban Peasant Woman* by Armando Menocal (1863-1942). All reflect the traditional liking for telling a story. In the paintings of Leopoldo Romanach (1862-1951) and Víctor Manuel (García) (1897-1967) and sculptures such as the figures done by Mirta Cerra in 1941, *The Creole Woman* (1940) by Juan José Sicre (1898-1974), and the works of Alfredo Lozano (b. 1913), one notes an attempt to portray types that evidence the mingling of races without any suggestion of cultural ambivalence. The only artist to engage in openly political painting was Marcelo Pogolotti (b. 1902), who upon his return from Europe in 1930 took to painting working-class scenes in Léger's tubular style. Later he evolved into a Surrealist.

Proto-modern painting in Cuba revolved around two figures, neither of whom bore any relation to Mexican Muralism, although they did exhibit a manifest social consciousness. The first of these figures was Víctor Manuel, who attracted into his circle artists such as Jorge Arche (1905-1956), the author of realistic portraits and figure paintings; Domingo Ravenet (1905-1969), the sole

muralist in the group, who decorated the chapel in Martyrs Park in Havana; and Romero Arciaga (b. 1905), whose paintings of modest social intent are done in Víctor Manuel's unadorned style.

The other polar figure was Mariano Rodríguez (b. 1912). In 1937, after visits to Paris and Mexico, he joined the Free School of Painting and Sculpture headed by Eduardo Abela (1891-1965). There the uncertainties of the generation active in 1942 found expression in excursions into folk themes and modern European trends. The generation represented by Mariano in 1943 was characteristically eclectic. Works such as *Cane Cutters* by Mario Carreño, who had received training in Mexico in 1936; *The Party* by René Portocarrero (b. 1912); *Musicians* by Cundo Bermúdez (b. 1914) *(pp. 38, 39)*; Mariano's female bathers; the aggressive scenes of labor unrest which Luis Martínez Pedro (b. 1910) did in 1937; and Antonio Gattorno's (1904-1980) *Women with Bananas* fall into the category of "the universally commonplace." Nonetheless, they represent the best in Cuban painting of the time. Max Jiménez (Costa Rican, 1900-1947) was an outsider, a little-known prophet of the changes that art would undergo after World War II. A work such as *Waiting at Ariguanabo* hints at the explosive force of ethnic and cultural cross-breeding.

In 1943 an exhibition of modern Cuban art was presented at the Hispano-Cuban Cultural Institute, under the aegis of David Alfaro Siqueiros, who had just executed a powerful Duco mural entitled *Democracy in America*. A counterpart to this exhibit was provided in the same year by the first retrospective of the work of Amelia Peláez (1897-1968), covering the years 1927 to 1943. Her work will be studied in the next chapter. Carlos Henríquez (1900-1957), generally classified as an "irrealist," went to extremes in seeking to define creole types. *The Abduction of the Mulatto Woman, Creole Balladeer*, and *The Burial of the Cuban Peasant Woman* are titles indicative of his recurring themes. Depiction of the Cuban peasant—treated dramatically by Abela, with elusive delicacy by Arístides Fernández (1904-1934), and with power and romance by Henríquez—was a step toward acceptance of the myth of a mulatto society, as invented by Wifredo Lam (1902-1982) in Paris during the '30s and brought back to Cuba in 1943, the year he painted the extraordinary fetish-women of *The Jungle*.

Mexican Muralism lent direct or indirect support to artists who in the years from 1920 to 1950 displayed an inclination to explore social themes, particularly as they involved Indians, mestizos, Negroes, or mulattoes. At the same time, however, another group of artists was seeking to create an atmosphere propitious to a radical change in the academic imagery of the nineteenth century. The language of plastic expression was their primary concern. The way was open for Latin America to join in the work of updating imagery and renewal in matters of form that has been the characteristic of twentieth-century art.

Notes

[1] Jorge Alberto Manrique, *América Latina en sus artes* (Mexico City: Siglo XXI, 1974).

[2] Taken from an article by Carlos Fuentes that appeared in *La Nación* of Buenos Aires for December 14, 1980.

[3] The revived interest in folk elements is also to be noted in the paintings of Jean Charlot (*Mother and Son with Masks*, 1937), Miguel Covarrubias (1904-1957), Francisco Goitia (1882-1960), Juan O'Gorman (1905-1982), Pablo O'Higgins (1904-1983), Jesús Guerrero Galván (1910-1973), Frida Kahlo (1910-1954), Jorge González Camarena (1908-1980), María Izquierdo (1906-1955), Raúl Anguiano (b. 1915), Francisco Dosamantes (b. 1911), José Chávez Morado (b. 1909), Angel Bracho (b. 1911), Manuel Rodríguez Lozano (1897-1971), Antonio M. Ruiz (1897-1964), and the sculptures of Mardonio Magaña (1866-1947), as well as others.

[4] The conflict between Church and State came to a head in 1926 with the anticlerical measures taken by President Plutarco Elías Calles. There were confrontations between religious rebels whose slogan was "Long live Christ the King!" (hence the name applied to them of *cristeros*) and government forces. President-elect Alvaro Obregón died at the hands of a religious fanatic. In 1929 a compromise was reached and armed confrontations ceased. For additional details see James W. Wilkie, "The Meaning of the Cristero Religious War," *Revolution in Mexico; Years of Upheaval, 1910-1940* (New York: Alfred A. Knopf, 1969).

[5] Delfina Flores, Juana Rosas, Ignacio Sánchez, José Guadalupe Castro, and Jesús Sánchez, to name but a few.

[6] David Alfaro Siqueiros, *No hay más ruta que la nuestra* (Mexico City, 1945).

[7] Raquel Tibol, *Textos de David Alfaro Siqueiros* (Mexico City: UNAM, 1969).

[8] David Alfaro Siqueiros, *Setenta obras recientes*, with a prologue by Angélica Arenal (Mexico City: Instituto Nacional de Bellas Artes, 1947).

[9] David Alfaro Siqueiros, "Carta a Orozco," *Hoy* (Mexico City: October 7, 1944).

[10] Manrique, *op. cit.*

[11] The Revolt of the Lieutenants is the name given to the dramatic episode of June 5, 1922, when young officers stationed at the fort in Copacabana rebeled against the government. Federal troops crushed the uprising at once. The insurgents were idealistic members of the middle class who aspired to national renewal. The few who escaped from the fort ("the Copacabana Eighteen") were nearly all shot down on the beach. This was not the end of the matter, however. Both the survivors and their sympathizers came to exert a certain influence that lasted as long as the period of Getúlio Vargas (1930-1945). One of them was Eduardo Gomes, who rose to the rank of brigadier in the air force and who was a candidate for the presidency in 1945. See Hubert Herring, *The History of Latin America from the Beginning to the Present* (New York: Knopf, 1968).

[12] It was the 1929 sculpture entitled "Bachué" by Rómulo Rozo that gave the group its name.

[13] The "decade of infamy" in Argentina began in 1930, when the radical government of President Hipólito Yrigoyen was overthrown by the military in a movement led by General José F. Uriburu. It covers the Roca-Runciman Treaty of 1933 and the preferential treatment accorded British enterprises up to 1943. Election frauds kept power in the hands of the military and the old conservative oligarchy. The presidents during this period were José F. Uriburu (1930-1932), Agustín P. Justo (1932-1938), Roberto M. Ortiz (1938-1942), and Ramón S. Castillo (1942-43). The period came to an end in 1943 with the appearance on the political scene of Juan Domingo Perón, a member of the military junta that took over the government in 1943. See Hubert Herring, *op. cit.*

NEW BLOOD FROM
THE AVANT-GARDE

III

IN THE YEARS FROM 1920 TO 1950, AVANT-GARDE TENDENCIES DID NOT loom so large on the cultural horizon as did the realistic trend which, responding in part to the influence of the Mexican Muralists and in part to pressures exerted by the less-favored classes of society, produced at times work of openly social or political intent. The Andean countries, with their strong Indian tradition, and the Caribbean area, where the concept of *négritude* was making itself felt, were relatively unreceptive to new ideas of European origin. In countries that had received wave upon wave of immigrants, however, the élite prided itself on being "European and universal" in its thinking.

There are some interesting parallels and contrasts between the two currents. Modern Art Week took place in São Paulo in 1922 *(p. 56)*, the same year that the Mexicans laid the foundations of a new aesthetic with monumental murals they executed in the National Preparatory School in the nation's capital. Articles published in the Mexican review *El Machete* and the proclamations issued by the union founded by Siqueiros called for artistic action paralleling the Mexican Revolution. The articles that appeared in the São Paulo review *Klaxon* and the numerous pamphlets that Modern Art Week inspired dealt, however, with aesthetic considerations and constituted a call for intellectual discussion. Oswald de Andrade's *Pau Brasil* Manifesto dates from 1924; Gilberto Freyre's Nationalist Manifesto, from 1926; the manifesto issued by the group centered around the review *Antropofagia*, from 1928; and the School of Fine Arts directed by Lúcio Costa got its start in 1930.

However, the intellectual ferment that culminated in Modern Art Week got under way in the years from 1915 to 1920. Long before issuing his manifesto, Oswald de Andrade envisioned the art of the future as a necessary alliance between the European and the Brazilian, and he advised the young "to take their place in our midst; to share in our life; and to draw from the resources offered by the country—from the treasures of the heart and our immediate surroundings— the elements of an art that, paralleling the intense effort we are making to build cities and open up the land, will constitute one of the higher manifestations of our

national character." Mário de Andrade, the author of the novel *Macunaíma,* wrote to Tarsila do Amaral, who was then studying in Paris with André Lhote: "Tarsila, Tarsila, come home. Give up Gris and Lhote, those promoters of decrepit aesthetics and decadent critical ideas. Turn your back on Paris, Tarsila: come back to the virgin forest, where there is no Negro art, where there are no babbling brooks. The virgin forest exists. I believe in what it represents." At first glance there might seem to be a similarity between the term "decrepit aesthetics" and the writings of the Mexicans; however, the latter's aggressiveness finds no echo in the romantic spirit of renewal that inspired the two Andrades and the most important painter of the period, Tarsila do Amaral. In 1924 the critic Sérgio Milliet described her as rejecting story-telling and rhetorical grandiloquence, seeking to achieve by the use of Brazilian elements such as direct light, bold colors, hard lines, and a feeling of weight "a type of painting that is truly our own." He added that her Paulista temperament was expressed in terms of "abstraction and synthesis." Tarsila's most important critic, Aracy Amaral, wrote in 1975: "The phases of her work corresponding to the ideas of the literary groups known by the names *Pau Brasil* and *Antropofagia* undoubtedly constitute the high point of her career as a painter, and it is from them that her importance in modern Brazilian art derives."

In Brazil, the beginnings of modern painting, sculpture, and architecture are all to be found in the uproar and polemics aroused by Modern Art Week. The premise underlying the work of the painters, sculptors, architects, and musicians who took so lively a part in that event was defined many years later by the writer Ferreira Gullar in these terms "Avant-garde art should spring from an analysis of a given country's social and cultural characteristics, never from advanced ideas imported intact from the developed countries to which they properly apply."

In this connection, one should note the importance attributed by Modern Art Week to the Black contribution to culture, and to the significance of the mixing of races and cultures. Tarsila's 1929 composition *Abapuru* represents a high point in recognition of the ethnic factor, of which the artist availed herself to express her independence of the European avant-garde. At the same time she profited from the novelties the latter had introduced into art. She could never have arrived at her bold distortions and her powerful syntheses, nor could she have achieved her expressive force, had it not been for the examples set by the European Cubists and Expressionists.

The work of Tarsila do Amaral (1890-1973) represents a fusion of the avant-garde tendencies of Europe and Latin America. From the time of her adolescence her years were divided between trips to Europe and long sojourns on the plantations of Santa Teresa do Alto, Bela Vista, and São Bernardo. In 1920 she settled in Paris for a while, studying at the Julien Academy. Two years later she returned to São Paulo, to become one of the Group of Five, whose other members were Anita Malfatti, Menotti del Picchia, and Mário and Oswald de Andrade. Her depiction of the Negro in works from her *Pau Brasil* and

Antropofagia phrases—works in which, according to the poet Haroldo de Campos, she attained her highest level of pictorial art— coincide with the illusion of a "return to primal origins" fostered by the European intellectuals of the period. Mário de Andrade's phrase, "We represent the primitive phase of a future perfection" echoes Marinetti's *Il Negro*, certain short stories of Blaise Cendrars (who paid a visit to Brazil), Francis Picabia's review *Cannibale*, and even the music of Heitor Villa Lobos, who often found inspiration in folk melodies. Tarsila's distortions of the human figure and such notable urban and rural landscapes as *São Paulo, Shantytown Hill, Brazilian Central Railway* (1924), *Manacã* (1927), and *Dead Calm* (1929) are stylizations in a manner reminiscent of Léger, but nonetheless entirely her own. Less intellectual than the European Postcubists, she never got away from organic concepts. Her flowers, woods, and animals are as erotic in effect as the sunken breast of her *Black Woman* of 1923. Hers is a carnal world, of softly yielding forms. By contrast, the works Rego Monteiro (b. 1899) exhibited in Paris in 1928 have a preciseness that foreshadows the apogee of *art déco*, and *Girls of Guarantiguetá*, Di Cavalcanti's famous 1930 work, leans toward the histrionic in its depiction of a popular theme. Toward the end of the '40s Tarsila made a brief return to the distortions of the phase associated with *Antropofagia*. In the strange pictures she painted at that time her technique is almost Pointillist. In the '60s she came full cycle by resorting once again to syntheses, rather more two-dimensional than before, but evidencing the same rigorous discipline.

Eliseu d'Angelo Visconti (b. Italy 1867-d. Rio de Janeiro 1944) had already shown that pictorial values could be divorced from the narrative content of a work, a lesson which the Modernists were quick to appreciate.[1]

The establishment of new rules for art in line with the innovations of the European avant-garde was the prime intent of the artists who participated in Modern Art Week. They sought support from the aristocracy, scorning the bourgeoisie, described by Assis Chateaubriand as an "abominable caste." Their great discovery was the "profound originality" of their race.

In 1972 the São Paulo Institute for Brazilian Studies organized an exhibition called "Brazil: First Modernist Phase, 1917-29." The period in question, which of course included Modern Art Week, was one of investigation and analysis. Getúlio Vargas' 1930 revolution against the great landholders resulted in a new Brazil. The aristocracy—which "delighted in saucy experiments and encouraged irreverent phantasies of the imagination" (the words are those of Assis Chateaubriand)—was forced to beat a retreat. Nonetheless, there can be no doubt that Brazil's position of continuing leadership in the arts in Latin America derives from this first Modernist phase, for it was then that the country developed both a strong national consciousness and flexibility in adapting to new aesthetics, gracefully identifying itself with the twentieth century.

In Argentina, the avant-garde constituted even more of an élite. The pressure exerted by the generation of realistic artists who dominated the '30s and '40s and the political opportunism of the Peronist regime in the 1950s did not favor artistic novelty. Unlike its counterpart in Brazil, the Argentine avant-garde did

• THE MODERNIST MOVEMENT WAS LAUNCHED IN BRAZIL BY MODERN ART WEEK, A FESTIVAL OF MUSIC, LITERATURE, POETRY, PAINTING, AND SCULPTURE HELD IN SÃO PAULO IN FEBRUARY 1922.

not seek to exert an influence on the cultural life of the nation as a whole. Separating itself from the masses, its members took on the role of intellectual guerrillas, a role maintained to this day by the avant-garde in Buenos Aires. (Note that we say "Buenos Aires" rather than "Argentina.")

The critic Lorenzo Varela writes: "It is the Argentine avant-garde that has brought about modernization of the Argentine mentality. It has created a new vision of the world and of the nation. In short, it has saved the country from degenerating into one vast provincial backwater." The period of radical agitation runs from about 1924 to 1950, the year in which the avant-garde became "institutionalized." In 1949 the Institute for Modern Art was founded. It began activities with a seminar given by Paul Dégand, a pioneer of nonfigurative art in France. The institutionalization process was advanced by the establishment of the prizes offered by the magazine *Ver y Estimar* and by the critical leadership exercised by Jorge Romero Brest, first as Director of the Museum of Fine Arts and after 1960 as Director for Plastic Arts of the Torcuato di Tella Institute. In *La revolución martinfierrista*, the critic Córdoba Iturburu wrote that the group identified with the review *Martín Fierro* was "fully conscious of the goal it pursued, namely achievement of a new mode of expression deriving from Argentine assimilation of European innovations. It wanted to speak the language of the day, but with an Argentine accent. It called for a new type of art, youthful and novel, structured along the lines of the aesthetic and technical experiments of the European avant-garde, but breathing the breath of our country and infused with an Argentine spirit."

The gamut run by the Argentine avant-garde is suggested by the names of the artists defended in the pages of *Martín Fierro*. (Most of the articles came from the pen of Alberto Prebisch, the theoretician of modern trends.) Horacio Butler (1897-1982) returned home in 1933, after studying in Paris with André Lhote and Othon Friesz. The critic Damián Bayón has this to say of the quality of his Intimist compositions: "With impeccable technique and unerring taste, Butler conveys a distinctly Argentine feeling of restraint, of unfeigned melancholy, utterly void of pose."[2] Pablo Curatella Manes (1891-1962), likewise praised by Prebisch, was much more avant-garde than Butler. He was the first Argentine sculptor to break with the academic tradition, which was far stronger in his area than in that of painting. By the time of his 1926 work *Rugby,* he was fully independent of the influence of his teacher Bourdelle and was working along the lines of the Cubists. One notes a particular affinity between his compositions and those which Laurens created after 1927, with their flow of movement and curvilinear forms.

Articles in *Martín Fierro* called attention to the originality of the gesso and terracotta compositions of Alfredo Guttero (1882-1932), who returned from Europe in 1927 to found the Plastic Arts Workshop, one of whose frequenters was Raquel Forner. They likewise recognized the pioneering character of the work done by Juan del Prete (born in Italy in 1897). In 1932 he was active in the "Abstraction-Creation" group in Paris, and when he returned home he produced the

first nonfigurative works of art to be created in Argentina—ingeniously varied compositions, always charged with emotion. The magazine enthusiastically hailed the triumphal reception accorded the Uruguayan Pedro Figari *(pp. 78, 79)* in Paris, contrasting with the noncommittal character of the reaction to his Buenos Aires exhibit of 1921. The most heated campaigns waged by the review were those on behalf of Xul Solar (1887-1963), Emilio Pettoruti (1892-1971) *(pp. 59, 60)*, and Norah Borges (b. 1901). Support of the last-mentioned is only to be explained by her relationship to Jorge Luis Borges, for with the publication of *Fervor de Buenos Aires* he had provided a poetic image that the *Martín Fierro* group could set up in opposition to the social concerns of the Boedo group.

Xul Solar, like Curatella Manes, stands in the forefront of the Argentine avant-garde. Like the poet Leopoldo Marechal of the "Ode anacreóntica a la cafetera Renault," he has a capacity for playing games in a straightforward man-ner which scarcely occurs elsewhere in Argentine art. The few creative artists who have engaged in playing games have done so on a basis of metaphysical transpositions: the line begun by Macedonio Fernández with *Papeles de recién venido* in 1926 continued through Borges to Julio Cortázar. Xul Solar, however, lays his cards on the table for all to see. In creating a "universal language" and a "universal game" he leaped into the unknown, but in doing so he expressed him-self in terms that are primarily plastic. The compositions he did between 1917

• **JOAQUIN TORRES-GARCIA**. *THE CONSTRUCTIVIST SHIP AMERICA.* 1943. OIL ON CANVAS, 50 X 75 CM. TORRES-GARCÍA MUSEUM, MONTE-VIDEO, URUGUAY. PHOTOGRAPH COURTESY OF THE TORRES-GARCÍA FOUNDATION, MONTEVIDEO.

and 1930, in which all kinds of objects can be found floating or moving about, have been rightly compared to those of Paul Klee. There is, however, a profound difference between the two artists. Klee creates poetry in painting through the use of graphic signs: atmosphere, plot, and drawing all correspond to stored-up memories. There is a surprising energy and life to Xul Solar's work. His fetishes, ruins, and inventions are presented not as suggestions but as positive assertions on his part. While *Cross-breeding between Men and Airplanes* (1935) comes close to Surre-alism, it nonetheless escapes that classification. Jorge Luis Borges once wrote that Xul Solar was "the only cosmopolitan man, the only citizen of the universe that I have known." This may explain the difficulty of classifying or labeling him.

The development of Emilio Pettoruti follows a more direct line than that of Xul Solar. From 1913 to 1924 he studied in France and Italy, where he estab-lished contact with the Futurists and the Cubists. He held his first exhibit in Buenos Aires in 1924, and it gave rise to fierce public debate between the old guard and the new, the latter being vigorously represented in the pages of *Martín Fierro.* Pettoruti, Juan Gris, and Gino Severini held a joint exhibit at the Galliera Museum in Paris in 1924, and the relation betwen the two European artists and the Argentine was too close for the latter not to be viewed as a derivative painter. Nonetheless he had appreciable qualities of his own, as can be seen in the series of *Interiors* he did from 1925 to 1935; in the Harlequins he painted off and on from 1926 to 1950 (the 1937 compositions *The Last Serenade* and *The Improviser* are, how-ever, reminiscent of the musicians in Harlequin attire that Picasso did around 1918); and the series of *Cups* painted from 1929 to 1935. One notes in particular

• **EMILIO PETTORUTI**. *MUSIC AL-BUMS*. 1919. INDIA INK ON PAPER, 20.2 X 26.5 CM. COLLECTION OF THE INTER-AMERICAN DEVELOPMENT BANK, WASHINGTON, D.C., U.S.A. PHOTOGRAPH BY WILLIE HEINZ.

the exceptional cleanness of line and coldness of tonality that distinguish the majority of these works. One notes also the small masterpieces of hyperrealism that find a place amid the frozen geometry of compositions such as *The Buzzer* (1938), *Oranges* (1944), and *The Pears* (1945). Pettoruti achieved the happiest fusion of avant-garde and nationalist tendencies to be found in the whole of modern Argentine art in a series of pictures in which sunlight entering a room falls upon a typical still-life grouping (usually a bottle of wine, a soda-water dispenser, and a bowl of fruit). The most significant works in this series were executed during the '40s: *Noon* (1941), *Study of Sunlight* (1942), *Intimacy* (1942), *Winter Sunlight* (1943), *Pampas Sunlight* (1944), *Blank Book* (1944), *Centerpiece* (1944), and *The Guitar* (1948). Never has the "neighborhood" aspect of Buenos Aires been better expressed than in these compositions, with their crystallization of sunlight and perfect articulation of illuminated forms. There has been insufficient study of this great period in Pettoruti's career and its consequences for modern Argentine art.

The list of artists upon whom Pettoruti has left his stamp is an impressive one: Fernando Catalano (b. 1883), Fioravanti Bangardini (b. 1906), Armando Chiesa (b. 1907), Norberto Cresta (b. 1929), Pedro Domínguez Neira (b. 1894), Amelia Fiora, Ernesto M. Scotti (1901-1957), Jorge Soto Acebal (b. 1891), Orlando Pierri (b. 1913), Vicente Forte (b. 1912), Francisco Fornieles (b. 1909), Jorge Edgardo Lezama (b. 1921), Germán Leonetti (b. 1896), Febo Martí (b. 1919), and Alberto Peri (b. 1929), to name but part. The works these artists were doing around 1956 reflect not only Pettoruti's abstract, simplified treatment of his subjects but the subject matter itself: a window, its frame, light, an open book, a fruit dish, fruit, a pitcher. During the twentieth century the art stage in Argentina has been largely occupied by a chorus of figures of second rank. Few among

those painting along abstract lines have achieved true individuality. Vicente Forte may be the exception. Pettoruti did what others did not: he educated the public to accepting abstraction as a legitimate form of present-day expression.

In 1939, 15 years after the launching of *Martín Fierro*, the Orion Group appeared in Buenos Aires, antedated, however, by the work of the first Argentine Surrealist, Juan Batlle Planas (1911-1966). The most important segment of Batlle Planas' work dated from the years 1938 to 1945. It came out in series, under titles such as *Paranoic X-rays*, *Noics*, and *Number Mechanisms*. Although, as Aldo Pellegrini says, his "Tibetan" series has "phantasmagoric figures submerged in an atmosphere that closely suggests Tanguy," Batlle Planas is a highly original painter. It is from figures such as those in his 1941 work *The Message* that later Argentine

Surrealism descends. Pellegrini correctly observes that, rather than being merely Surrealistic, the Orion Group "represents a neoromantic spirit infused with elements of eccentricity." The definition fits the work of Luis Barragán (b. 1914), Vicente Forte (b. 1912), Ideal Sánchez (b. 1916), and Orlando Pierri (b. 1913), who along with others constituted the Orion Group.

Argentine Surrealism took on new life with the appearance of the Boa Group in 1950. It was founded by the poet Julio Llinás as branch of the Paris circle known as "Phases." Although this European affiliation was to have very different consequences, which will be examined in the next chapter, it was the presence of Batlle Planas that is most strongly to be felt in developments in Argentine Surrealism from Roberto Aizenberg (b. 1928) on.

The third path to the modernization of art in Argentina was opened up by the appearance in 1944 of the first and only issue of the review *Arturo*. Its founders—Carmelo Arden Quin (born in Uruguay in 1913, but active in Buenos Aires from 1938 on), Edgard Bayley, and Gyula Kosice (a Czecho-Hungarian, born in 1924, who was taken to Buenos Aires in 1928)—were all disposed to do away with figurative art, but the group soon split over matters of aesthetic principle into the movement known as Concrete Art Invention, founded by Tomás Maldonado (b. 1922), and the Madí Art Movement led by Gyula Kosice. In 1949 Raúl Lozza (b. 1911) split off to form a further movement, known as Perceptism. Like the European coteries from which they derived, the Argentine groups indulged in theorization about what the new art should be. The Inventionist Manifesto, the Perceptist Manifesto, and the declarations issued by the Madí group concurred in exalting the self-contained values of painting and sculpture. The Madists also made a vague, confused appeal for "a humanity struggling for a classless society," while Perceptism called upon painting to exercise its true social function by reintegration into "muro-architecture."

Although the whole of the generation born around 1923 benefited from the pioneering efforts of the previously mentioned groups—without them it would be difficult to imagine the pictorial accomplishments of an Alfredo Hlito (b. 1923) or a Kenneth Kemble (b. 1923)—the most striking advances were made by the new sculptors: Líbero Badii (b. in Italy in 1916, moved to Argentina in 1927), Noemí Gerstein (b. 1910), Julio Gero (b. in Hungary in 1910), and Enio Iommi (b. 1926). Two special cases in sculpture are those of Alicia Penalba (1913-1982) and Sesostris Vitullo (1899-1953). Taking different roads, in Paris they executed totem-like compositions that in some cases are quite similar in effect, Vitullo's work anteceding that of Penalba by 15 years. Finally there was Lucio Fontana (1899-1968). He began as a figurative sculptor of finely conceived works. Presented at the national salons, they won him first prize in 1944. In 1947 he took up residence in Milan and there founded the movement known as Spatialism, aimed at the creation of "illusory space" through real perforation of a painted surface. In his White Manifesto, issued in Buenos Aires in 1946, Fontana had already ceased to distinguish between painting and sculpture, calling his compositions "spatial concepts."

The works produced toward the end of the '40s by Fontana and by the Madí group (which was to persist until the late '50s) facilitated Argentina's incorporation into the international current of Geometric-Constructivist art. Max Bill, André Bloc, Vasarely, and Pevsner, whose time was divided between Paris and the United States, and Pietro Dorazio in Rome constituted a veritable international of nonfigurative art. In Latin America aggressively avant-garde positions, aimed at radical tranformation of local art, were taken only in connection with the project for the exterior decoration of the Central University of Venezuela, which the architect Carlos Raúl Villanueva brought to completion in 1952, and by the Madí group. It paved the way for later experimentation with kinetic art and "breaking out of the frame." (All this, it should be noted, had previously been envisioned by the Russian Constructivists.) "Representational art belongs to the past" one reads in Madí texts. "The first objective is to take all paintings down off their walls and to dynamite all statues." All this led to a hypertrophy of the avant-garde in Buenos Aires. As a result, works such as Juan del Prete's 1932 string collages and Pettoruti's *Portrait of María Rosa* no longer had a bomblike effect at lifeless national salons, seeming rather to exemplify the only path art could now take.

During the period that now concerns us—from 1920 to 1950—the third country to possess an organized avant-garde was Mexico. In this case it was composed of Surrealists. At first their most vigorous supporter was the critic Luis Cardoza y Aragón, who had frequented the French Surrealists during his 1930 stay in Paris. When André Breton came to Mexico in 1938, he greeted him thus: "In Breton I salute Revolution! Not, however, this or that particular revolution, with its bovine disciplines and dogmatic idiocies." It was Cardoza y Aragón— born in Guatemala like Carlos Mérida *(pp. 57, 66)*—who took the most balanced view both of the great achievements of the Mexican Muralists and of their unquestionable shortcomings. In his words of welcome to Breton, he was setting Surrealism up in opposition to the single track of politically inspired Muralism.

Immediately after signing, along with Diego Rivera and Leon Trotsky, the "Manifesto for an Independent, Revolutionary Art" (1938), the French poet exalted the figure of Frida Kahlo *(p. 63)*, describing her as a "bomb with a ribbon around it." In 1940 a Surrealist exhibit was held at the Inés Amor Gallery in Mexico City. Its organizers in Mexico were Wolfgang Paalen (1905-1959) and César Moro; in Paris André Breton played a corresponding role. The local painters who participated were Carlos Mérida, Frida Kahlo (1910-1954), Diego Rivera, Antonio Ruiz, Agustín Lazo, Roberto Montenegro (1881-1968), and Manuel Rodríguez Lozano. All this made Surrealism an object of discussion and controversy, particularly among poets and other writers. The reservations expressed by the group known as Contemporaries, especially Cuesta y Villaurrutia, Cardoza y Aragón's withdrawal from the movement, Octavio Paz's adherence to it, and the illustrations Tamayo *(pp. 64, 65)* did for the poet Benjamin Péret's book *Air mexicain*[3] tended to situate Surrealism in the realm of literature. However, in the plastic arts one notes the increasing importance of Rufino Tamayo (1899-1991), and a group of women: Cordelia Urueta (b. 1908), Frida Kahlo,

• **FRIDA KAHLO**. *SELF-PORTRAIT DEDICATED TO LEON TROTSKY.* 1937. OIL ON CANVAS, 70.2 X 61 CM. NATIONAL MUSEUM OF WOMEN IN THE ARTS, WASHINGTON, D.C., U.S.A. GIFT OF THE HONORABLE CLARE BOOTHE LUCE. PHOTOGRAPH FURNISHED BY THE NATIONAL MUSEUM OF WOMEN IN THE ARTS.

Leonora Carrington (born in England in 1917), and Remedios Varo (1913-1963), born in Spain, who came to Mexico with her husband Benjamin Péret in 1942.

Certain internal factors must be taken into account, such as the importance of Julio Ruelas (1870-1907), whose fantastic paintings were first studied with the care they deserve by the critic Ida Rodríguez Prampolini. There were also external factors, such as the arrival from France of Antonin Artaud, who was later to publish a book entitled *Au pays des tarahumaras;*[4] the arrival of Paul Eluard in 1949; and the appearance in that same year of *Prometeus*, a review edited by Francisco Zendejas and illustrated by Leonora Carrington. The most important elements in Mexican Surrealism, however, derive from the life of the people, with its colorfulness, liveliness, fantasy, black humor, and continuous awareness of death.

All these lie at the root of the work of Rufino Tamayo, particularly the compositions executed between 1930—when he freed himself from the strong influence exerted by Torres-García *(pp. 58, 75, 76, 77)* and his sharp slices of organized reality (see *The Alarm Clock*, 1928)—and 1945, when he entered into a period of more nocturnal, starry compositions, more closely attuned to the uni-

• **RUFINO TAMAYO**. *ANIMALS*. 1941. OIL ON CANVAS, 76.5 X 101.6 CM. MUSEUM OF MODERN ART, NEW YORK, U.S.A. INTER-AMERICAN FUND. PHOTOGRAPH FURNISHED BY THE MUSEUM OF MODERN ART.

verse. In the extraordinary series of works dating from 1945 to 1960, figures are bathed in a chromatic atmosphere of rare intensity. It was in the years from 1926 to 1938 that Tamayo's compositions gradually took on a character of their own, distinct from the work of the Muralists. When Tamayo journeyed to New York for the first time in 1940, he was halfway to attaining what Octavio Paz was to call "the constellation of forces" that would permit him to view the world as an interplay of appeals and responses, sustained by trust in ubiquitous energy. No other artist has expressed so well in pictorial terms the mythical thought that the Romanian philosopher Mircea Eliada explained as existence within a "living, articulate, significant cosmos." In 1950 the mysterious, cryptic character of that cosmos is admirably reflected in *Sleeping Melodies* and *Cosmic Maternity*. In compositions such as his 1952 *Tribute to Our Race* one can perceive the special flavor imparted to Tamayo's work by his continuing bond with folk art. Between 1950 and 1960, as Octavio Paz puts it, Tamayo, "discovered the old formula of consecration."[5] His painting, based in a bipartite, cosmic vision of sun and moon, becomes a vast metaphor. In his murals one can note the steps in his development from sign language to metaphor: 1933, mural for the National School of Music; 1938, mural for the National Museum of Anthropology (an object lesson in how a revolutionary message can be conveyed without sacrificing pictorial values); 1954, murals for Sanborn's in Mexico City; 1956, mural entitled *America* in the Bank of the Southwest in Houston, Texas; 1957, mural entitled *Prometheus*, Río Piedras, Puerto Rico. These enormous compositions, though designed to go

● **RUFINO TAMAYO**. *CARNIVAL.*
1941. OIL ON CANVAS, 112.3 X 84.4
CM. THE PHILLIPS COLLECTION,
WASHINGTON, D.C., U.S.A. PHOTO-
GRAPH FURNISHED BY THE PHILLIPS
COLLECTION.

on walls, are generally painted on movable frames. They evidence none of the
Renaissance concepts of mural art that characterize the works of the Mexican
School. They are to be read indirectly, in a figurative sense, without the assis-
tance of any code for interpreting their Surrealist intent. Unlike Frida Kahlo, for
example, Tamayo has no recourse to code. Kahlo's work, like that of Carrington
and Varo, is inner-directed: physical pain, madness, or fantasy provide keys for
reading on an individual basis. Tamayo goes beyond individual codes. What
Cardoza y Aragón calls his "transfigurations" are in reality structures in which
sensations are combined with forms capable of conveying them—structures that
possess universal validity. Tamayo's work betokens on the one hand a carnal re-
lationship with Mexican history and the Mexican people, as for example in the
Glorification of Zapata (1932) and the *Monument to Juárez* (1935), and on the other
hand an elevation of daily life to a sacred plane by mythical-poetic Surrealist in-
vention.

The Mexican picture in the period under study is completed by the figure
of Carlos Mérida. Born in Guatemala in 1891, by 1929 he was established in
Mexico. His style, marked by symbolic transpositions and decorative syntheses of
rhythmic intent, provides a bridge to pre-Hispanic art. His career in Mexico had

• **CARLOS MERIDA**. *STORMY PUR-PLE: TEXAS SKIES SERIES*. 1943. OIL ON CANVAS, 61 X 50.5 CM. COLLECTION OF THE ART MUSEUM OF THE AMERICAS, OAS, WASHINGTON, D.C., U.S.A. PURCHASE FUND 1960. PHOTOGRAPH BY ANGEL HURTADO.

its origin in a modest task assigned him in 1934 by the Secretariat of Public Education's School of Dance. He was charged with making a study of some 160 native dances, some of prehistoric origin, and with seeking to clarify their ritual character and place them in their proper setting. This called for small-scale pictorial work, often of a merely descriptive character, such as the series he did in stencil. However, it led later, in 1950, to two different types of artistic activity on Mérida's part. First there were easel paintings, generally in casein on parchment, in which flat geometric shapes are delineated in lively, rhythmic relationships with one another: *Dances* (1949), *The Moon and the Deer* (1951), *The Three Totonac Kings* (1951). Then there were the mural decorations he did in mosaic for the Benito Juárez Housing Project in Mexico City in 1952 (*The Four Suns, Mexican Legends*); for the hall of the Reinsurance Building in Mexico City; and the mural in Venetian mosaic, dedicated to the mestizo race, which he did for the Municipal Building in Guatemala City in 1956. The whole of Mérida's effort has been dedicated to a delicate task of recuperation: there is his research into the artistic ground regained by mestizo and creole craftsmen during the colonial period, his investigation of Maya codices and featherwork, his laborious use of *amatl* paper and paper made of maguey fiber. His persistence in "chamber" composition stands in sharp contrast to the enthusiasm of the Muralists for mighty orchestration. When attacked by Siqueiros on this subject he chose to maintain silence. He

was well acquainted with Walter Gropius, Moholy Nagy, and Josef Albers, having worked with them in 1941 and 1942 at Black Mountain College in North Carolina. He himself, however, practiced a "mestizo" form of abstraction.

While Argentina, Brazil, and Mexico constitute the three main areas of innovation during the period under study, certain individuals already recognized as forerunners of things to come stood out elsewhere: in Cuba there were Wifredo Lam (1902-1982) and Amelia Peláez (1897-1968) *(p. 68)*; in Chile, Roberto Matta (b. 1912) *(pp. 52, 71)*; in Venezuela, Armando Reverón (1889-1954) *(pp. 72, 73)*; and, in Uruguay, Joaquín Torres-García (1874-1949). The need to defend Latin America's artistic independence of Europe and the United States has led critics (for good aesthetic reasons) to promote these artists to the point of creating a Latin American art boom—one that preceded the 1970s boom in Latin American literature by a good 10 years. In art as in literature there was excessive concentration on a few key figures. Other artists, who were perhaps less systematic in their production but nonetheless authored works of importance, were ignored. This injustice can be remedied. A reevaluation of the artists involved in the boom should take into account the context in which each worked to such brilliant effect. Their importance as inventors of a Latin American visual repertory—similar to the accomplishment of their European and United States colleagues—will not be diminished thereby. It was they who gave the measure of Latin America's capacity to "create images" and who reestablished in the twentieth century the continuity of a culture that did not come into existence in 1900 but that extends from pre-Hispanic times to our days. There are occasional breaks, splits, or interruptions brought about by outside forces, but the tradition is ever ready to assert its existence and its individuality.

Amelia Peláez established her presence in Cuban painting early in her career, by participating in the 1927 exhibition organized by *Revista de Avance*. From 1927 to 1934 she lived in Europe, studying with Alexandra Exter, one of the most original and multifaceted figures in Russian Constructivism. In 1938 she accepted the prize of the National Salon in Havana—an award that had already been offered her three years earlier. In 1940 and 1941 she spent a whole year traveling and sketching in California. Between 1946 and 1949 further trips took her to Mexico and Europe, whither she did not return until 1966. Throughout her travels, however, Amelia Peláez remained spiritually a woman of Havana, seated on a high-backed, cane-bottomed Louisiana plantation chair, in a plant-filled patio or a room into which light filtered through stained-glass windows and half-open Venetian blinds.

Lam traveled in 1923 to Spain to study at the Madrid School of Fine Arts. He did not return to the Antilles until 1941, when some 300 intellectuals—among them Breton, Claude Lévy-Strauss, and Victor Serge—were transported to Martinique, where they were placed in an internment camp. It was 40 days before Lam was able to obtain his release and go to Havana. Lam was no neophyte in matters of modern art. Picasso took him under his wing in 1938 and sponsored an exhibit of his work in Paris; a year later the two of them had a joint

• **AMELIA PELAEZ**. *THE HIBISCUS*. 1943. OIL ON CANVAS, 115.5 X 89.5 CM. COLLECTION OF THE ART MUSEUM OF THE AMERICAS, OAS, WASHINGTON, D.C., U.S.A. GIFT OF IBM, 1969. PHOTOGRAPH BY ANGEL HURTADO.

exhibit in New York. Lam established a base in Cuba in 1942, but until 1965, when he took up more or less permanent residence in Albisola Mare, Italy, he traveled constantly, mingling the civilized life of Paris and New York with excursions into the realms of myth and magic, such as the six months he spent in Haiti in 1946, soaking up voodoo, and the trip he made to the depths of Mato Grosso 20 years later.

The writer Alejo Carpentier has carefully brought out the relationship between Amelia Peláez's work and certain architectural features of Havana, notably the fretworked wooden partitions and the stained-glass fanlights that separate galleries from patios and soften the brilliant sunlight streaming in from outside. The Colombian painter Beatriz González has refined this idea, explaining that the fanlights with their wooden separations and the large color areas they divide are conducive to abstraction in a way that church windows with their narrow leads and fragmentation of color for descriptive purposes are not. Peláez's sedentary existence in her Franco-Cuban residence in La Víbora brought her into daily contact with color zones and arabesques, and this visual experience is reflected throughout her work and in her rare public utterances, just as are her

• **WIFREDO LAM**. *THE JUNGLE*. 1943. GOUACHE ON PAPER MOUNTED ON CANVAS, 239.4 X 229.9 CM. MUSEUM OF MODERN ART, NEW YORK, U.S.A. INTER-AMERICAN FUND. PHOTOGRAPH FURNISHED BY THE MUSEUM OF MODERN ART.

contacts with the Postcubists and her European apprenticeship. Her intent was to develop an art full of life, endowed with the natural splendors of everyday existence. The critic Adelaide de Juan writes: "Her zealous search for 'national' elements is manifested in the '40s by fixation on certain details: interiors, furniture, stained-glass windows, and screens." Thanks to the still lifes she painted for over 30 years "the soursop, the mammee, the pineapple, the mango, the banana, the sweetsop, and the star apple were incorporated into our painting," the same critic observes.

After a period of painting extraordinary fruit-like men and women in 1942 and 1943, in 1943 Wifredo Lam produced his masterpiece, *The Jungle*. It bears a certain relationship to the explosion of fruits and vegetables in Amelia Peláez's work, but whereas she used them for decorative purposes in his case the intent is erotic and reflects his well-known fetishistic tendencies. The work of both artists is of a repetitive nature, as befits its origins in myth. Myth, according to the semiologist Jakobson, tends toward the invariable and finds its strength in unilateral visions that permit a high degree of concentration and focalization. Peláez explores the world about her. Lam, owing to his combination of Chinese and mulatto ancestry, is imbued with an Afro-Oriental culture that is expressed in a religious syncretism that lends an extraordinary supernatural force to all his

work. As the writer Fernando Ortiz says, it was inevitable that he would produce "symbols of erotic effect." The capital importance of *The Jungle* in contemporary art derives from its accumulation of totems, the intricate interweaving of figures and background, and the interaction between rounded shapes and the flat wall of the tropical selva. Of equal importance is the abyss that this composition creates between European and Latin American Surrealism. Lam makes use of African masks that closely resemble those in *The Young Ladies of Avignon*, but, whereas for Europeans they served a merely intellectual purpose, for Lam they exemplified a mythical concept possessed of genuine meaning. In contrast with the work of the European Surrealists, there is no open space in the compositions of Peláez and Lam. Seemingly affected by agoraphobia, Peláez fills every nook and cranny with lines and colors, and Lam locates the fetishes he painted from 1950 on in a sort of anti-space, an amniotic fluid on which they feed and in which they move. If we compare the work of Amelia Peláez with that of the Matisse of the odalisques and thereafter, we note that in Matisse the arabesque is a side feature, offsetting the color zones, whereas in Peláez it devours and asphyxiates everything.

The splendor of these two artists' achievement greatly outshines that of their fellows, but the work of Fidelio Ponce de León (1895-1949) cannot be neglected in a consideration of the avant-garde. Unlike Amelia Peláez, he never moved from Havana. His first exhibit there marks the beginning of the history of modern Cuban painting. With his erratic vision and his use of thick impasto, Ponce, like the Colombian Andrés de Santa María, is a transition figure between the last of the Postimpressionists and the first representatives of new things to come. In both cases, the artist's avant-garde spirit takes the form of complete disdain for reality. Forms disappear as the painting dissolves into an unbridled orgy of color. In their concentration on paint for paint's sake, they were unsystematic, and this doubtless weakens their compositions. However, in their revolt against the tyranny of visible reality, they showed themselves heralds of the future.

The sudden appearance of Roberto Matta (b. 1912) had an electrifying effect on Chilean painting. In 1925 the Montparnasse Group had broken with academic tradition, proclaiming its enthusiasm for the new tendencies then being manifested in Paris. In turn it was rejected by what the critic Antonio Romera has called "the Generation of '40." None of the artists in either of these two groups—neither Luis Vargas Rosas (1897-1976), the leading light of the Montparnasse Group, nor Manuel Ortiz de Zárate (1886-1946) or Camilo Mori (1896-1974)—produced more than pale updatings of Cézanne or Lhote, much less interesting than the highly skilled, freely Impressionistic canvases of their predecessors Juan Francisco González and Pablo A. Burchard.

Matta not only reacted against the Generation of '40 but also managed to resist the patronage offered by André Breton, avoiding the repertory of the Parisian Surrealists. In the inner landscapes he presented at the International Surrealist Exhibition in Paris in 1938 space is charged with a dizzily electrifying tension that is one of the most original creations of the century. An "antisystem" of concentric lines, spirals, transparent planes, floating objects, bulbs, and sprouts

• **MATTA** (ROBERTO SEBASTIAN ANTONIO MATTA ECHAURREN). *HERMALA II.* 1948. OIL ON CANVAS, 114.2 X 146 CM. COLLECTION OF THE ART MUSEUM OF THE AMERICAS, OAS, WASHINGTON, D.C., U.S.A. GIFT OF THE WORKSHOP CENTER FOR THE ARTS, WASHINGTON, D.C., 1957. PHOTOGRAPH BY WILLIE HEINZ.

characterizes the works which followed, such as *The Disasters of Mysticism* and *The Heart of Man* (1942), a high point being reached with *The Vertigo of Eros* (1944). After the extraordinary explosions and fragmentations incorporated into the compositions he did during the '50s, he arrived at a more reasonable degree of disorder in the 1956 mural he painted for UNESCO, *The Doubts of Three Worlds.* The retrospective exhibit of his work held at the Museum of Modern Art in New York in the following year established him as the greatest of Latin American Surrealists, notwithstanding the fact that he had been expelled from the Surrealist movement in 1948. No one else has shown his capacity for exploring the unconscious and the subconscious and for inventing a dream world that has no basis in literature. (The Belgians Magritte and Delvaux are his precise opposite in this respect.) He reached a degree of psychic automatism that permitted him to serve as his own medium.

The energy discovered by Matta infuses a large part of the work of his Chilean contemporaries. The tension and dynamism he imparted to space take on dramatic profundity in the compositions Enrique Zañartu executed during his best period (1950-1960); produce magic effects in the work Pablo A. Burchard did at the same time; are handled with everyday confidence in the somewhat disorderly pieces turned out by Carmen Silva; and even leave traces in the 1960

• **ARMANDO REVERON**. *COCONUT TREES*. PHOTOGRAPH COURTESY OF THE ART MUSEUM OF THE AMERICAS ARCHIVE, OAS, WASHINGTON, D.C., U.S.A.

Reincarnations of Enrique Castro-Cid. Although Matta never abandoned his animated treatment of space—as is evidenced by the extraordinary illustrations he did for Arthur Rimbaud's *Une saison en enfer* in 1978—the visit he made to Cuba in 1963, the work *Grimau, the Powers of Disorder* (1964), and the trips he made home to Chile in 1971, 1972, and 1973 during the Allende administration changed the direction of his work. In the enormous panels done as illustrations for the novel *El gran burundú-burundá ha muerto* by the Colombian writer Jorge Zalamea (1975), for political reasons he was obliged to resort to more concrete and visible forms than in his previous "germinations." In *Autoapocalypse*, painted for the Fiat offices in Bologna in 1976, and in the "Odyssean" series of 1977, figures loom larger, though they continue to be moved by a convulsive, destructive force into continuous collisions from which their sole protection is their invariable transparency. Although the matter does not relate to the period now under consideration, it is important to emphasize the definite influence Matta had on the U.S. artist Arshile Gorky in 1939, and on the future Abstract Expressionists of the School of New York. America was not forgotten in his works. The *Inscapes* of the 1940s, inspired by Mexican volcanoes, show that the presence of the Andes that loom over Santiago had accustomed him to landscapes of limitless sweep.

Unlike Matta, who always had a surrounding circle, the Venezuelan Armando Reverón (1889-1954) lived a life of solitude. 1912 is famous in the history of Venezuelan art as the year the students at the School of Fine Arts went on

strike and the Fine Arts Circle was founded. It was also the year in which Reverón traveled on a government scholarship to Spain, staying in Europe until early 1915.

The leading participants in the First National Salon (1913) then dominated the artistic scene in Venezuela. Tito Salas carried on the academic tradition, while Edmundo Monsanto (1890-1947) was trying to make an opening for landscape painting. The members of the Circle wrought little change in the environment, which was enlivened only by the arrival of the Romanian Samys Muntzer (1869-1958) and the Russian Nicholas Ferdinandov (1886-1925) in 1916 and by the return of Boggio in 1919. In the latter year, influenced by Ferdinandov's vivid blues, Reverón painted one of the masterpieces of his first period, *The Cave*. Muntzer's short, rapid brushstrokes are reflected in another important work, *The Baths of Macuto*. It was not until 1921, however, when Reverón made his permanent move to Macuto, near La Guaira on the Venezuelan coast, that he began to paint in the hallucinating manner that is responsible for one of the most independent and original bodies of work to be found in the whole of Latin American art. The critic Alfredo Boulton[6] has divided Reverón's development into a series of periods, the "white period" of the years 1925-1932 being characterized by compositions done in a "milky monochrome." The critic assigns Reverón's masterpieces to the "sepia period," initiated in the year 1938, when the artist took to painting in brown tempera on burlap coffee sacks, using

an almost Pointillist technique. The encounter with the light of the seacoast, according to Boulton, produced "so powerful and disconcerting a shock that the painter completely forgot all he had seen and done before and completely transformed his palette." Boulton's insistence on the overwhelming nature of this experience provides the best key for understanding a work of visual genius that has no like. It is not to be explained by Reverón's use of halftones, or touches of white set off by the reddish, greenish, and yellowish pigments he usually used. It is not to be explained by the rapidity with which he captured images, as if on film struck by light. Neither is it to be explained on a personal level, by his fits of depression that bordered on madness and led him to take up a savage existence à la Robinson Crusoe, or by speculations on his difficulty in relating to the real world of sex and the life-size dolls he made for himself. It is impossible to say whether his was a case of intuitive consciousness of color in the atmosphere, of sensitivity to its visual aspects and technical genius in capturing it in paint, or whether it was a case of conscious and premeditated development, over a period of years, of an appreciation of light that could be gained only in the Caribbean area.

Reverón's first exhibit, organized by the painter Alejandro Otero and the writer Juan Liscano, took place in Caracas in 1949 at the Free Art Studio. It served to confirm once and for all both his genius and his extravagance. The truth of the matter is that no other painter in Latin America took the course followed by Reverón. Starting with certain factual liberties taken by the Impressionists, he leaped to making notes in paint of the visual disorder that light can effect. In the overpowering brilliance it reaches along the coast, light both dissolves and creates images. The painting of light can be carried no further. Reverón's work in this respect resembles the series of waterlily paintings Monet did at Giverny, as the writer Mariano Picón Salas acutely observes.

An artist such as Reverón could have no followers, contrary to the case with the Uruguayan Joaquín Torres-García. In 1952, two years before Reverón's death, a new stage in Venezuelan art was ushered in by the return of Alejandro Otero (b. 1921) from Paris and a start on the decoration of the University City, an outstanding feature of which was the acoustical ceiling executed that year by Alexander Calder for the Auditorium. Construction of the University City had begun earlier, in 1944, under the direction of the architect Carlos Raúl Villanueva (1900-1975). The "Venezuelan subconscious" that Picón Salas identified in the work of Reverón was outflanked and neutralized by Vasarely and Pevsner.

The founding of the Theseus Association in 1927 marked Uruguay's entrance onto the stage of modern art. Stimulated by the critic Eduardo Dieste, a group of properly innovative painters held at the headquarters of the Friends of Art in Buenos Aires an exhibit that was hailed for its avant-garde character and the break it made with the past. The exhibitors included Carmelo de Arzadún (1888-1968), a disciple of Anglada Camarasa, and José Cúneo (1887-1977), a painter of outstanding merit. That same year Cúneo returned to Europe. (His previous visits included one in 1911 when he studied in Paris with Anglada

• JOAQUIN TORRES-GARCIA. *COS-MIC MONUMENT.* 1938. WORK BY THE ARTIST IN RODÓ PARK, MONTEVIDEO, URUGUAY. PHOTO-GRAPH COURTESY OF THE ART MU-SEUM OF THE AMERICAS ARCHIVE, OAS, WASHINGTON, D.C., U.S.A.

Camarasa.) He then became acquainted with the work of Chaim Soutine, which was to have a striking influence on his later compositions, particularly the ones that make up the astonishing "moon" series. Up to that time he had used a tech-nique involving relatively orderly color planes, in a manner suggesting Gauguin. This he abandoned for a much more expressive impasto and a deliberate use of diagonals and curves that impart dramatic movement to the composition. In this style he painted the thatch-roofed earthen houses of the Uruguayan peasant, with great moons shining through small breaks in stormy skies, producing effects of mysterious beauty that at times recall the violent romanticism of the American Albert Pinkham Ryder. The critic José Pedro Argul writes: "He deals openly with the problem of the infinite in landscapes of planetary sweep; the endless abyss of sky conveys the anguish of the beyond. His poetic moons were inspired by the po-etry of Julio Herrera y Reissig, some of whose verses served as the preface to Cúneo's first exhibit of this series."[7] Carmelo de Arzadún won the gold medal at the National Salon in 1941; Cúneo in 1942; and Torres-García in 1944, the year he published his masterwork *Universalismo constructivo* (Universal Constructivism). The fact that styles as diverse as those of Cúneo and Torres-García could exist side by side suggests the lively character of the Uruguayan art scene at that time. The period was one of economic prosperity and political stability. The former derived from the climate of forced saving and the excellent market for Latin American products during World War II. The latter was due to the dominance in politics of the faction of the Colorado Party led by Luis Batlle

• JOAQUIN TORRES-GARCIA. *CONSTRUCTIVIST COMPOSITION.* 1943. OIL ON CANVAS, 68.6 X 76.8 CM. COLLECTION OF THE ART MUSEUM OF THE AMERICAS, OAS, WASHINGTON, D.C., U.S.A. GIFT OF NELSON ROCKEFELLER, 1963. PHOTOGRAPH BY WILLIE HEINZ (ABOVE). *COMPOSITION.* 1931. OIL ON CANVAS, 114.6 X 89.5 CM. HIRSHHORN MUSEUM AND SCULPTURE GARDEN, SMITHSONIAN INSTITUTION, WASHINGTON, D.C. GIFT OF JOSEPH H. HIRSHHORN, 1972. PHOTOGRAPH BY LEE STALSWORTH (BELOW).

Berres, who was president from 1947 to 1951, and of the party in power from 1954 to 1958. It carried out a socialist policy acceptable to the nationalistic middle class.

In a climate favorable to cultural debate, the figure of Joaquín Torres-García (1874-1949) assumed extraordinary importance in the years between his return to Uruguay in 1934 and his death in 1949. He was the son of an Uruguayan mother and a Catalan father, and when they moved back to Barcelona he accompanied them. He was then 17. His training in art was entirely European, and his early work as a muralist shows a strong link with Catalan *art nouveau*. Good examples are the 1913 wall painting he did in Barcelona for the Central Library and the Hall of St. George in the Chamber of Deputies building. The works he exhibited at the Dalmau Galleries in the same city in 1917 showed a capacity for synthesis and orderly structure that was thenceforth to be his basic characteristic. From 1919 to 1928 Torres-García led a wandering life, traveling from Barcelona to Paris, then to New York, and after that back to Italy and France. All the while he was engaged in threefold activities: easel painting, the manufacture of painted wooden toys, and illustration of design books. In 1928, having been rejected at the Paris Autumn Salon, he transferred his allegiance to the Salon of Independent Artists. A year later he took a stand with the Neoplasticists in strong opposition to the vague lyricism and lack of definition characterizing the work of the Surrealists. In 1930 he and the critic Michel Seuphor founded the group known as "Cercle et Carré" (Circle and Square), to-gether with the review of the same name. A year afterward the group dissolved and its members joined the ranks of "Abstraction-Creation." Torres-García maintained a place apart, and in 1931-1932 in the course of 12 months he held four exhibits in which the concept of Universal Constructivism was clearly present: if nature submits to a certain order, it is possible to visualize the unifying laws that rule the cosmos. Torres-García carried this half-philosophic, half-aesthetic idea to Madrid, where he founded the Constructivist Art Group. In 1934 he returned to Montevideo for good, and at the age of 60, after an absence of 43 years, he undertook a series of activities that were to make of him unques-tionably the outstanding figure in Uruguayan art and the leading mentor of the Latin American art scene. He expounded his theories in more than 600 lectures. He published a number of books: *Estructura* (Structure, 1935), *La tradición del hombre abstracto* (The Tradition of Abstract Man, 1938), and, most notably, *Universalismo constructivo* (Universal Constructivism), which was issued in Buenos Aires in 1944. He did murals, executing the *Cosmic Monument* for Rodó Park in Montevideo in 1938, and he painted personally seven of the 34 mural panels in the Colonia Saint Bois[8], the remainder being the product of his studio.

His teaching was imparted at the Workshop he founded in 1944 and in the pages of the review *Removedor*, which served as a platform for his ideas. The Workshop acquired a mystique without parallel in other countries. Torres-García considered himself a realist, saved from the banalities of naturalism by his passion for "geometry, order, synthesis, construction, and rhythm." Statements

• **TORRES-GARCIA** WAS BOTH A CREATIVE ARTIST AND AN ART THEORIST. IN DISSEMINATING HIS IDEAS HE RELIED NOT ONLY ON HIS WORKSHOP BUT UPON PUBLICA-TIONS SUCH AS THE REVIEW *REMOVEDOR*.

● **PEDRO FIGARI**. *THE MARKET PLACE*. CA. 1935. OIL ON CANVAS. 38 X 60.3 CM. COLLECTION OF THE ART MUSEUM OF THE AMERICAS, OAS, WASHINGTON, D.C., U.S.A. GIFT OF THE BANK OF THE REPUBLIC OF URUGUAY, 1950. PHOTOGRAPH BY ANGEL HURTADO.

made later by disciples such as Gonzalo Fonseca and Julio U. Alpuy agree that his teaching was methodical and drew from life and reality its strongly utopian flavor. According to the Uruguayan critic Juan Flo, the utopia for which Torres-García sought was the creation from scratch of an all-but-anonymous type of art, suggestive of the cosmic rites of civilizations such as those of the pre-Columbian Indians. Pointing out the visible ideograms that appear in the artist's work, the critic Angel Kalenberg declares that Torres-García was a pioneer in the area of plastic structural grammar and the real inventor of "qualitative linguistic" concepts. Only the evangelic fervor of his teaching can explain the closeness with which the score of talented and sensitive artists enrolled in the Workshop mimicked his modes of expression. His influence can be felt on artists as far removed from Uruguay as the Americans Gottlieb and Nevelson (as the U.S. critic Jacqueline Barnitz has noted) and the Guatemalan Roberto Ossaye.

The imitative character of the work produced by even the most important members of the Workshop is not here pointed out as a defect. Despite the sensitivity displayed by Torres-García in drawing his compartments and filling them with signs, the system was unduly rigid and the Workshop introduced the required amount of variety. Augusto and Horacio Torres, Alceu and Edgardo Ribeiro, Gonzalo Fonseca, Francisco Matto Vilaró, Jonio Montiel, Anhelo Hernández, Manuel Pailós, José Gurvich, Julio U. Alpuy, Jorge Visca, and others carried on the tradition of the Workshop after the master's death. The graphic signs appearing in works which José Gamarra (b. 1934) did in the 1960s reflect the influence of Torres-García's mysterious petroglyphs, though the younger artist had never come into contact with the elder.

• **PEDRO FIGARI**. *COUNTRY IDYLL*. CA. 1935. OIL ON CARDBOARD, 35 X 50.2 CM. COLLECTION OF THE INTER-AMERICAN DEVELOPMENT BANK, WASHINGTON, D.C., U.S.A. PHOTOGRAPH BY WILLIE HEINZ.

The intentionally avant-garde stand which Torres-García took implied an abrupt break with "normality." In his Seventh Lesson (1947) the artist exclaimed: "Normality! How horrible it seems to a person engaged in abstraction, who admits only flat surfaces, distorted to fit the demands of the construction he has in mind, who acknowledges no restrictions of any kind upon his freedom to create."

Pedro Figari (1861-1938) was not concerned with the outward appearances of reality, but with the truth that underlies it. Jules Supervielle has termed his works "a poet's recollections of childhood." The characteristics that give them their feeling of playfulness and spontaneity—color without shadow, the rococo lines of his arabesques, the apparent lack of method in his distortions—are the product of long speculation on aesthetics. Figari's 1912 book *Arte, estética e ideal* (Art, Aesthetics, and the Ideal) shows him to be a Positivist and Spencerian, with a personal enjoyment of a certain type of Postimpressionism exemplified in the works of Bonnard, Vuillard, and Roussel, which Figari saw for the first time in Milo Beretta's collection in Montevideo. Figari's adherence to Positivism was in line with the general tendencies of Latin American thought in the nineteenth century, when the attempt was made to find a biological explanation for spiritual forces, differing from the explanations offered by Idealism. Putting into practice his confident belief in art as a universal form of action, he did 3000 paintings on cardboard in the 17 years following his first exhibit in Buenos Aires in 1921. He took an equally optimistic view of history and tradition, as is evidenced by his choice of themes—scenes of everyday life during the colonial period, the life of the Blacks in the city and of the gauchos in the countryside. While the repertory

would seem to fall into the area of folklore, nothing could be farther from its tranquil, conservative spirit than Figari's dynamic, constantly inventive work. He had a unique manner of painting Negro themes. As Angel Rama writes, it derives from his interest in a model of behavior whose naturalness, lack of restraint, and free enjoyment of folkways showed the positive side of the human conduct of "the illiterate, who do not lose sight of the true path and follow their instincts closely, rubbing elbows with reality." The energy engendered by community existence, which provides the sole environment in which man can live life to the full, is not diluted by Figari's warm, rich impastos. The joy and sensuality generated by his use of color serve but to reaffirm it.

Self-portrait with Wife, which Figari painted in 1890 when his career as a magistrate was fully on the ascendant, gives clear indication that his style is not the product of visual naiveté, as is the case with so-called primitive painters, but corresponds to a preconceived intent to paint with freedom, but still within certain bounds. As with all great artists, this implies that he had worked out a certain method for himself. It included the use of colors and tonalities similar to those of Pierre Bonnard, and a horizontal concept of space. City and folk dances, country scenes, groups of people, even an attempt at history painting such as the undated *Assassination of Quiroga*—all, without exception, are horizontal in structure and either flat in effect or convey very little sense of depth. Figari's chronicle of Montevideo is presented in a horizontal sequence, like the frames of a motion picture, and should be seen in order to appreciate its true meaning.

The plastic freedom of Figari's work, like that of the Venezuelan Reverón, represents an individual act of artistic renovation. Figari goes much farther than Bonnard, for while the Frenchman provided in fragmented color notations a freely interpreted chronicle of bourgeois society at the beginning of the century, Figari invents his chronicle, free of all dependence on a model. Description becomes a gratuitous act; Figari engages in painting for its own sake. This was an achievement that most artists of Latin America were not to realize for another half century.

Notes

[1] The Modernists formed a brilliant elite. The sculptor Víctor Brecheret (1894-1955) was the first in Latin America to break away from the idea that a monument necessarily implies figurative representation. Anita Malfatti (1896-1964) was the most notable of the painters to take part in Modern Art Week; as an Expressionist she was often the equal of the Europeans. There was Tarsila do Amaral. There were architects: Gregori Warchavchik (1896-1973), the first in Brazil to design a building in the International Style (1927); Lúcio Costa (b. 1902); and Oscar Niemeyer (b. 1907). Painters like Waldemar da Costa (b. 1904), Cícero Dias (b. 1908), and Yolanda Mohaly (born in Hungary, 1909-1979) opened the way for abstraction. Regina Graz was a pioneer in the field of decorative arts. Roberto Burle-Marx (b. 1909) is the greatest landscape architect in Latin America. Menotti del Picchia (b. 1892), Ismael Néry (1900-1933), and Antônio Gonçalves Gomide (1895-1967) engaged in various types of Cubism. Antônio Bandeira (1922-1967) made striking use of symbols. Oswaldo Goeldi (1895-1961) and Lívio Abramo (b. 1903), whose woodcuts and lithographs set off a great burst of activity in the field of graphics, were almost alone in not seeking to establish new rules for art.

[2] Damián Bayon, *Adventura plástica en Hispanoamérica* (Mexico City: Fondo de Cultura Económica, 1974).

[3] Benjamin Péret, *Air méxicain* (Paris: Editions Arcanes, 1952).

[4] Antonin Artaud, *Au pays des tarahumaras* (Paris: Fontaine, 1945). A poet, essayist, stage director, and actor, Artaud (1886-1948) traveled to Mexico in 1936 and spent several months living among the Tarahumara Indians in the Sierra Madre. He learned from them the rituals of peyote, by which he was much impressed.

[5] Octavio Paz, *Tamayo* (Mexico City: UNAM, 1958).

[6] Alfredo Boulton, *La obra de Armando Reverón* (Caracas, 1966).

[7] José Pedro Argul, *Proceso de las artes plásticas del Uruguay* (Montevideo: Barreiro y Ramos, 1975).

[8] In 1974 the frescoes were removed from the walls at Saint Bois, restored, and mounted on movable frames. In 1978, while on exhibit at the Museum of Modern Art in Rio de Janeiro, they were destroyed by fire.

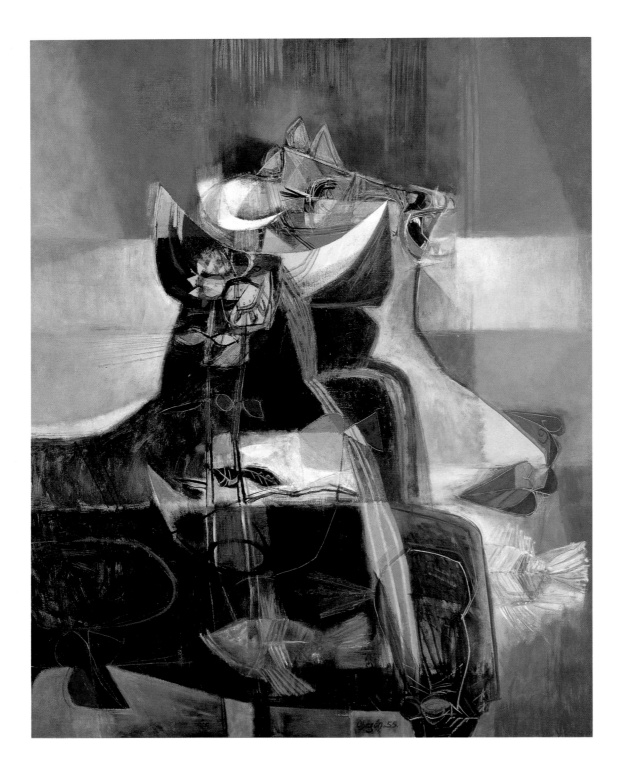

DECADES
OF CHANGE

THE EARLY 1950s SAW A BLOSSOMING OF ARTISTS THAT COULD NOT HAVE been imagined in the previous period. Till then, the elements of modern plastic language had been provided by a mere handful, exceptional in their intuition, working in isolation. Suddenly the stage that had been held by a few solo performers was crowded with a vast chorus. Whereas Reverón had been an outsider in Venezuela, and Torres-García had single-handedly led the way to modernism in Uruguay, the scene was now occupied by some 400 artists of relatively equivalent quality. Economic and political factors as well as ones of a cultural nature contributed to this explosion of activity.

A number of inter-American exhibitions stimulated contact among artists from different countries and an appreciation of one another's work. The inauguration of the São Paulo Biennials in 1951 was the capstone of a series of events that had been initiated with the opening in 1947 of the Assis Chateaubriand Art Museum in São Paulo. This was followed in 1948 by the establishment of the Modern Art Museum of that same city and in 1949 by the founding of the Modern Art Museum of Rio de Janeiro. The Biennial constituted the first significant forum at which the work of Latin American artists could be contrasted and compared on an international scale. The energy with which Brazilian artists shook off the outmoded avant-garde notions of the 1920s, evolving toward *tachiste* Abstract Expressionism or Neoconcretism furthered, moreover, the modernizing trend set in motion by the Madí group in Argentina in the 1940s.

Little by little artists of various countries took up the challenge of modernism. The manifesto of "The Dissidents," a Venezuelan group headed by Alejandro Otero, dates from 1950. A year later the Venezuelan architect Carlos Raúl Villanueva called upon a number of artists to decorate the new University City of Caracas. This was the first monumental ensemble of art and architecture conceived in Latin America. (Brasília, planned by the architects Lúcio Costa and Oscar Niemeyer, was proclaimed capital of Brazil in 1960 by President Kubitschek.) Villanueva enlisted the services of artists of international renown,

● ALEJANDRO OBREGON. *CATTLE DROWNING IN THE MAGDALENA RIVER.* 1955. OIL ON CANVAS, 158.6 X 126.1 CM. MUSEUM OF FINE ARTS, HOUSTON, TEXAS, U.S.A. PHOTOGRAPH FURNISHED BY THE MUSEUM OF FINE ARTS.

such as Calder (who designed the ceiling of the main auditorium, executed in 1952), Arp, Laurens, Pevsner, Léger, and Vasarely. They set a tone that was immediately recognized by the local artists who collaborated in the project: Manaure, Vigas, Barrios, Oramas, Lobo, González Bogen, Narváez, Otero, Valera, Soto *(p. 108)*, Poleo, Arroyo, Carreño, and Salazar.

The "Group of Eleven" appeared in Havana in 1953. The New Art Movement of Paraguay was launched in 1954. The Praxis group was formed in Nicaragua in 1963. The great centers—Buenos Aires, Rio, and São Paulo in the south, and Mexico City in the north—were no longer totally dominant in art novelties.

The United States recognized the significance of the activity to the south. At the 1956 Caribbean Exhibition in Houston, a Colombian, Alejandro Obregón *(pp. 82, 127)*, won first prize with his *Cattle Drowning in the Magdalena River*. The Pittsburgh International of 1958 was the first to invite a substantial number of Latin Americans to participate. On that occasion awards went to the Brazilians Mabe *(p.95)*, Piza, Grassmann, Di Prete, Lemos, and Maria Bonomi; to the Mexican José Luis Cuevas; to the Nicaraguan Armando Morales *(p. 117)*; and to the Guatemalan Rodolfo Abularach *(p.125)*. The 1959 "South American Art of Today" show held in Dallas, Texas, constituted something like a statement of principles by contemporary Latin American painters.

Most of the participants in these group shows were born between 1920 and 1925. In contrast with the preceding generation, they were decidedly open and international in outlook. They were no longer content with the the three traditional forms of expression: portraits, still lifes, and (largely urban) landscapes, discreetly updated with a few modern touches. Painting and sculpture advanced from the level of adaptation to that of invention. In order to understand this leap forward one must take into account not merely the work of the so-called pioneers but also that of a number of other artists who, though less well known, nonetheless contributed to the flowering that took place in the 1950s.[1] Thanks in part to them, artists born between 1920 and 1930 were able to defy the salons and reject the conservative criteria of the bourgeoisie. No longer content with passive storytelling, they gave standing to more indirect and symbolic modes of expression, advancing to the limits of art without specific meaning. The acceptance by timid and uninformed provincials of looser, more complex standards for judging art represented the real beginning of modernism in Latin America.

The outward expansion lasted 10 years and took a parabolic course. The culmination was reached in 1966 with the presentation in New Haven, Connecticut, of the show "Latin American Art since Independence." Organized by the critic Stanton L. Catlin, it was without doubt the most significant overview of Latin American art held to that date. Previously the first Kaiser Biennial had taken place in Córdoba, Argentina, in 1962, and in 1965 the critic Thomas Messer had organized another roundup, which he entitled "The Emergent Decade," aimed at bringing together the most brilliant leaders of the moment. In that same year Jean-Clarence Lambert, the director of Opus International, pre-

sented the first large-scale collective exhibit to be seen in Europe, "Latin American Art in Paris." Including abstractions, collages, and the many facets of kinetic art, it reflected the scene fairly correctly. Lam, Matta, Tamayo, and Alicia Penalba presided over a heterogeneous sampling which nonetheless succeeded in covering the developments of the '50s. In 1963 the Institute of Hispanic Culture presented in Madrid an exhibition entitled "Art of Spain and Latin America," with a full cast of artists. The only absentees were Szyszlo *(p. 94)* and José Luis Cuevas, who boycotted the exhibition in protest against the Franco dictatorship. A large number of the artists represented had been launched on the international stage during the 1950s by the Visual Arts Division of the General Secretariat of the Organization of American States (formerly known as the Pan American Union), headed by the critic José Gómez Sicre. In 1966, with his advice, a Latin American show drawn from private collections was organized for presentation at the University of Puerto Rico. It ran the full continental gamut, including Fernández Muro, Grilo *(p. 89)*, and Polesello *(p. 97)* from Argentina; Pacheco *(p. 92)* from Bolivia; Grassmann, Mabe, and Piza from Brazil; Botero *(pp.115, 126)* and Manzur from Colombia; Lam, Bermúdez, Peláez, and Portocarrero from Cuba; Poveda from Costa Rica; Matta from Chile; Tábara *(p. 93)* from Ecuador; Abularach from Guatemala; Cuevas from Mexico; Morales and Aróstegui from Nicaragua; and Julio Rosado del Valle from Puerto Rico.

The Latin American Exhibition of Drawing and Printmaking organized in 1967 by the Cultural Division of the Central University of Venezuela may be considered the last in a continuous round of group shows. On that occasion one could note a change in direction toward techniques more in accordance with concerns that had manifested themselves during the '60s: a preoccupation with quality and meaning; a well-conceived pride in belonging to communities distinct from those of Europe and the United States; and rejection of imitation of the models the latter provided.

The boom that took place from approximately 1950 to 1967 resulted not only from a new concept of the artistic phenomenon but also from political and economic changes that shook Latin America out of its age-old languor.

The change in concept was naturally related to events in Europe and the United States, where the three trends of the moment were Abstract Expressionism, to which Informalism may be linked; Neogeometry and kinetic art; and figurative painting of a symbolic character. The Latin American Abstract Expressionists were rather timid in taking up the challenge of U.S. Action Painting, which, as exemplified in the major works of Kline, Pollock, and Rothko, typified not merely an aesthetic principle but also a moral order. An artist such as the Peruvian Ricardo Grau had less difficulty in adjusting to the experience of the European *tachistes*, rooted primarily in an aesthetic hedonism that is clearly evident in the work of Mathieu. Informalism drew directly upon Spanish groups in Barcelona and Madrid, headed by Tapies and Millares. Certain situations resulted from circumstance: the convergence in Informalism that occurred in

Caracas at the beginning of the '60s could never have come about without the presence of the anthropologist José María Cruxent, nor could the Neoconcretist explosion have taken place in Brazil without the example of Max Bill's work. A single Latin American artist, the Argentine Kenneth Kemble (b. 1923) produced works of large dimensions, realizing that a radical change of scale was of fundamental importance for the new effort. It was only with the appearance of Noé, Macció, De la Vega *(p. 123)*, and Deira *(p. 122)* that one again encounters—once more in Argentina—compositions of large format, the aggressiveness of which derives more from the European group known as COBRA (*i.e., Co*penhagen-*Br*ussels-*A*msterdam) than from the New York School.

Neogeometry and kinetic art likewise have obvious roots in Europe. The Argentine Le Parc *(p. 101)* and the Venezuelan Soto worked there side by side with local artists. In 1960 Julio Le Parc (b. 1928), Horacio García Rossi (Argentine, b. 1929), and Francisco Sobrino (Argentine, b. 1932), joined the "Visual Art Research" group of F. Morellet, Joel Stein, and Yvaral. Their ranks were soon enlarged by other Argentines: Hugo Demarco (b. 1932), Marta Boto (b. 1925), Gregorio Vardánega (b. 1923), and Luis Tomasello (b. 1915). The Venezuelan Jesús Soto (b. 1923) worked at the level of Vasarely; later Carlos Cruz-Díez (Venezuelan, b. 1923) *(p. 109)* was active in the same area of optical research as Agam.

None of this effort represented a significant change in scale, or adoption of the monumental proportions favored by the U.S. Minimalists. U.S. sculptural tendencies were taken up and refined by two Colombians, Edgar Negret (b. 1920) and Eduardo Ramírez Villamizar (b. 1923) *(p. 113)*. It was a Mexican, Mathias Goeritz (born in Germany in 1915), who promoted Minimalist ideas in the mid '60s.

The connection with Europe remained lively and unbroken, but the teacher-pupil relationship of previous generations was no longer maintained. The new artists picked and chose from what Europe had to offer, with a view to different combinations. Some were purely formal, as in the case of the Neogeometrists and the kinetic artists. In the case of figurative artists, however, there was a substantial alteration of content. It was only natural that they should engage in revision of the European and U.S. repertory, with a view to recycling it in local terms. In the '50s and '60s, figurative painting was not just one more possibility open to the artist. There had been a profound renewal in that mode of expression. Instead of "applying makeup to reality," as painters, sculptors, and graphic artists had done previously, they now engaged in development of a broadly symbolic language and the creation of richly complex visual and interpretive codes.

It is important to recognize another important change that had come about. During these new decades there was no longer talk of nationalism: "indigenist" and "nativist" art was no longer in fashion. "Dependency" was the great subject of debate. The topic was first seriously addressed by sociologists and economists, and was then taken up by art critics, who by that time were no longer

moonlighting poets and prose-writers, but full-time professionals. The subject of dependency was closely linked with that of "identity." The search for the latter reached dramatic proportions following the Bandung Conference of 1955, at which the concept of the Third World was formulated. It began to be seen that the existence of a Latin American art with characteristics of its own was a real possibility, rather than empty rhetoric. Connections began to be established between existing works with a view to providing evidence that would substantiate this theory. Third World solidarity and the drive for cultural autonomy were favored by political events of the time. Four Latin American dictators fell in five years—the Argentine Perón in 1955, the Colombian Rojas Pinilla in 1957, the Venezuelan Pérez Jiménez in 1958, and the Cuban Batista in 1959. The political mobility of the period stimulated an important social change, astutely noted by the French historian Pierre Riado: the rise of the middle classes to political power. In the early years of the century only in Argentina and Uruguay had politics been the province of the bourgeoisie. In the continual military takeovers that characterized the period now under study, officers of middle-class origin tended to look out for the interests of the group from which they came, breaking the grip traditionally held by the oligarchies. In cases of somewhat different nature, such as the Peruvian revolution led by General Velasco Alvarado or the action taken by General Torres in Bolivia—not to speak of the militia takeovers resulting from armed revolution in Cuba and Nicaragua—the oligarchies were pushed aside and concentrations of political and economic power were dissolved. The middle classes supported the military to the extent that it favored their interests and repressed with iron hand all protest by the dispossessed majority, its university-student spokesmen, and the urban guerrillas that sprang up following the radicalization of Cuba. Characteristics of the middle classes that came to power varied from country to country, but one was shared by all: fear of social revolution. The military coups that took place from 1959 on met with acceptance in that they constituted a shield against that fear.

During the 1950s then, artists found their clientele in a newly expanded middle class, which battened on the ruin of the oligarchies. In the 1960s they confronted the dilemma of choosing between freedom and fear, between democracy and dictatorship.

Abstract Expressionism

In the mid '50s abstract tendencies in Latin America reflected less international fashion than the "persistent impulse" to engage in subjective expression of which the U.S. critic Dore Ashton wrote. Whereas in the United States Action Painting and the like were supported by powerful galleries and critics who kept careful watch over their artists' development, in Latin America abstraction tended to reflect a desire on the part of the artist to give free rein to emotions and sensations. Vacant spaces, color patches, and random brushstrokes were justified as

expressions of spiritual force. There is therefore a persistent poetic note in Latin American abstraction; it characterizes both individuals and groups.

The Argentine circle constituted in 1960 by Sarah Grilo (b. 1920), Miguel Ocampo (b. 1922), José Antonio Fernández Muro (born in Spain in 1920, active in Argentina from 1938 on), Clorindo Testa (b. 1923), and Kazuya Sakai (b. 1927) was pushed by enthusiastic reviews from the critic Jorge Romero Brest and supported by the Museum of Fine Arts. The artists had their individual characteristics: Grilo had her letters and graphic signs; Testa, his spotted spaces; Fernández Muro engaged in Informalist heraldry; Sakai manifested a geometric leaning later to be developed along frankly decorative lines. Nevertheless, all exhibited the same cultural sensitivity and a similar desire to enrich the painted surface by freeing it from "story-telling." However great the resemblance of Ocampo's large, calm forms to hills or bodies at rest, one can discern in his work, even as in that of his companions, a determination to replace literal meaning by gentle lyricism. Later arrivals on the Argentine scene showed more of a disposition to assert their individual personalities—Mario Pucciarelli (b. 1928), Víctor Chab (b. 1930) during his dark period, Alberto Greco (1931-65), and Josefina Miguens (b. 1932). The "impulse" was no longer expressed in lyric terms but manifested itself in forms that were at one and the same time ingenious and romantic.

At about the same time Mexico was producing Abstract Expressionists of strong but varying personality. Lilia Carrillo (b. 1930) took a poetic and confident approach to the painted surface; the work of Manuel Felguérez (b. 1928) *(p. 90)*, first characterized by graphic signs and flecks of great sensitivity, later evolved toward hard-edge abstraction; Vicente Rojo (born in Spain in 1932, came to Mexico in 1949) made use of color-signs and color-language to produce the most persuasive and coherent body of nonfigurative works in the country. The Russian Vlady (born in 1920, came to Mexico in 1942), Gilberto Aceves Navarro (b. 1931), Edmundo Aquino (b. 1939), Rodolfo Nieto (b. 1937), and Arnaldo Coen (b. 1940) gave the painted surface a value of its own. Pedro Coronel (b. 1923) was a pioneer in this area; his flat arabesques and daring textures linger unforgettably in the memory. Roberto Donis (b. 1934), whose spirit is akin to that of the U.S. painter Rothko, engaged in elliptical painting involving two color planes.

Central America provided good examples of Abstract Expressionism, the Panamanian Alfredo Sinclair (b. 1915) being a pioneer in the line. Although his fellow countrymen Guillermo Trujillo (b. 1927), Manuel Chong Neto (b. 1927), and Antonio Alvarado (b. 1938) never turned completely from figurative painting, they made free use of vaguely flecked backgrounds and loose brushstrokes, purposely designed to blur the clarity of the image.

Such indulgence in indefinite elements was not to be found in Guatemala, however. The abstract paintings done in the early '60s by Luis Díaz (b. 1939), Efraín Recinos (b. 1932), and Roberto Cabrera (b. 1939), go back to ancient native sources, as do the works of the Nicaraguan César Izquierdo (b. 1937). They are characterized by violence not exempt of romanticism and textures approach-

• **SARAH GRILO**. *MOTIF IN BLUES NO. 5.* 1955. OIL ON CANVAS, 65.7 X 81.5 CM. COLLECTION OF THE ART MUSEUM OF THE AMERICAS, OAS, WASHINGTON, D.C., U.S.A. PUR-CHASE FUND, 1957. PHOTOGRAPH BY WILLIE HEINZ.

ing relief. The work of Rodolfo Mishaan (b. 1924), on the other hand, shows clearly defined color planes and a magical shading altogether counter to the rigidities of Geometric Abstraction.

In Nicaragua, during the '60s Armando Morales (b. 1927) concentrated on slight shifts of irregular forms, making austere use of color. The powerful undercurrent of abstraction later surfaced in the work of Rolando Castellón (b. 1937), who sought gropingly for an interweaving of forms.

The creation, reconstruction, and interweaving of forms characterize painting in the Andean region, which also shows a strong pre-Hispanic influence. This we observe in the sectioned structures of María Luisa Pacheco (1919-1982), with their unexpected angles, and in the intricate compositions of Alfredo La Placa (b. 1929) and Alfredo Da Silva (b. 1936). In the work of their fellow Bolivians María Esther Ballivián (b. 1927) and Oscar Pantoja (b. 1925), on the other hand, we find a more flowing use of color and occasional ventures into chromatic improvisation. Pantoja's compositions tend to be centripetal, Ballivián's centrifugal.

It was the Ecuadorians who most persistently sought a return to pre-Hispanic origins, via abstraction. Faced by the aesthetic challenge of Oswaldo Guayasamín (b. 1919), Aníbal Villacís (b. 1927), Enrique Tábara (b. 1930), Oswaldo Viteri (b. 1931), Theo Constante (b. 1934), and Juan Camilo Egas

(b. 1935) produced in the late '50s "wall-art," complementing the wall textures of the Spanish Informalists—with whom Tábara had studied—by graphic signs, collages, arabesques, and objects of Ecuadorian folk art of obvious or implicit cultural significance. By incorporating the humble creations of present-day Indians into surfaces worked in relief, they brought about one of the great moments in Ecuadorian art.

The totem-like figures that impart an electric spark to the compositions of Fernando de Szyszlo (b. 1925) are of his own invention, but nonetheless evoke in elegiac tones the fate of the vanquished pre-Columbian Indians. Szyszlo had a decisive influence on the art of his native Peru in the 1960s as can be noted in the work of Venancio Shinki (b. 1932), Enrique Galdós Rivas (b. 1933), and Arturo Kubotta (b. 1932). He also influenced the Puerto Rican Luis Hernández Cruz (b. 1936).

Abstract Expressionism seemed well suited to artists of the Andean area. Chromatic atmosphere, which reached a maximum of expressiveness in the work of Rufino Tamayo and had taken its most dramatic form in the compositions of Szyszlo, was used with dazzlingly magic effect. Sensual in character, it does not lose materiality even when cosmic ideas are suggested. It bears no relation to the electric charge of the Chilean Matta's work. It is a special atmosphere, archaic and rooted in reality. Its effects were felt in Cuba, where it enriched the work of Raúl Milián (b. 1914), Rafael Soriano (b. 1920), and later Raúl Martínez (b. 1927) and Fayad Jamis (b. 1930), when they appeared on the Cuban art scene

● **TOMIE OHTAKE**. *UNTITLED*. 1968. OIL ON CANVAS. 138.5 X 113 CM. COLLECTION OF THE ART MUSEUM OF THE AMERICAS, OAS, WASHINGTON, D.C., U.S.A. GIFT OF THE ARTIST, 1988. PHOTOGRAPH BY ANGEL HURTADO.

in 1960. In Colombia, if it had a restraining effect on the lively, romantic imagination of Alejandro Obregón (1920-1992), it benefited Nirma Zárate (b. 1936) and María Teresa Negreiros (born in Brazil in 1930, active in Colombia from 1964 on).

Whereas in the regions of strong pre-Hispanic culture painting aimed at creation of emotion through evocation of the past, in Brazil the appeal was more to the senses. A number of artists of Japanese origin—Tomie Ohtake (b. 1913, arrived in Brazil in 1936) *(p. 91)*, Tikashi Fukushima (b. 1920, moved to Brazil in 1940), Manabu Mabe (b. 1924, came to Brazil in 1934), Kazuo Wakabayashi (b. 1931, came to Brazil in 1961)—were much in evidence at the Sixth São Paulo Biennial (1961). Rejecting Concretism, they made forceful use of color, freely applied in patches recalling Japanese calligraphy, of textured surfaces, or of strange, purposely irrational planes. The pioneer work of Iberê Camargo (b. 1914), with its violent explosions of color, comes close to that of the European COBRA movement, as does that of Flávio Shiro (b. 1928). The delicate but firm transgressions against geometric precept into which Mira Schendel (b. 1919) entered, along with the cosmic landscapes of Danilo di Prete (born in Italy in 1911, moved to Brazil in 1946), strengthened an antiabstract tendency that

• **MARIA LUISA PACHECO**. *COM-POSITION*. 1960. OIL ON CANVAS, 122 X 152 CM. COLLECTION OF THE ART MUSEUM OF THE AMERICAS, OAS, WASHINGTON, D.C., U.S.A. PURCHASE FUND, 1960. PHOTO-GRAPH BY ANGEL HURTADO.

received valuable support from the critic Mário Pedrosa. The sculptures of Nicolau Vlavianos (born in Greece in 1929, moved to Brazil in 1960) and Caciporé Torres (b. 1932) increased confidence in material, gesture, and emotion.

Abstraction in Brazil was largely a matter of poetic improvisation. In the case of the Mexican Luis López Loza (b. 1939), the Bolivian Hugo Rojas Lara (b. 1936), and the compositions which the Venezuelan Elsa Gramcko (b. 1925) painted toward the end of the 1950s, freedom was manifested in a loose relation-ship among fragments. Gramcko was later to lay her stress upon textures.

Abstraction in Venezuela led to Informalism, with the constitution in Caracas in 1960 of the strongest group to represent that trend in all of Latin America. Maruja Rolando (1923-1970), Oswaldo Vigas (b. 1926), Angel Hurtado (b. 1927) *(p. 96)*, Angel Luque (b. 1927), Teresa Casanova (b. 1928), and Manuel Espinoza (b. 1937), while sticking to their individual aims, engaged in common experimentation with collage, employing a variety of materials. It was in this period, for example, that Alejandro Otero (b. 1921) did his series of old letters on wood. Other facets of this activity are represented by the gesturalism of Francisco Hung (b. 1937), which later underwent spectacular development, the ever-anarchic brushwork of Luisa Richter (b. 1928), and the fierce counterimages of Régulo Pérez (b. 1929). The delicate graphics of Marieta Bermann (b. 1917) and the wire reticulations of "Gego" (Gertrude Goldschmidt,

• **ENRIQUE TABARA**. *SUPERSTITION*. 1963. OIL ON CANVAS, 130.5 X 130.5 CM. COLLECTION OF THE ART MUSEUM OF THE AMERICAS, OAS, WASHINGTON, D.C., U.S.A. PURCHASE FUND, 1964. PHOTOGRAPH BY ANGEL HURTADO.

born in Germany in 1912, in Venezuela from 1939 on) likewise profited from the freedom of technique and procedure permitted by the Venezuelan enthusiasm for Informalism.

Agustín Alamán (born in Spain in 1921, came to Uruguay in 1955), Jorge Damiani (b. 1931), and Giancarlo Puppo (born in Italy in 1938, came to Uruguay in 1957) engaged in experiments with materials and color that liberated Uruguayan art from the straightjacket of Torres-García's little rectangles, though the change was not radical. The product of the Cuban Agustín Fernández (b. 1928) lies on the border between nonfigurative art and painted textures. His world of blacks, grays, and earth tones—most unusual in Abstract Expressionism—verges on the erotic, although no image is ever clearly discernible. Like the previously mentioned painting of Fernández Muro and the reliefs of Rodolfo Krasno (Argentine, b. 1926), these endeavors foreshadowed the future appearance of objects-as-art and object-pictures, without however falling into the purposeful vulgarities of Pop Art.

Abstract Expressionism had many indirect repercussions. A number of important painters and sculptors availed themselves of its devices to free their work from the burden of meaning. One can note in this regard the freedom in brushwork and use of materials of Roser Bru (born in Spain in 1923, came to

• **FERNANDO DE SZYSZLO**. *HUA-NACAURI II*. 1964 ENCAUSTIC ON CANVAS, 158.4 X 129.5 CM. SOLOMON R. GUGGENHEIM MUSEUM, NEW YORK, U.S.A. GIFT OF THE NEUMANN FOUNDATION, CARACAS, VENEZUELA, 1966. PHOTOGRAPH BY DAVID HEALD FURNISHED BY THE SOLOMON R. GUGGENHEIM FOUNDATION, NEW YORK.

Chile in 1939), the flexibility with respect to form of the Cubans Hugo Consuegra (b. 1929) and José Bermúdez (b. 1922), the "anamorphoses" of Enrique Castro-Cid (Chilean, b. 1937), the "lands" of Ricardo Yrarrázabal (Chilean, b. 1931), the gesturalism of the "Phases" group in Argentina perceptible in compositions of Rogelio Polesello (b. 1939) and Marta Peluffo (b. 1931), the imaginary landscapes of the Venezuelans Hugo Baptista (b. 1935) and Mateo Manaure (b. 1926), and the objects included in masses of color by Cynthia Villet-Gardner (b. 1934) of Barbados.

At the same time, sculpture—which had stagnated in statues of heroes and other public monuments—managed an escape into the liberty won by nonfigurative painting. Argentina provided a leader in this line, Líbero Badii (b. 1916). It should also be remembered that late in their careers Noemí Gerstein (b. 1910) and Alicia Penalba (b. 1913) engaged in Expressionist sculpture of a nonfigurative type. María Juana Heras Velasco (Argentine, b. 1924) and Lía de Bermúdez (Venezuelan, b. 1923) executed sculptures free of figurative and geometric commitment, but they showed less energy than the Cubans Agustín Cárdenas (b. 1927) and Rolando López Dirube (b. 1928), the last mentioned distinguished for the variety and dynamism of his concepts of form in space. Frans Krajcberg (born in Poland in 1921, moved to Brazil in 1948), was a great pro-

• **MANABU MABE**. *AGONY*, DETAIL.
1963. OIL ON CANVAS, 189 X 189
CM. COLLECTION OF THE ART MU-
SEUM OF THE AMERICAS, OAS,
WASHINGTON, D.C., U.S.A. GIFT OF
FRANCISCO MATARAZZO SOBRI-
NHO, 1964. PHOTOGRAPH BY AN-
GEL HURTADO.

moter of experiments in space concepts. The Peruvian Alberto Guzmán (b. 1927) and the Venezuelan Pedro Briceño (b. 1931) operated on a calmer plane.

A highly original form of aesthetic expression developed in Latin America during the late '60s consisted of works woven of fiber, cord, wire, and other materials. Notable figures in this area are those of Olga de Amaral (Colombian, b. 1932) *(p. 98)*, the Brazilian Myra Landau (b. 1926), and the Mexicans Carmen Padín (b. 1930), and Marta Palau (b. 1930), as well as that many-sided artist Feliciano Béjar (b. 1920). Amaral worked in the best modern textile tradition, but her art achieved full realization when she turned to the humblest of materials, imparting to her work a strong telluric feeling. The Mexicans were bolder and more varied in their efforts, making use of beads, glass, plastics, and feathers.

Significant among the liberating effects that abstraction had on Latin American art were the variety—at times approaching chaos—and spontaneity of the works produced. In the United States abstraction drew upon the national romantic tradition to achieve an effect of well-orchestrated modernism, and it was soon devoured by the implacable demands of the market. Though the products can be grouped by affinities, Latin American Expressionism sprang up spontaneously everywhere. It cannot be viewed as a link in a chain, unlike the situation in Europe, where Monet's waterlilies and Matisse's "condensation of sensations" led inevitably to the painting of surfaces unrelated to images of reality.

It is true that Abstract Expressionism was imported into Latin America from abroad, but artists profited primarily from the freedom it brought to get away from salon painting and the need to reflect ambient reality. Gains are to be measured in terms of techniques, atmosphere, the strongly defended idea that a

• **ANGEL HURTADO**. *SIGN IN SPACE*. 1962. OIL ON CANVAS, 152 X 193 CM. COLLECTION OF THE ART MUSEUM OF THE AMERICAS, OAS, WASHINGTON, D.C., U.S.A. PURCHASE FUND, 1976. PHOTOGRAPH BY ANGEL HURTADO.

painting's value is independent of extraneous considerations, the introduction of imagination into sculpture, and a great rebirth of graphic art, to which attention will be given in the next chapter. Rarely did artists go to extremes. Scrap iron—an extreme in sculpture—found few enthusiasts. Among them were the Mexican Manuel Felguérez (b. 1928), who used it most notably in his murals for the Diana Theater in Mexico City; the Colombian Feliza Burztyn (1934-1982), who caused a great stir in her country with several series of works of strong impact, especially the one termed "hysterical," dating from the early '60s; and the Venezuelan Víctor Valera (b. 1927), who gave new value to metals, rust, and rivets in a huge sculptural project that he eventually abandoned in favor of kinetic art.

Viewed from the perspective of almost 30 years, Abstract Expressionism can be perceived as a shake-up of the existing order and a leap into the dark. Coming after the orderly avant-garde movement of the 1940s in Argentina and paralleling the Brazilian Concretism of the late 1950s, it represented a great gamble on Latin American art's ability to win a place of its own on the international stage. Proper account should be taken of its intensity and its underlying characteristics in establishing the difference between "reflected" modernism and "conditioned" modernism.

Neogeometry and Kinetic Art

While it was the Argentine Madí group, centered around the review *Arturo*, that in 1944 first experimented with geometric forms and Concrete art, the most important work in this area was done by Brazilians. Abraão Palatnik

• **ROGELIO POLESELLO**. *ORANGE ON MAGENTA*. 1961. OIL APPLIED ON CANVAS WITH AIRBRUSH, 139.7 X 161.8 CM. COLLECTION OF THE ART MUSEUM OF THE AMERICAS, OAS, WASHINGTON, D.C., U.S.A. PURCHASE FUND, 1961. PHOTO-GRAPH BY ANGEL HURTADO.

(b. 1928) was the real pioneer in the field with his "kine-chromatic apparatuses" of 1949. The "Rupture" movement led by Waldemar Cordeiro (1925-1973) and Luis Sacilotto (b. 1924) dates from 1952. The "Front" group, the leading members of which were Lygia Pape (b. 1929) and Décio Vieira (b. 1922), was active from 1953 to 1955. The modulated surfaces of Lygia Clark (b. 1920) were produced from 1956 to 1958. Amílcar de Castro (b. 1920) planned huge Minimalist sculptures in 1957, the same year that the Mexican Goeritz was working with large-scale simple forms. This manifold activity, which has as its background the spectacular flowering of modern Brazilian architecture in the '50s with the planning of Brasília by Lúcio Costa and Oscar Niemeyer, was given literary expression by the poet-critic Ferreira Gullar's 1959 "Neoconcrete Manifesto." "Neoconcretism," he said, "was born of the need to express the complex reality of modern man within the structural language of the new plastic art. It denies the validity of scientific and positivist attitudes in art. It restates the problem of expression, incorporating the new 'verbal' dimensions characteristic of neo-figurative Constructivist art.... We do not conceive of a work of art as a 'machine' or an 'object,' but as a *quasi-corpus*, in other words an entity whose reality is not confined to the external relations of its elements. It is an entity that can be discovered by analysis, but can be fully captured only by a direct, phenomenological approach." This manifesto is one of the most intelligent texts produced by

Latin American criticism in endeavoring to define the ontological differences that may exist between Latin American manifestations that are apparently similar to the works of Mondrian and European Concretism. In 1960, Hélio Oiticica (b. 1937), the youngest figure in Neoconcretism, proposed the idea of "penetrables." The 1958 Neoconcrete Ballet of Lygia Pape and her 1960 *Unity of the Planetary System* by no means exhausted the inventive spirit of the group. Dynamism and joyfulness characterize the work of Lygia Clark, being admirably expressed in her "animal" series. A constant revolutionary, right up to her *Cannibal Slime* of 1975, Clark spurred the large number of artists who practiced, or were influenced by, Neoconcretism to never-ending invention. Among the forerunners of Brazilian Neogeometry were Alfredo Volpi (born in Italy in 1896), whose famous pennants for street festivals anticipated the production of an art that, though disciplined, was constantly in motion. Inventive movement and discipline likewise marked the work of another pioneer, Franz Weissmann (born in Austria in 1914, moved to Brazil in 1924) as well as the compositions of Iván Serpa (1923-1973), the "polyvolumes" of Mary Vieira (b. 1927), and the paintings of Milton Dacosta (b. 1915). Though Dacosta was not an adept of Neoconcretism, he nonetheless benefited from its insistence on invention, as did—and with more seductive results—Carlos Scliar (b. 1920). The influence of the movement is also to be felt in the famous white sculptures of Sérgio de

• **EDUARDO MAC ENTYRE**. *SIX FORMS IN TWO CIRCUMFERENCES*. 1966. OIL AND COMPASSES ON CANVAS, 144.7 X 179.6 CM. COLLECTION OF THE ART MUSEUM OF THE AMERICAS, OAS, WASHINGTON, D.C., U.S.A. PURCHASE FUND, 1967. PHOTOGRAPH BY ANGEL HURTADO.

Camargo (b. 1930)*(p. 100)*, the forceful and highly original paintings of Tereza Brunet (b. 1928), and the works of Abelardo Zaluar (b. 1924). It can even be found to some extent in the works of Odetto Guersoni (b. 1924), which border on Op Art, and the articulated movement in great planes of the compositions of Arcângelo Ianelli (b. 1922). Neoconcretism, as developed both in São Paulo and Rio, created circumstances favorable to the endeavors of artists such as the sculptor Yutaka Toyota (born in Japan in 1931, moved to Brazil in 1958); Iván Freitas (b. 1932), with his light-and-movement compositions; Marília Kranz (b. 1937), whose work is of great importance; and Massuo Nakakubo (b. 1938), with his highly original hard-edge compositions. Even the work of Ione Saldanha (b. 1921), in the period in which she painted bands on bobbins and pieces of sugar cane, and the later atmospheric compositions of Lydia Okumura (b. 1948) evidence at one and the same time respect for geometric concepts and a playful will to break their bonds.

It is important to note that in all of these innovations—breaking the bounds of the frame, fusions of time and space, incorporations of movement, new uses of space, and energizing of surfaces—there was none of the cold rationality that marked the work of the Bauhaus artists in Germany or the Dutch movement known as De Stijl. Neoconcretism laid such a solid base for further exploration in the geometric area that it opened the way to the kinetic experiments of the 1970s. In 1972, no less than 92 artists working in light and movement exhibited at the first Elétrobras Salon.

Another positive feature of Brazilian Neoconcretism was its strongly national character. It developed along perceptibly different lines in São Paulo and Rio, but it never sought to impose itself elsewhere or to identify itself with European or

• **SERGIO DE CAMARGO**. *COLUMN*. 1967-1968. MARBLE, 141.5 X 28 X 22.8 CM. HIRSHHORN MUSEUM AND SCULPTURE GARDEN, SMITHSONIAN INSTITUTION, WASHINGTON, D.C., U.S.A. GIFT OF JOSEPH H. HIRSHHORN, 1972. PHOTOGRAPH FURNISHED BY THE HIRSHHORN MUSEUM AND SCULPTURE GARDEN.

U.S. developments. Neither artists nor critics gave any thought to a conflict between internationalism and localism. The critic Frederico Morais recalls that, upon the occasion of the International Exhibition of Concrete Art in 1960, its organizer, Max Bill, who emphasized the "end of the *tachiste* deluge," expressed "amazement at the intuitive character of the Brazilian Concrete compositions."

Quite the opposite was the case with the geometric and kinetic artists in Argentina. Two principal groups were formed in 1960. Although Julio Le Parc arrived in Paris in 1958, only two years later did he organize the Visual Art Research group, including the artists that have already been mentioned. In 1961 it had an exhibit at the Denise René Gallery, which, with the assistance of the critic Frank Popper, was to become the center for the promotion of kinetic art. Light theaters, bands of light and sound, and ingenious mechanisms and apparatuses of all sorts are typical of the first, best-known, and most significant phase in the ca-

● **JULIO LE PARC**. *INSTABILITY*. 1963. WOOD, PLASTIC, AND ALUMINUM, 79.6 X 79.6 X 9.8 CM. HIRSHHORN MUSEUM AND SCULPTURE GARDEN, SMITHSONIAN INSTITUTION, WASHINGTON, D.C., U.S.A. GIFT OF JOSEPH H. HIRSHHORN, 1966. PHOTOGRAPH FURNISHED BY THE HIRSHHORN MUSEUM AND SCULPTURE GARDEN.

reer of Le Parc, who, however, did not attain the level of pure invention reached by his compatriot Gyula Kosice (b. 1924). Like the rest of his group, he never went beyond a clever programming of effects of light and movement. All these artists were good, solid experimenters, more scientific than intuitive in their work; their compositions were worked out mechanically, rather than derived from sudden flashes of inspiration. The "chromoplastic atmospheres" that Tomasello turned out at the time relied on physical effects and the reflections of light from small cubes attached to white surfaces.

It was also in 1960 that the critic Ignacio Pirovano applied the name "Generative Art" to the work of a group originally led by Miguel Angel Vidal (b. 1928) *(p. 102)* and Eduardo Mac Entyre (b. 1929) *(p. 99)*, who were later joined by Ary Brizzi and Carlos Silva (both born in 1930). "In Generative Art," they said, "an optical sequence is produced by evolution of a given form, such as a circle, a square, or a step. By consecutive shifts of the form, either in the same direction or in opposite directions, a perfect generative development is produced." In light of their declarations and work, they can be linked to the Op Art movement. U.S. influence, and the simultaneous launching of Op Art and Pop Art during a period of great prosperity, when works of art were produced and distributed *en masse*, had a decided impact on Argentine Generative Art. 1960 was a crucial year for Argentina as regards developments in the geometric area. It was the year of the inauguration of the Plastic Arts Section of the Torcuato Di

• MIGUEL ANGEL VIDAL. *EQUILIB-RIUM.* 1975. ACRYLIC ON CANVAS, 100 X 100 CM. COLLECTION OF THE ART MUSEUM OF THE AMERICAS, OAS, WASHINGTON, D.C., U.S.A. PURCHASE FUND, 1975. PHOTO-GRAPH BY ANGEL HURTADO.

Tella Institute in Buenos Aires. The director, the critic Jorge Romero Brest, steered his country's art in the direction of technological advance and avant-garde experimentation to such good effect that Argentine Op Art and Pop Art all but parallel their U.S. models.

The geometric movement in Argentina—whether aimed at optical effects or expressed in hard-edge terms—had a numerous following. Notably faithful to geometric concepts was the sculptress María Simón (b. 1922); her "box-spaces" have complex "inside-outside" relationships. Juan Melé (b. 1923) with his diagonals and Mercedes Esteves (b. 1939) with her horizontals produced works of great semantic richness. Raquel Rabinovich (b. 1929) moved from highly lyrical geometric concepts to corridors and enclosures made up of transparent plates. Her work resembles that of Kásmer Féjer (born in Hungary in 1923, moved to Brazil in 1929). The sculptors Claudio Girola (b. 1923), Enio Iommi (b. 1926), Enrique Torroja (b. 1934), and Davite (b. 1911) produced freely geometric constructions or experimented with effects of movement and direct or reflected light. The success they achieved lent great prestige to efforts in such lines.

Note should next be taken of the brilliant generation of painters born between 1931 and 1939, in whose work the geometric tendency regained strength and balance. Its members were César Paternosto (b. 1931), Margarita Paksa (b. 1933), Eduardo Rodríguez (b. 1934), Armando Durante (b. 1934), Gabriel Messil (b. 1934), Antonio Trotta (b. 1937), Alicia Orlandi (b. 1937), Carlos Salatino (b. 1939), and the previously mentioned Mercedes Esteves (b. 1939). Accompanying it were the sculptors Alejandro Puente (b. 1933), Víctor Magariños

(b. 1934), and Rogelio Polesello (b. 1939), who alternated between work in two dimensions and work in three—the most significant career development of the 1960s. A place apart should be assigned to the work of Julián Althabe (1911-1975), a true forerunner of the purist inclination to simplification, and to Marcelo Bonevardi (b. 1929) *(p. 104)*. Bonevardi's compositions, like the sculpture in relief of the Uruguayan Gonzalo Fonseca (b. 1922), evidence a somewhat different approach, akin to Torres-García's Constructivism. He tended, however, toward the creation of objects that can stand on their own, albeit strongly impregnated with archaisms.

The prize awarded to Julio Le Parc (b. 1928) at the Venice Biennial in 1966 marked a high point of recognition for these geometric and kinetic artists, whose creative power was duly acknowledged by the critic Damián Bayón at the same time that he stressed the rational character of their work. On the occasion of the exhibition the Buenos Aires Museum of Fine Arts organized in 1964 under the name "Instability," he termed them "creative artists who make use in their work of geometric shapes, transparencies, and glitter, artists for whom new materials, capable of producing new effects, serve as vehicles of expression."[2] To all one might apply the famous words of the Mexican writer Alfonso Reyes: they made an entrance on the international stage, but, owing to the cultural pressures exerted by the milieu and the singular nature of their individual personalities, they found themselves in a state of "involuntary independence."

The work of geometric artists in the rational-decorative line was unfailingly marked by perfection of craftsmanship, a virtue required by their visual mode of expression. Once Mathias Goeritz (b. 1915) had stirred the Mexican milieu to life in the 1950s, Mexican geometric art developed similar characteristics. The Satellite City Towers that Goeritz planned in conjunction with the architect Luis Barragán date from 1957 and 1958. They marked the first step in the propagation of geometric art "after long decades of figurative and subjective trends," as the Peruvian critic Juan Acha recognizes. It is true that the pioneer work of Carlos Mérida had set a standard for Mexican art in his period, but it had no repercussion, probably because of its "chamber work" quality, whereas Goeritz's public activity and his early adherence to Minimalism were to have a decisive influence on younger generations. The publication in 1977 by the National University of Mexico of *El geometrismo mexicano*, written by Jorge Alberto Manrique, Ida Rodríguez Prampolini, Juan Acha, Xavier Moyssén, and Teresa del Conde, gives clear evidence of the official recognition the movement had attained.

From the time of his arrival in Mexico in 1949, Goeritz engaged in a didactic effort, introducing industrial design into the country as the basis of visual education. In 1953 he produced a work he called the *El Eco Experimental Museum*, a dramatic piece of architecture featuring a metal serpent four and a half meters high. It was with the Satellite City Towers, however, that his driving force came to be fully recognized. Varying between 37 and 57 meters in height, the five triangular-based towers, painted white, red, and yellow at the time of their con-

• **MARCELO BONEVARDI**. *TRAP*. 1975. CONSTRUCTION OF DIVERSE MATERIALS, 66 X 55.9 CM. PHOTO-GRAPH FURNISHED AND REPRO-DUCTION AUTHORIZED BY MARY-ANNE MARTIN/FINE ART, NEW YORK, U.S.A.

struction, established a scale that was adopted by the architect Fernando González Cortázar in *The Great Gate* (1969) and other similarly monumental ensembles. Nevertheless, in the chronological development of the geometric movement, Mexico was 20 years behind the times. Only the work of Helen Escobedo (b. 1936) was destined to be of influence. One of her most representative sculptures, *Gates in the Wind*, dates from 1968, as does *Monument 18* of Jorge Dubón (b. 1936). Juan Luis Díaz (b. 1939), who executed a huge sculpture for **INFONAVIT** in 1972, can be considered in the context of this chapter, though his work belongs more to the 1970s than to the preceding decade. The chronological dislocation of the Mexican geometric movement can be attributed to the persistence of Muralist and Surrealist tendencies. During the 1950s the only dissidence admitted was a lyrically inclined Abstract Expressionism and an Expressionist type of figurative painting which was considered to derive from Orozco.

In reality the number of artists was relatively small. This may be explained by the fact that the demands of the middle class were satisfied by the

work of the Muralists. Modern art in Mexico had to make its way between a visible indifference for anything unlike Rufino Tamayo and the overwhelming respect for traditional forms evidenced by official entities such as the Museum of Modern Art, the National Institute of Fine Arts, and the Institute for Aesthetic Research. Just as in politics, continuity rather than break has been the characteristic of Mexican art. Even the work of Cuevas, which constitutes the extreme in rebellion, derives from the admirable drawings of Orozco. The generation represented by Felguérez, Carrillo, and Von Gunten lived "climatically" in the shade of Tamayo. It is possible that if Mathias Goeritz had never come to Mexico, the Mexican geometric movement would never have undergone the development it knew in the '70s, to be examined in the next chapter.

Gunther Gerzso (b. 1915) *(p. 106)* brought no new technique or method to Mexico, merely a personal vision of the world; there was no reason for him to exert a transforming influence on the country's art. (An echo of his systems of disguise and his handling of spaces and planes can be perceived only at the end of the '70s, in the work of the Salvadoran painter Roberto Galicia.) The originality of his treatment of the painted surface, which vacillates between severity and the poetic vision of spaces filtered through planes, is markedly effective in *Papantla Landscape* (1955) and *Lab-na* (1959). When the critic Luis Cardoza y Aragón said of his painting that "it represents nothing, but still conveys meaning," he made clear the difficulties of reading this subtle work. Direct narration, which prevailed in the work of the Muralists, is discarded; symbolic suggestion is fostered. Far re-

• **GUNTHER GERZSO.** *SOUTHERN QUEEN.* 1963. OIL ON MASONITE, 46.7 X 61 CM. PHOTOGRAPH FURNISHED AND REPRODUCTION AUTHORIZED BY MARY-ANNE MARTIN/ FINE ART, NEW YORK, U.S.A.

moved from Gerzso, whose work is characterized by calm control and attention to minute detail, a much younger artist, Fernando García Ponce (b. 1933), was the only Mexican painter to view the relationship between color patch, plane, texture, and space as an emotional conflict, often expressed in violent terms.

Resemblances between Argentina and Venezuela tend to be superficial, though once again we find cases of "involuntary independence." Artists of both countries enthusiastically identified themselves with Paris and European tendencies. In Venezuela the leaders of the international trend were the painter Aimée Battistini (b. 1916) and the critic J.M. Guillén Pérez. In his *Historia de la pintura en Venezuela,* the critic Alfredo Boulton writes: "The new freedom with regard to materials used and work created was brought to Venezuela by a number of artists who had attended Monsanto's classes and who found themselves in Paris from 1945 on. In 1950 they constituted the group known as 'The Dissidents.' This group was the first to make use of heterogeneous material—such as Rubén Núñez's wires—and drew upon abstraction to create forms and to pose visual and structural problems, at times of great linear formality. They took as their guide the stylistic concepts of the outstanding representatives of those tendencies, who lived in France."[3] The points brought out by Boulton constituted the principal characteristics of the group: experimentation with form and materials, and assimilation to international trends in kinetic art. From 1955 to 1960 Alejandro Otero (b. 1921) painted 75 "color-rhythms," to which special feeling was imparted by the subtle interplay of colored stripes. A like effect was produced by

Jesús Soto (b. 1923) in his "double sculptures": wire shapes in the foreground stand out against a striped background. The optical illusions thus achieved surpassed in inventiveness similar efforts made at the same time by the Hungarian Vasarely, and a little later by the Israeli Agam. In the late '60s Carlos Cruz-Díez (b. 1923) produced other types of optical illusions, which he called "chromoscopes," "chromo-kinetic environments," and the like. These and the "holokinetic" works of Rubén Núñez (b. 1930) parallel scientific research in the area of optics.

It was in Paris that the artists met and identified problems, though their works may have been executed elsewhere. To the names already mentioned should be added those of Carlos González Bogen (b. 1920); Mateo Manaure (b. 1926), active in the geometric line in the late '50s; and the sculptors Víctor Valera (b. 1927) and Omar Carreño (b. 1927). Among the less derivative, more personal experiments with rhythm produced in the '50s should be mentioned Víctor Valera's series of small circles, the interconnecting planes of Luis Guevara Moreno (b. 1926), and the Duco-on-wood compositions of Ramón Vázquez Brito (b. 1927) with their interrupted horizontals. The first works in the kinetic line produced by Juvenal Ravelo (b. 1931) date from 1965. In the 1950s the painting of Mercedes Pardo (b. 1922) resembled that of the Argentine Sarah Grilo. The work of both in turn showed similarities to the freely structured compositions of the Frenchmen Estève and De Staël. In the late '60s, however, Pardo's work exhibited new inspiration and exceptional breadth, as she treated color zones in the hard-edge manner. Otero and Soto also underwent a healthy evolution toward large-scale public sculpture, with the former's *Solar Deltas* and the latter's "penetrables." These constituted not merely novel visual experiences but also provided a new type of relationship between the artist and his public.

The work of foreigners residing in Caracas served decidedly to strengthen geometric and kinetic tendencies. Mention has already been made of Gego and Marcel Floris (b. 1914). Other names are those of Gerd Leufert (b. 1914 in Lithuania, came to Venezuela in 1959) *(p. 110)*, Nedo (born in Italy in 1926, moved to Venezuela in 1950), and Paul Klose (born in Denmark in 1914, moved to Venezuela in 1955). Leufert won the National Prize for Painting in 1965, after producing hard-edge works of great perfection and educating the eye of the Venezuelan public by patient labor in the area of graphics. Gego alternated between almost mathematical precision and spontaneity in her wire compositions. Nedo executed relief-painting in white, with textural additions of a linear type. Floris came late to geometric composition, in the mid '60s, but thereafter created highly expressive works of an elliptical nature. The dean of this group was Narciso Debourg (b. 1925), who began his constructive experiments in Paris in 1951 and has continued them to the present.

The flowering of kinetic art in Venezuela was directly related to the emergence of a powerful middle class, vastly enriched by the oil economy. The demand of this class was for symbols of development and high technology—its expectations of the future. Kinetic art was supported on the one hand by this new

• **JESUS SOTO**. *HURTADO SCRIPTURE*. 1975. WOOD, PAINT, WIRE, AND NYLON, 102.8 X 171.7 X 46 CM. COLLECTION OF THE ART MUSEUM OF THE AMERICAS, OAS, WASHINGTON, D.C., U.S.A. PURCHASE FUND, 1975. PHOTOGRAPH BY ANGEL HURTADO.

class and on the other by the state, which held a similar vision of a modern country on the go. In the '50s and '60s kinetic art played the same role in Venezuela that Mural art had played in Mexico in the '20s and '30s: it was the aesthetic image of the country that the ruling classes wished to impart.

The geometric trend of the '50s offered a means of identification with an international movement that neutralized local influences and eliminated the possibility of conveying messages other than those of a visual character. It was natural that it should find its greatest development in "open-door" countries, receptive to currents from abroad, primarily Argentina and Brazil, and to a smaller degree in the less populous countries of Uruguay and Chile. Although artists in other countries were attracted by the possibilities of geometric art and felt the desire to identify with international trends, in "closed-door" areas in which tradition counts for much, such as the Andean region, the Caribbean, and Mexico, they never constituted a dominant group.

In Uruguay and Chile the geometric trend was just one of a number of possible artistic choices. In Uruguay emphasis on structure was stimulated by the experiments of the Workshop founded by Torres-García in the preceding decade. One of the Neogeometric leaders was Manuel Espínola Gómez (b. 1921).

• **CARLOS CRUZ-DIEZ**. *PHYSIO-CHROME NO. 965*. 1978. MIXED TECHNIQUE, 100 X 150 CM. COLLECTION OF THE ART MUSEUM OF THE AMERICAS, OAS, WASHINGTON, D.C., U.S.A. PURCHASE FUND, 1978. PHOTOGRAPH BY WILLIE HEINZ.

In 1949 he organized a group named for the painter Carlos F. Sáez, who had lived from 1878 to 1901. The group included Juan Ventayol (b.1915); Washington Barcala (b. 1920), whose work straddles Abstract Expressionism and Neogeometry; and the printmaker Luis A. Solari (b. 1918). Their work evidenced a broad range of escape from Torres-García's quadrangles, though Augusto Torres (b. 1913) in his painting of the 1950s, Lincoln Presno (b. 1917), and Américo Spósito (b. 1924) long kept the master's teachings alive. In 1956 the Uruguayan Concretists, whose movement had been founded in Montevideo the year before, were represented at the Museum of Modern Art in São Paulo by works of María Freire (b. 1919) and José Pedro Costigliolo (b. 1902). Neogeometry was revitalized by the work of Nelson Ramos (b. 1932). At the Kaiser Biennial held in Córdoba, Argentina, in 1960, his tridimensional geometric objects showed him to be the artist most closely in tune with international trends. Another figure of rank was the painter Miguel Battegazzore (b. 1931), who showed himself familiar with the optical experiments in vogue abroad. Enrique Medina Ramela (b. 1935) and Freddy Sorribas (b. 1938) found a firm basis for expression in Neogeometry. So did Yamandú Aldama, who, like Nelson Ramos, belonged to the "Talent" group. With his refined works, defined in great blocks, the sculptor Alfredo Halegua (b. 1930) made a strong contribution to Neogeometry.

The critic José Pedro Argul notes that the "Nineteen Artists of Today" show in 1955 represented a "strong stand for modernism." It was on this occasion that a number of the artists just mentioned made their debut and defended their work in public, breaking with the Torres-García tradition. The renewal in

• **GERD LEUFERT**. *TIRIMA*. 1966.
ACRYLIC ON CANVAS, 250.2 X 149.5
CM. COLLECTION OF THE MUSEUM
OF ART, RHODE ISLAND SCHOOL OF
DESIGN, U.S.A. NANCY SALES DAY
FUND FOR MODERN LATIN AMERI-
CAN ART. PHOTOGRAPH BY CATHY
CARVER FURNISHED BY THE MUSEUM
OF ART, RHODE ISLAND SCHOOL OF
DESIGN.

Uruguayan art was favored by the rise of the Blanco party to power in 1958. This made the country more receptive to ideas from abroad. Healthy confrontations at the national level during the '60s were provoked by certain salons that gave rise to discussion and polemics—the one organized in 1960 by the critic María Luis Torrens for the Center for Arts and Letters sponsored by the newspaper *El País*, and the General Electric Salon presented in Montevideo in 1964. However, the subsequent economic crisis and the political polarization of the country brought about by the establishment of the National Labor Confederation and—after 1962—the activities of the Tupamaro guerrillas led to a gradual fall-off in artistic creation during the latter part of the decade.

In Chile modernization of painting and sculpture coincided with the free rein given to capitalism by the Alessandri regime in 1958, as a result of which the country was swept by an illusion of energy and dynamism. The group known as "Rectangle" was formed in Santiago in 1955 and presented three shows between

• **GEGO** (GERTRUDE GOLD-SCHMIDT). *ENVIRONMENTAL AERIAL STRUCTURES.* 1972. IRON AND NYLON ROPE, 18 X 17.5 X 22 M. OUTDOOR INSTALLATION, SOFÍA IMBER MUSEUM OF CONTEMPORARY ART, CARACAS, VENEZUELA. PHOTOGRAPH FURNISHED BY MACCSI.

that date and 1962, when the first international "Form and Space" exhibition took place. In it Argentines and Uruguayans participated, as well as local artists of geometric persuasion.

Ramón Vergara Grez (b. 1923), Miguel Cosgrove, Francisco Pérez, Robinson Mora, Claudio Román, Elsa Bolívar, and Carmen Piemonte (born in 1932, she did not join the group till 1969) were the principal practitioners of a type of Neogeometric painting marked by precision and discipline. Vergara Grez, the leader of the movement, explained that "confronted by the inconsistencies of mood and dramatic anecdote, artists rebelled against fleeting sensations... They conceived of plastic-functional structures that would symbolize their own essence." He went on to assert that the group's Neogeometric art, based on relations between forms, was nonetheless subjective: "The relation between the forms we conceived and between those forms and plastic space is affective." He makes this statement despite the fact that the group contained painters whose work was oriented toward optical effects, such as Matilde Pérez (b. 1920).

Emilio Hermansen (b. 1917) was a true pioneer in this line, producing rigidly geometric astral images. The contribution of sculpture was by no means inconsiderable. The great structures of Marta Colvin (b. 1917), with their junctures and openings, are not far from the monumental concepts of pre-Hispanic archi-

tecture. For her part, Lily Garafulic (b. 1914) imparted a value all her own to nonfigurative forms.

In Ecuador, Peru, and Colombia, the fate of Neogeometry was linked to the understanding individual artists had of form. In Ecuador it was Manuel Rendón (1894-1980) and Araceli Gilbert (b. 1914) who first broke with local tradition and its strong attachment to "indigenist" realism. In 1944 Araceli encountered the shock of nonfigurative art at Amédée Ozenfant's studio in New York. His stay there awakened an interest in planes and the interrelation of forms, and thereafter he engaged in Neogeometric painting marked by strong conviction. These concepts were not taken up again until the generation born in the 1930s came on the scene: Luis Molinari (b. 1929), Estuardo Maldonado (b. 1930), and Mauricio Bueno (b. 1939) had some difficulty finding room for serialist works or ones aimed at optical effect in an environment that was dominated by Abstract Expressionism. The same feeling of alienation with respect to the milieu—easily understood in the case of one characterized by strong pre-Hispanic influence—can be noted in the kinetic and cybernetic works of the Bolivian Rudy Ayoroa (b. 1927), in the painting of his compatriot Walter Terrazas (b. 1928), and in the three-dimensional compositions of the Paraguayans Laura Márquez (b. 1929) and Carlos Colombino (b. 1937) dating from the late 1960s. It can also be felt in the painting of the Peruvians Ciro Palacios (b. 1943), Gastón Garreaud (b. 1934), Carlos Dávila (b. 1935), Jaime Dávila (b. 1937), and Milner Cajahuaringa (b.1932), who were perfectly integrated into the Neogeometric international.

The Peruvian Jorge Eielson (b. 1923), however, adopted quipus (pre-Hispanic knotted cords) as a means of modern visual expression, and created works to which they lend significant weight. Their value derives not from the mere presence of the quipus but from the capacity Eielson showed for reviving a lost form and assigning it a place in Neogeometry.

Renewal also characterized the extraordinary work of Lika Mutal (born in The Netherlands, came to Peru in 1968). Mutal's monumental sculpture, with its great blocks of heavy materials, belongs to the '70s, however, as do the reliefs intelligently executed in local woods by the Puerto Rican Luis Hernández Cruz, already mentioned in connection with the Abstract Expressionism deriving from the work of Tamayo and Szyszlo at the end of the '50s.

Three Central American artists produced important works during their Neogeometric phases: Constancia Calderón (Panamanian, b. 1937), Margot Fanjul (Guatemalan, b. 1931), and Luis Díaz (Guatemalan, b. 1939). Their positions with respect to the trend have varied greatly. Constancia Calderón, an award winner at the Central American competition held in El Salvador in 1967, has always exhibited a tendency to escape from the rigidity of Neogeometry by affective disadjustments in structure, similar to those in the work of her compatriot Manuel Adán Velázquez (b. 1934). After experimenting with several avant-garde extremes, in the 1960s Margot Fanjul settled down to sculpture and painting, the former marked by precise, well-articulated forms, the latter by lozenges of color suggestive of those to be found in the embroidered shifts worn by Guate-

malan women. Luis Díaz was another experimenter, showing great talent in his handling of figurative, Neogeometric, and Conceptual compositions. Víctor Vaskestler (Guatemalan, b. 1927) preceded the others in showing an interest in self-sufficient Neogeometric work, to take the place of traditional figurative compositions.

In Colombia, too, the Neogeometric tendency constituted an exception, but in the late '50s and during the '60s it was cultivated by such strong personalities as to represent a viable alternative to the figurative efforts of the majority. In 1953 the sculptor Edgard Negret (b. 1920) presented a group of "Thirteen Recent Sculptures," which, despite their figurative associations, already evidenced the talent for simplification and confidence in the use of sheet metal that were thereafter to constitute the basis of his art. At the Modern Art Salon sponsored by the Bank of the Republic in 1957, Eduardo Ramírez Villamizar (b. 1923) exhibited solemn, impeccably executed works characterized by a precise balance between color planes and inner variations in form. At the same salon Negret presented a project for a public sculpture, *Column in Commemoration of the Massacre*, in which for the first time he evidenced interest in work for the urban setting. Compositions by both artists were later set up in public in Bogotá.

There was only one forerunner of Neogeometric painting in Colombia: Marco Ospina (1912-1983). Only in the generation born around 1930, represented by Omar Rayo (b. 1928), David Manzur (b. 1929), and Carlos Rojas (b. 1933), does one again find a taste for combinations and syntheses of sharply defined forms. Rayo took optical experimentation as his province and has contin-

• **EDUARDO RAMIREZ VILLAMIZAR**. *MECHANICAL COMPOSITION*. 1957. OIL ON CANVAS, 100 X 200 CM. COLLECTION OF THE ART MUSEUM OF THE AMERICAS, OAS, WASHINGTON, D.C., U.S.A. PURCHASE FUND, 1959. PHOTOGRAPH BY ANGEL HURTADO.

ued in that line to this day. David Manzur's Neogeometric work has suffered interruptions of a poetic nature. As for Carlos Rojas, at the end of the '60s he engaged in sculpture in the Minimalist vein, but in the following decade he shifted to painting marked by horizontal bands of color suggestive of Andean textiles. Fanny Sanín (b. 1938) *(p. 105)* first practiced a discreet form of Abstract Expressionism; only in the 1970s did she turn to painting simply structured chromatic variations, based on relationships between verticals and horizontals, which are nonetheless rich in effect.

One may note as a sort of appendix to painting in this line the work of a group of tapestry designers. Two were Brazilian: Jacques Douchez (b. 1924) and Norberto Nicola (b. 1930). For a long period of years they engaged in highly inventive geometric design, producing tapestries of excellent quality that hold a place of distinction in Brazilian Concretism. The Colombian Marlene Hoffmann (b. 1934) first exhibited her tapestries, in which geometric planes are combined to powerful effect, in 1963 at the Museum of Modern Art in Bogotá. The tapestries of geometric design presented in 1971 by the Costa Rican Lola Fernández (b. 1926) are superior to her usual Abstract Expressionist compositions.

From the overall Latin American viewpoint, Neogeometry was closely linked to the problem of dependency on outside influences. Optical and kinetic experiments represented a deliberate effort to escape from the Latin American milieu. The sole exception was constituted by Brazilian Concretism, which sought to make a "carnal" appeal to its public. Whatever the attitude, however, the tendency was to identify modernity with international tendencies in art. Toward the end of the 1960s, however, in the worldwide aspiration to new life styles, the pendulum swung in the other direction and emphasis was laid on the *region* as the environment best suited to invention and creative activity. Neogeometry constituted as it were an island of calm in the stormy seas of those days.

Symbolic Figuration

"The real avant-garde is to be found in realism," Fernando Botero declared in 1958, when his *Tribute to Mantegna* won the National Prize for Painting in Colombia. The same view might have been expressed by any one of 150 Latin American painters, sculptors, and graphic artists who viewed with mistrust the advances of the European and U.S. avant-gardes. In 1954 the English critic Lawrence Alloway launched the term "Pop Art," the characteristics of which were enumerated by the painter Hamilton, who went on to prepare the environmental composition he called *$11a ($he)*. In 1957 the Frenchman Yves Klein presented his "blue anthropometries." A year later the U.S. artist Allan Kaprow came out with "happenings," such as *An Apple Shrine*. Divided into six parts, it ran for 18 hours, participation by the public being one of its essential elements. From 1961 to 1964 the Leo Castelli Gallery in New York actively promoted Pop works, such as Oldenburg's *The Street* and Andy Warhol's *Dick Tracy* series. Declarations

• **FERNANDO BOTERO**. *CAMERA DEGLI SPOSI: TRIBUTE TO MANTEGNA II.* 1961. OIL ON CANVAS, 231.7 X 259.8 CM. HIRSHHORN MUSEUM AND SCULPTURE GARDEN, SMITHSONIAN INSTITUTION, WASHINGTON, D.C., U.S.A. GIFT OF JOSEPH H. HIRSHHORN, 1966. PHOTOGRAPH BY JOHN TENNANT FURNISHED BY THE HIRSHHORN MUSEUM AND SCULPTURE GARDEN.

by Pop artists were published in *Time* and *Life*. The road to consumer-product art let to the "Prospect" exhibition presented in Düsseldorf toward the end of the '60s. The Franco-Swiss Jean Tinguely invented a painting machine; the Italian Piero Manzoni exhibited packaged excrement; while Martha Jackson presented in New York "New Media - New Forms," anti-museum art offered in opposition to, and contradiction of, the art establishment. Paradoxically all this invaded the establishment institutions—galleries, museums, and cultural centers.

It was not a question of artistic renewal or of a break with precedent, within a logical process of change. It was simple out-and-out rejection, an accelerated pursuit of anything that constituted novelty. No longer did artists make pictures to hang on the wall. In the words of the critic Michel Ragon, they had become as much of an anomaly as the art of Sumer. The next step was represented by the "artist without art," defined—or rather un-defined—in the '60s as the post-artistic artist. The U.S. critic Harold Rosenberg was alone in having a clear vision of the situation. According to him, despite the great illusions engendered by new forms of creation, the individual arts, however conditioned they might be by the pressures of cultural change or the example of particular artists, had never been so indispensable as then to both individuals and society. With their accumulation of vision, their discipline, and their inner conflicts, Rosenberg said, painting or poetry or music provide a medium—perhaps the only one—for active individual self-development.

• **ANTONIO SEGUI**. *LA-LA FELIZA MARU.* 1963. OIL ON WOOD, 83.5 X 68.9 CM. COLLECTION OF THE HIRSHHORN MUSEUM AND SCULPTURE GARDEN, SMITHSONIAN INSTITUTION, WASHINGTON, D.C., U.S.A. GIFT OF JOSEPH H. HIRSHHORN, 1966. PHOTOGRAPH BY LEE STALSWORTH FURNISHED BY THE HIRSHHORN MUSEUM AND SCULPTURE GARDEN.

Faith in art as an integral system activated through contemplation, deteriorated to such an extent that it was thought antiquated and dangerous to give voice to it. Critics joined artists in the same race, and artists fell into the trap laid for them by the media. The aesthetics of obsolescence consumed their works and their performances.

Latin American figurative artists active in the 1950s weathered the world situation well. That situation became known to the public to the extent that art— or whatever replaced it—became the object of commentary by the media. Shock art, the "art of nothingness," the "art of obscenity," and the bloody rites of which there were a number of victims came to be considered news items. The transformation of art as a system into a mechanism for public exhibition resulted from a wave (not merely French but worldwide) that reached its greatest height in May 1968, amid illusions that it was possible to achieve a radically different world in which the artist born of middle-class revolution would simply disappear. With the failure of efforts toward radical change, expressions of rebellion were

• **ARMANDO MORALES**. *WOMAN ABOUT TO RETURN*. 1972. OIL ON CANVAS, 102 X 81 CM. COLLECTION OF THE ART MUSEUM OF THE AMERICAS, OAS, WASHINGTON, D.C., U.S.A. PURCHASE FUND, 1972. PHOTOGRAPH BY ANGEL HURTADO.

quickly absorbed by museums, galleries, and specialized reviews. In Latin America, as we shall see in the last chapter, the illusions of 1968 were dissipated in restatements and redefinitions of traditional forms. Extreme positions were viewed from a distance, and only late and to a limited degree—and hence paradoxically—did artists partake of them. In the course of the '50s, however, the furious revolt against tradition served as a stimulus to figurative artists in efforts to preserve imagery. Realism did indeed constitute the avant-garde, and it manifested itself in many forms. For the sake of guidance, it can be classified as fantastic realism, synthetic realism, expressionistic realism, and hyperrealism. The objects favored by Pop Art resemble, but do not really fall into, the last category, being foreign to its intent.

It would be unjust to view the attachment to traditional media that had been abandoned in world art capitals as failure to participate in the cultural

● **BENJAMIN CAÑAS**. *KAFKA: LET-
TERS TO MILENA*. 1976. OIL ON
WOOD PANEL, 61 X 61 CM. COL-
LECTION OF THE ART MUSEUM OF
THE AMERICAS, OAS, WASHINGTON,
D.C., U.S.A. PURCHASE FUND, 1976.
PHOTOGRAPH BY ANGEL HURTADO.

scene. Latin American artists practiced realism during this period as a matter of
choice. They were fully conscious of their opposition to the avant-garde in vogue
abroad. While they made no specific statements to this effect, and had few critics
on their side (Marta Traba, with her theory of "the culture of resistance"; Aracy
Amaral, with his theory of "a continent under cultural occupation"), artists felt,
and responded to, the need for maintaining continuity with what had gone be-
fore. Their behavior constituted recognition that art was in a state of transition
and that it must of necessity undergo change, but that, at the same time, it could
not afford to lose contact with the public (*i.e.*, society) which is not to be ignored.
Thanks to this behavior on their part, there was no alienation between artists and
the public, such as occurred in the United States and in Europe, where the vari-
ous manifestations of nonart were rejected by the public at large, becoming no
more than spectacles for a handful of the initiate. Promoted by the media, artists
became celebrities; interest was transferred from their work to their personalities.
(Andy Warhol is a case in point.) The like did not occur in Latin America, since
it lacked the requisite promotional network.

By their moderation, Latin American artists ensured that the new lan-
guage of art, reflective of local cultural manifestations, existing political and eco-
nomic conditions, and differing ways of life, would remain comprehensible to the

• **MARISOL ESCOBAR**. *THE MER-CHANTS*. 1965. WOOD AND OTHER MATERIALS, 185 X 119.3 X 184.7 CM. COLLECTION OF THE SOFÍA IMBER MUSEUM OF CONTEMPORARY ART, CARACAS, VENEZUELA. PHOTO-GRAPH COURTESY OF MACCSI.

community. During this figurative period emphasis was laid on meaning and professionalism. The attempt was made to enhance the value and complexity of meaning, whereas in European and U.S. nonart meaning was neglected or utterly forgotten. The renewed interest in professional skill favored training in drawing and engraving, which were to flower and come into renown in the subsequent period.

In the event the avant-garde's endeavors to reintroduce art into life by extreme measures proved vain. Latin American artists sought to achieve the goal by emphasizing a symbolic language comprehensible to the public. If such a language, rich in semantic values, could achieve common currency, then art could once again be identified with life, serving the people's need for artistic creation at the professional level, higher than that of folk art.

The Mexican critic Ida Rodríguez Prampolini rightly holds that, beginning with Surrealism, irreality has gained such ground that every formal device that departs from literal representation tends to engender it. The fact that both artists and public seek for, and accord recognition to, irreality necessarily implies that they find it appealing. It provides nourishment for dreams and myths—the

strong element of the subconscious that runs through Latin American societies.

In a line which we may term fantastic realism, Argentina provides a full complement of artists, though their numbers are a bit difficult to determine owing to the "dispersion-of-Surrealism phenomenon" noted by the Argentine critic Aldo Pellegrini. At the exhibition held at the Torcuato Di Tella Institute in Buenos Aires in 1967, Pellegrini grouped together numerous artists whose fantasy, expressed either as a pictorial concept or as an approximation to Pop Art, corresponded to the "purely inner model" advocated by André Breton. The demands of this inner model were met with an exactitude impregnated with mystery by Roberto Aizenberg (b. 1928), Miguel Caride (b. 1920), Noé Nojechowitz (born in Poland in 1929, came to Argentina in 1933), Zoravko Ducmelic (born in Yugoslavia in 1923, came to Argentina in 1955), and Juan Carlos Liberti (b. 1930) in their landscapes and figure paintings. Toward the end of the '60s the graphic artists of the GRABAS group—Delia Cugat (b. 1930), Pablo Obelar (b. 1930), Sergio Camporeale (b. 1937), and Daniel Zelaya (b. 1938) showed similar sleight of hand in transformations of reality.

Fernando Maza (b. 1936) with his large-scale letters in landscapes, Mildred Burton with her fiercely ironic figures, and Antonio Seguí (b. 1934) *(p. 116)* in the photo-portraits he did in the '60s broadened to some degree the area of inner vision. Irreality took the form of disquieting atmosphere surrounding the figures of Vechy Logioio (b. 1933), in the horizontal landscapes of Hilda Crovo (b. 1933), and in the violent ambience characterizing the work of Lea Lublin (b. 1929). The generic attraction of Surrealism manifested itself rather differently in the box-machines painted by Osvaldo Borda (b. 1929) and in the overlapping, interwoven, or cut-off organic forms found in the compositions of Juan Carlos Langlois (b. 1926) and Julio H. Silva (b. 1930). Somewhat similar to their work are the later paintings of Brian Nissen (Mexican, b. 1939). While the violence of the crude figure paintings of Jorge de la Vega (1930-1971), Jorge Demirjian (b. 1932), and Raúl Alonso (b. 1923) obviously derives from Expressionism, the seductive influence of Surrealism is evidenced in the mingling of basic elements. The note of falseness appears continuously in the work of the participants in the previously mentioned exhibition at the Torcuato Di Tella Institute. It was conveyed to the public by the paintings of Marta Peluffo (b. 1931) and Erik Ray King (b. 1935), the Camembert cheese boxes of Alberto Heredia (b. 1924), and the polyester figures on ladders produced by Juan Carlos Distéfano (b. 1933), whose singular oeuvre vacillates between Expressionism and Surrealism.

Other works in the line of irreality are the figures in landscapes painted and sketched by Oscar Mara (b. 1935), the false mirrors of Héctor Borla (b. 1937), and the reliefs of Gloria Prioti, which, like many of the three-dimensional works of the '60s, are closely akin to the everyday prosaicness of Pop Art. Among those working in this same line was Aldo Paparella (1920-1977), one of the most uninhibited talents in Argentina. In the paintings, sketches, boxes, and environments he turned out at this time he showed himself fully involved in relating art

to daily life. Likewise akin to Pop Art was the Informalism practiced by Luis Alberto Wells (b. 1939); Mario Pucciarelli (b. 1928), who won the Di Tella Prize in 1960; and Alberto Greco (1931-1965). It was Wells who, together with Segui, headed the "Destructive Art" group in 1961. It never lived up to its title, but persisted in painting. The admirable watercolors of Guillermo Roux (b. 1929), with their ambiguous images and artificial atmosphere, constitute another Argentine contribution to irreality.

Variants of fantastic realism can be found throughout Latin America during this period. In Central America and the Caribbean islands cultural isolation and Indian and Negro influences rendered irreality readily acceptable. The eyes sketched or painted by Rodolfo Abularach (Guatemalan, b. 1933) seem to explore the great beyond; the atmospheric compositions of Elmar Rojas (Guatemalan, b. 1937), and the petrified figures of Efraín Recinos (Guatemalan, b. 1932) are similarly weighted with mystery. The Dominican painters Fernando Peña Defilló (b. 1928), Ada Balcácer (b. 1930), Domingo Liz (b. 1931), and Aquiles Azar (b. 1932) readily avoided reality, the political side of which was represented up to 1962 by the dictatorial Trujillo regime. It is not surprising that the "Proyecta" group formed in 1968 emphasized above all the artist's right to freedom.

Cuba had an ongoing Surrealist tradition, thanks to the work of Mario Carreño (b. 1913), Felipe Orlando (b. 1911), and René Portocarrero (b. 1912). Carreño gradually evolved toward an openly European form of Surrealism, similar to the work of Magritte. While Orlando's paintings resemble those of the Frenchman Dubuffet, they lack neither originality nor sarcasm. The paintings of

• **ERNESTO DEIRA**. *VERONICA*. 1964.
OIL ON CANVAS, 114 X 146 CM.
COLLECTION OF THE ART MUSEUM
OF THE AMERICAS, OAS, WASHING-
TON, D.C., U.S.A. GIFT OF THE ART-
IST, 1964. PHOTOGRAPH BY ANGEL
HURTADO.

Portocarrero's "city" period seem the product of hallucination. Cuban Surreal-ism was further developed and diversified by Emilio Sánchez (b. 1921), Jorge Camacho (b. 1934), and Angel Acosta León (1932-64), whose style featuring as-tonishing organic machines was quickly taken up by Raquel Lázaro (b. 1917).

During the '60s the leading personality in modern Nicaraguan art, Armando Morales (b. 1927), who had previously practiced abstraction, rediscov-ered the human figure, under the influence of the metaphysical painting of the Italian De Chirico, although in his case the background was provided by the vast expanse of Lake Nicaragua. The tin-can-encrusted tables and the contradictory spaces of Alejandro Aróstegui (b. 1935) had a great impact on the artists who fre-quented the Tagüe Gallery in Managua. The series of owls painted by Orlando Sobalvarro (b. 1943) were a stroke of invention indicative of a complex talent.

The most important person in Latin American fantastic painting was Benjamín Cañas (Salvadoran, b. 1933) *(p. 118)*. His morbid world of monsters was depicted with a preciseness that rendered it far more horrible than the uni-verse of madness and death sketched by José Luis Cuevas (Mexican, b. 1934), or the agitation and deformity of the figures drawn by Nelly Freire (Argentine, b. 1933), Julio A. Zachrisson (Panamanian, b. 1930), and Marcelo Grassmann (Bra-

• **JORGE DE LA VEGA**. *HISTORY OF THE VAMPIRES*. 1963. OIL AND COLLAGE ON CANVAS, 162.5 X 130.9 CM. MUSEUM OF ART, RHODE ISLAND SCHOOL OF DESIGN, U.S.A. NANCY SALES DAY FUND FOR MODERN LATIN AMERICAN ART. PHOTOGRAPH BY CATHY CARVER.

zilian, b. 1925). Although there is a strong Expressionist element in the work of all those just mentioned, fantastic invention provides the dominant note. To understand the compositions, one must do as Alice did: step through the looking-glass and accept the impossible as real.

As noted in the previous chapter, Mexico has a strong Surrealist tradition, which has found a variety of expressions. Pedro Friedeberg (born in Italy in 1937, came to Mexico in 1940) engaged in the creation of fantastic objects, a line which was to be taken up in the following decade by Xavier Esqueda (b. 1943). Olga Dondé (b. 1935) shifted from fantasy to eroticism. At the end of the '60s, Ricardo Martínez (b. 1918) went to the ultimate extreme in effects of irreality obtained by artifices of illumination and an almost supernatural condensation of painted atmosphere. Similarly excellent representatives of the trend were Rafael Coronel (b. 1932) and Francisco Corzas (b. 1936). Others who entered into the game of challenging reason were Fernando Ramos Prida (b. 1937), whose work recalls children's drawings, and Alfredo Castañeda, who made use of double vision and reversals of normal situations.

Fantastic realism was energetically exploited by a number of artists scattered throughout Latin America. Toward the end of the '60s Nemesio Antúnez (Chilean, 1918-1993) painted a series of imaginary beds moving along roads in Chile. At the same time he produced a group of large-scale, nightmare-like urban ambiences in which man is reduced to a dot. Another Chilean, Rodolfo Opazo

(b. 1935) was a Surrealist *par excellence*: flat figures and empty, silent spaces constitute a vast panorama of the subconscious. Figures painted by Myrna Báez (Puerto Rican, b. 1931) are apparently realistic, but she surrounds them with a highly suggestive atmosphere of tensely eloquent solitude. When the Venezuelan Jacobo Borges (b. 1931) *(p.121)* made his debut at the São Paulo Biennial of 1957, his work evidenced a *terribilità* akin to the aggressively mocking tone of the "Whale's Roof" group, whose spirit in turn resembled that of Colombian "Nothingness" and the Mexican "Plumed Horn" circle. In the 1970s, after a long period of inactivity, he took up a more "Proustian" mode of expression, indulging in ellipses and double images—a mixture of dream and reality. In some respects these works resemble the suggestive compositions of the Peruvian Hermann Braun (b. 1933) and the later painting of the latter's compatriot Rafael Hastings (b. 1945), whose soft, cottony highlights recall those of Borges.

Chromatic atmosphere also provided a way out for the Colombian Luciano Jaramillo (b. 1938), an artist of great critical gifts and mordant vision. The Peruvian Tilsa Tsuchiya (b. 1936) and the Colombian Jim Amaral (b. 1933) constitute cases apart. The former painted with the perfection of a Persian miniaturist erotically entwined figures of Indian origin, whereas Amaral created a surprising series of small-scale, tormented compositions sexual in inspiration. The Peruvian Fabián Sánchez (b. 1935) first presented his metal sculptures and montages at the Sixth Paris Biennial (1969). His strange beings constructed from sewing-machine parts constitute a true "sculpture of poverty" at the level of the unconventional machines of Tinguely or Takis; they represent one of the most successful inventive moments in Latin American art.

In opposition to the excesses, ironies, criticisms, and disfigurations of fantastic realism we find synthetic realism, which emphasized economy of means and fusions of forms, rather than dissolutive irreality. In the landscapes of a number of artists active in the years between 1950 and 1970 there is a visible intent not only to describe a given space but also to provide an element of lyric surprise. Good examples are furnished by the Brazilians Tomaz Ianelli (b. 1932) and Cybèle Varela (b. 1943), and the Argentines Mario Crenzans (b. 1932) and Josefina Robirosa (b. 1932). In the case of the last-mentioned, the normality of the landscape is frequently broken by strong touches of fantasy. These are four delicate artists whose work is more airy and elusive than that of the Venezuelan Carlos Hernández Guerra (b. 1939), whose long horizontal landscapes show greater liveliness and more touches of the unexpected. Direct spiritual descendants of these landscapists born after 1940 were the Argentines Américo Castilla and Hugo de Marziani, the Puerto Rican Francisco Colón (b. 1941), and the Colombian Alvaro Marín (b. 1946).

Another type of synthetic realism emphasized the outline of form. This was practiced by the Mexican Arnaldo Belkin (b. 1930), in whose work images underwent ingenious rearticulation; by the Haitian Hervé Télémaque (b. 1937), who resembles the Italian Adami but is even bolder in his outlines; and by the Venezuelan Margot Romer (b. 1938). Romer's treatment of some themes is not

• **RODOLFO ABULARACH**. *ARTEMIS*. 1979. OIL ON CANVAS, 121.9 X 152.4 CM. PHOTOGRAPH BY WILLIE HEINZ REPRODUCED BY PERMISSION OF THE ARTIST.

far removed from Pop Art. Basically, however, she has a passionate concern for a brutal definition of color areas emanating from urinals and banners.

The extraordinary sculptural syntheses of Marisol Escobar (Venezuelan, b. 1930) *(p. 119)* also relate to Pop Art, but she is highly original in her manner of turning images into blocks, which she then combines with flat, realistic painting. Slipping quietly toward irreality, like Fernando Botero she separates herself from the remainder of her contemporaries. Color effects suggestive of light diffracted by a prism mark the figure paintings of the Peruvian Teresa Burga (b. 1939). Gilberto Rebaza (Peruvian, b. 1939) combined geometric and realistic forms in a manner all too reminiscent of Armando Morales. The semigeometric figures of Leoncio Sáenz (Nicaraguan, b. 1935), and the combination of flat colors and violent masses practiced by Vilma Pasqualini (b. 1930), a Brazilian whose work resembles that of the English Pop artist Allen Jones, demonstrate the enormous number of possible variables between Postcubism and Pop Art.

Expressionist Realism is clearly identifiable. It was well suited to the shocks and anxieties of the day. The disorder and aggressiveness to be noted in those decades was not a reflection of the contradictions and crises of European and U.S. art but a clear recognition of the region's own capacity for aggressiveness. In Argentina this began to manifest itself in the distortions of Macció, Noé, De la Vega, and Deira, when they were promoted by the Di Tella Institute. Other artists redefined Expressionism in individual terms. Carlos

• **FERNANDO BOTERO**. *MONA LISA AT THE AGE OF TWELVE*. 1959. OIL AND TEMPERA ON CANVAS, 211 X 195.5 CM. MUSEUM OF MODERN ART, NEW YORK, U.S.A. INTER-AMERI-CAN FUND. PHOTOGRAPH FUR-NISHED BY THE MUSEUM OF MOD-ERN ART.

Alonso (b. 1929) manifested his dissidence at the 1963 exhibit in the Bogotá Museum of Modern Art, in sketches and collages that anticipate the unusual richness of resources of which he later availed himself in his 170 illustrations for the edition of the *Divine Comedy* sponsored by Olivetti in 1966. In 1960, Antonio Berni (of whom mention was made in Chapter 1) reappeared on the scene with a remarkable series of collages recounting the story of Juanito Largo, a dweller in the shantytowns surrounding Buenos Aires. Eduardo Giusiano (b. 1931) developed a nonaggressive line of Expressionism, based on disadjustments of color and brushstrokes. The hard line was asserted in the painting of Carlos Gorriarena (b. 1925), who depicted society and authority in a brutally grotesque manner, also to be noted in the painting of Oscar Smoje (b. 1939). Smoje, however, is closer to the violent caricature of the English painter Francis Bacon. The sculptures of Juan Carlos Distéfano tend to depict the world as a prison and place of torment. Expressionist shock reaches its climax in the baroque oeuvre of Ezequiel Linares (b. 1927).

Chile produced an Expressionist generation notable for the high quality of its work and its conviction in transmitting a message. Outstanding examples

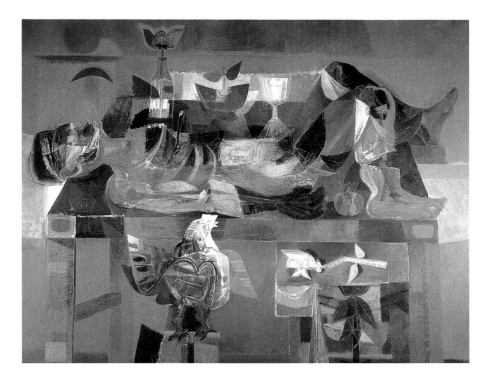

● **ALEJANDRO OBREGON**. *THE WAKE*. 1956. OIL ON CANVAS, 140 X 175 CM. COLLECTION OF THE ART MUSEUM OF THE AMERICAS, OAS, WASHINGTON, D.C., U.S.A. PURCHASE FUND, 1957. PHOTOGRAPH BY ANGEL HURTADO.

are provided by the paintings of José Balmes (b. 1927), Gracia Barros (b. 1927), and Eduardo Vilches (b. 1932), and the notable work done by Roser Bru (born in Barcelona, Spain, in 1923, came to Chile in 1939) both in painting and in graphics. After the dramatic fall of the Allende regime in 1973, all tended toward a type of Expressionism in keeping with the somber climate of ongoing events. In the sculptures of Juan Egenau (b. 1927) bodies are as it were rearticulated and clad in armor.

In this same line of convulsive Expressionism are the monstrous figures of Félix Arauz (Ecuadorian, b. 1935), Antonia Eiriz (Cuban, b. 1929), and the Colombian Norman Mejía (b. 1938), who won the National Prize for Painting at the 1965 Bogotá Salon with a masterpiece entitled *The Horrible Chastising Woman*. Quite different are the Expressionist figures of the Colombians Alejandro Obregón (1920-1992) and Fernando Botero (b. 1932). Obregón transformed the vast expanses of landscape into geometric symbols of his country. His series of paintings of condors, volcano-condors, and bull-condors, among which one finds masterpieces such as *Chimborazo: Dawn in the Andes*, have an epic sweep unequalled in Latin America. Going to a different extreme, in the late '50s Botero depicted the authorities and myths of bourgeois society, mordantly yet tenderly, in a gallery of gigantic portraits, overwhelming in their effect, Enrique Grau (b. 1920) *(p. 128)*, Juan Antonio Roda (b. 1921), Jorge Elías Triana (b. 1921), and Carlos

Granada (b. 1933) worked along more conventional lines. The high points of their Expressionism are to be found in the series of *Philips* done by Roda in 1963, the huge baroque figures executed by Grau at about the same time, and the later aggressive compositions of Granada, which show a debt to the Englishman Francis Bacon, an artist who was to have a lively influence on the next generation.

Women made significant contributions to Expressionism in its multifaceted manifestations. There were for example the Uruguayans Teresa Vila (b. 1931) and Lily Salvo (b. 1928); the Colombians Freda Sargent and Emma Reyes (b. 1919), who painted striking heads, landscapes, and fruits; and the distinguished landscapists Joy Laville (Mexican) and Luisa Richter (born in 1928 in Germany, came to Venezuela in 1955).

Often Expressionism served but as an accent, imbuing the image with additional energy and meaning. Such was visibly the case with the paintings of the Panamanians Desiderio Sánchez (b. 1929) and Guillermo Trujillo (b. 1927), the Guatemalan Roberto Cabrera (b. 1939), the Mexican Juan Soriano (b. 1920), and the Dominican Pablo Giudicelli (b. 1921), and with the sculptures of Cornelis Zitman (born in The Netherlands in 1926, came to Venezuela in 1946), Joaquín Roca Rey (Peruvian, b. 1923), and the Chilean Raúl Valdivieso (b. 1931). On the other hand, the macerated figures appearing in the relief paintings of Alberto Gironella (Mexican, b. 1929) *(p. 129)*, Roger von Gunten (Mexi-

• **ALBERTO GIRONELLA.** *THE GLUT-TON.* 1958. OIL ON CANVAS, 100.5 X 80.5 CM. COLLECTION OF THE ART MUSEUM OF THE AMERICAS, OAS, WASHINGTON, D.C., U.S.A. PUR-CHASE FUND, 1959. PHOTOGRAPH BY ANGEL HURTADO.

can, b. 1933), and Hermenegildo Sábat (Uruguayan, b. 1933) bespeak a certain ontological disorder. In a science-fiction vein, which was to be taken up in the '60s by the Argentine Raquel Forner, the Venezuelan Alirio Rodríguez (b. 1934) sought to convey visions of man's cosmic fate using an improvisational technique close to finger painting. His work and the pantheistic eroticism of the Mexican Francisco Toledo (b. 1937) show the difficulty of delineating clearly the area of Expressionist Realism. The many-sided nature of Expressionism is further demonstrated by the cautious fashion in which Luis Guevara Moreno (Venezuelan, b. 1926) explored the world of harrassed personages he discovered in the '60s, and the fierce eroticism of Leonel Góngora (Colombian, b. 1932), whose work precedes by two decades the dissonances of the European "ultravanguard."

In a few rare cases, Latin American works executed between 1950 and 1970 approximate the hyperrealism that manifested itself in the United States in the close-ups produced by certain Pop artists, with their blown-up detail and clear resemblance to the techniques and products of advertising. In Latin America, realism in all its forms evidenced an interest in objects of daily life,

• CLAUDIO BRAVO. *MYSTICAL PACKAGE*. 1967. CHARCOAL, CONTÉ CRAYON, AND INK ON PAPER, 74.8 X 110.2 CM. PROPERTY OF THE SAMUEL M. GREENBAUM 1989 TRUST, WASHINGTON, D.C., U.S.A. PHOTOGRAPH BY WILLIE HEINZ.

which constitutes an old Hispanic tradition, running in Spain from the still lifes of Zurbarán through the works of Antonio López García.

This interest is clearly evident in the painting of the Chilean Claudio Bravo (b. 1936) *(p. 130)* and the Colombian Santiago Cárdenas (b. 1937), despite the close relationship between some of the latter's compositions and paintings by Oldenburg. It is slightly less evident in the paintings the Chilean Ernesto Barreda (b. 1929) did during the 1960s. The Argentines José de Monte (b. 1929) and Ricardo Garabito (b. 1930) showed themselves perfectionists in their landscapes and still lifes.

Certain regions seemed particularly inclined toward realism. One was Colombia. Juan Cárdenas (b. 1939) and Alfredo Guerrero (b. 1936) were invariably faithful to their subject matter and the following generation persisted in this line with brilliant results. The preciseness with which Raúl Cattelani (Uruguayan, b. 1927) rendered his painted symbols shows the continuing influence—in his generation and the next—of Torres-García's spirit of synthesis. Only with the generation represented by Clever Lara (b. 1952) did Uruguayan painting become fully realistic.

The letters—complete with address and postage stamp—which the Peruvian Luis Arias Vera (b. 1932) painted may serve as a bridge to a final form of realism, which manifested itself above all in three-dimensional objects. The Venezuelan Mario Abreu (b. 1919) and the Brazilian Rubem Valentim (b. 1922) showed remarkable ingenuity in constructing their boxes and magic objects. The "furniture-piece" women that Hernando Tejada (Colombian, b. 1925) turned

out in the 1970s and the "boxed" women the Uruguayan Germán Cabrera (b. 1903) produced after 1955 are more realistic in effect than the boxes of the Venezuelan Gabriel Morera. Closer to Pop Art are the erotic sculptures of the Argentine Emilio Renart (b. 1925) and the free-form works of his compatriots Rubén Santantonín (1919-1969), Vicente Marotta (b. 1935), and Pablo Suárez (b. 1937).

This listing of the most representative artists of the decades from 1950 to 1970 makes clear, first, the assurance with which individuals working within an international repertory asserted their personalities in compositions of their own invention and, second, their persistence in these personal projects during the difficult period of the '60s. In no case did they yield to the facile slogan "Death to Art."

Notes

[1] Among artists who contributed to the flowering that took place in the '50s were Julio Verdié (Uruguayan, b. 1900), Francisco de Narváez (Venezuelan, 1905-1982), Guillermo Wiedemann (1905-1969, born in Germany, active in Colombia after 1939), Francisco Amighetti (Costa Rican, b. 1907), Noemí Gerstein (Argentine, b. 1910), María Martorell (Argentine, b. 1909), Manuel de la Cruz González (Costa Rican, b. 1909), Marina Núñez del Prado (Bolivian, b. 1910), Luis Martínez Pedro (Cuban, b. 1910), Felipe Orlando (Cuban, b. 1911, moved to Mexico in 1951), Vicente Martín (Uruguayan, b. 1911), Luis García Guerrero (Mexican), José María Cruxent (born in Barcelona, Spain, in 1911, active in Venezuela), Juan Ventayol (Uruguayan, b. 1915), Manuel Espinosa (Argentine, b. 1912), Lorenzo Homar (Puerto Rican, b. 1913), Mario Carreño (Cuban, b. 1913), Tomie Ohtake (born in Japan in 1913, active in Brazil after 1936), Mauricio Lasansky (Argentine, b. 1914), Alfredo Sinclair (Panamanian, b. 1915), Luis Tomasello (Argentine, b. 1915), Marcel Floris (born in France in 1914, active in Venezuela after 1950), Gunther Gerzso (Mexican, b. 1915), Líbero Badii (born in Italy in 1916, active in Argentina), Braulio Salazar (Venezuelan, b. 1917), Marta Colvin (Chilean, b. 1917), Nemesio Antúnez (Chilean, b. 1918), Ricardo Martínez (Mexican, b. 1918), and Mauricio Aguilar (Salvadoran, b. 1919).

[2] Damián Bayón, *Aventura plástica en Latinoamérica* (Mexico City: Fondo de Cultura Económica, 1974).

[3] Alfredo Boulton, *Historia de la pintura en Venezuela* (Caracas, 1964-[72], 3 vols.).

NEWCOMERS AND
NEW TRENDS (1960-1980) V

THE RELATION BETWEEN ART AND SOCIETY, THE POLITICIZATION OF ART through "commitment" on the part of the artist, and recourse to forms of expression divorced from visible reality as a springboard for the leap into modernity—these were the key issues for artists between 1920 and 1960. Since 1960 the issues with which artists have had to contend can be summed up by the slogan "What counts is life."

This slogan was often repeated during the 1970s, when problems of "identity" and "dependency" were relegated to second rank. The new feeling was well conveyed by the Manifesto of the "Fed-up" (Mexico City, Antonio Souza Gallery, 1961), whose authors declared: "We are fed up with the pretentious structures of logic and reason, with functionalism, with carefully calculated decorative effects, and—obviously—with the pornographic chaos of individualism, passing fame, the day's fashion, vanity, ambition, bluff, artistic jokery, conscious and unconscious egotism, fatuous ideas, and the boring publicity given to 'isms' and their adepts in both figurative and abstract lines."

The spirit of revolt against the established order grew from 1960 to 1968, as part of a worldwide protest movement. 1968 was the year of the May riots in Paris, with barricades in the streets and rejection of the Sorbonne as the archetypical establishment institution. It was also the year of the Russian invasion of Czechoslovakia, which put an end to hopes for democratic socialism, and the year of Martin Luther King's assassination, the result of his struggle for racial equality. In the theater and on the screen it was the year of *Hair*, of mocking insult to the public, and of the end of an author-audience relationship based on mutual restraint. It was the year of *Easy Rider*, and the beginning of an escalation of out-and-out violence.

The confrontation between ideologies and generations reached an unparalleled degree of ferocity, resulting from the growing disbelief in accepted values that manifested itself in the societies of highly developed countries. Countering the spreading tyranny of technology, which government could do nothing to check, the young engaged in a brutal, boisterous movement whose aim was a re-

● JOSE LUIS CUEVAS. *DR. RUDOLPH VAN CREFEL AND HIS PATIENT.* 1975. LITHOGRAPH 17/150, 55.8 X 76.2 CM. COLLECTION OF THE INTER-AMERICAN DEVELOPMENT BANK, WASHINGTON, D.C., U.S.A.

turn to nature and communal life. Disbelief undermined all social institutions, beginning with government and the university and extending to affect science, technology, and every aspect of daily life.

Spontaneous anarchy—symbolized by the black flag raised by Parisian students in the May riots—swept away all that lay in its path. The effects were felt in Latin America, though the crisis produced by advances in science and technology had not reached the same pitch there. The "fed-up" attitude expressed in the Mexican manifesto was primarily a reflection on the frivolity of the ambient society. Not even the most highly developed urban centers of Latin America exhibited the characteristics that provoked revolt in the industrialized countries. In the world for which Herbert Marshall McLuhan served as spokesman, eyes were blinded by televised images, ears were bombarded with advertising, and cybernetics and data-processing provided instant access to information for all. When McLuhan prophesied the disappearance of the "Gutenberg Galaxy"—the end of the written word—and the coming of the "global village," in which life is uniformly homogeneous, in which "the medium is the message," he was addressing readily identifiable societies. McLuhan's views, the revolt against society typified by the hippies, the assertion of the primacy of imagination over traditional knowledge, and the categorical rejection of past models caused a great stir in Latin America. Art wavered on its base as radical changes were introduced at varying times and with different effects, depending on the power wielded by critics. During this period the avant-garde indulged in self-advertisement to an extent unknown before, but at the same time there was fierce defense of the right to individual or collective expression by those who sustained the connection between man and his dreams and between those dreams and the hopes of the community.

The avant-garde's capacity for self-promotion was astonishing, considering the relative insignificance of Latin American coteries and the poverty of the critical environment. The avant-garde made such strides that at times it took over the whole stage, forcing the representatives of traditional media of expression to beat a retreat. The confrontation was summed up in two phrases: "Art is dead," proclaimed by a variety of speakers from a number of different platforms, and "Art is not dead," maintained by those whose work evidenced renewal in form and meaning.

A third feature to be noted was a renewed interest in drawing and printmaking, activities that permitted a variety of individual expression and that were modest in their material demands, in contrast to the art forms promoted in Europe, the United States, and Japan. The latter possessed sophisticated means of production and could afford the costly materials required for technological experimentation. Their affluence also permitted indulgence in the destruction of automobiles, walls, furniture, and food that was featured in "happenings" and other "performances."

Graphics took on profound significance. They proclaimed the primacy of sight over touch. They could be read without a key, in contrast to works based on

hermetic concepts that could be understood only by the initiate and that re-
mained incomprehensible to the community at large. They also provided a
stimulus to the creative spirit of the spectator, whose imagination could visually
complete this open-ended type of composition. Printmaking has a peculiar po-
tential for communication and education, since the reproductive process breaks
down the barrier surrounding the work available in but a single copy. This ob-
stacle had not been resolved by so-called multiples, whose cost as a rule has been
too high for the general public.

The burst of activity in graphics was spectacular. An important part in the
upsurge was played by biennials and competitions held from 1960 on, and by the
support lent by the Latin American subsidiaries of the Container Corporation of
America. The following are a few of the more representative events. The first
American Biennial of Printmaking took place in 1963 at the Museum of Contem-
porary Art of the University of Chile. At that time the institution was headed by
the painter Nemesio Antúnez, who invited participation from Argentina, Brazil,
Chile, Colombia, Costa Rica, Cuba, El Salvador, Mexico, Panama, Paraguay,
Peru, Uruguay, and Venezuela. Beginning in 1959, the Central University of
Venezuela held a series of eight national exhibitions of graphics, organized by the
printmaker Antonio Granados (b. 1917). These led up to the Latin American
Exhibition of Drawings and Prints, held in 1967. The First Latin American Print
Biennial took place in 1970 in San Juan, Puerto Rico, under the sponsorship of
the Institute of Puerto Rican Culture; a total of five exhibitions have been held to
date. In 1970, also, the Pan American Exhibition of Graphic Arts took place in
Cali, Colombia. This led to the First American Biennial of Graphic Arts, cover-
ing drawings, prints, and graphic design, which was presented the following year
in the same city under the auspices of La Tertulia Museum. The series thus be-
gun has continued to the present. Biennials of American Printmaking were held
in Maracaibo, Venezuela, from 1977 to 1981, and in 1978 Benson and Hedges
sponsored a show entitled "New Printmaking and Drawing in Argentina." All
these, plus local graphic-arts shows that were held throughout Latin America,
add up to an impressive display of activity, broad in range and substantial in
value.

Printmaking reached its highest point of development, both technically
and thematically, in Brazil, which has set an example for the rest of Latin
America. Established masters in the field, such as Isabel Pons (b. 1912), Edith
Behring (b. 1916), Fayga Ostrower (b. 1920), Ruth Bess (b. 1924), Marcelo
Grassmann (b. 1925), and Artur Luís Piza (b. 1928), have been joined by others
of similar rank—Maria Bonomi (b. 1935) *(p. 136)*, Anna Letycia (b. 1929), and
Roberto de Lamônica (b. 1933). Thematic renewal is evidenced in the work of
Fábio Magalhães (b. 1942), José Alberto Nemer (b. 1945), Arlindo Daibert
(b. 1952), and José Bezerra Dias (b. 1957).

There were pioneer figures in graphics in other parts of Latin America as
well: Francisco Amighetti (Costa Rican, b. 1907), Lorenzo Homar (Puerto
Rican, b. 1913), Mauricio Lasansky (Argentine, b. 1914, active in the United

• **MARIA BONOMI**. *STAGE*. 1962. WOODCUT, 111.8 X 101.6 CM. COLLECTION OF THE ART MUSEUM OF THE AMERICAS, OAS, WASHINGTON, D.C., U.S.A. GIFT OF FRANCISCO MATARAZZO SOBRINHO, 1964. PHOTOGRAPH BY ANGEL HURTADO.

States) *(p. 137)*, the Venezuelan Luisa Palacios (b. 1923), and the Uruguayans Luis A. Solari (b. 1918) *(p. 139)*, Antonio Frasconi (b. 1919), Leonilda González (b. 1924), and Anhelo Hernández (b. 1922). All continued active during the period now under consideration and performed an important role as teachers. Lorenzo Homar, for example, trained all the young printmakers of his native island, emphasizing wood engraving, the silk-screen process, and poster production.

The upsurge in graphics brought about a return to communal activity in collective workshops, where artists supported one another in moments of doubt and international crisis. A number found complete fulfillment in graphics, instead of alternating activity in this line with painting or sculpture. Such was the case with the Argentines Ana María Moncalvo (b. 1921), Eduardo Audivert (b. 1931), Julio Guillermo Paz (b. 1939), and Cristina Santander (b. 1942); with the Colombians Alonso Quijano Acero (b. 1927), Augusto Rendón (b. 1933), and Pedro Alcántara (b. 1940); with the Mexicans Juan Manuel de la Rosa (b. 1945) and Nunik Sauret (b. 1951); with the Puerto Rican Antonio Martorell (b. 1939);

• **MAURICIO LASANSKY**. *KADDISH*. 1975. COLOR ETCHING, 107 X 66 CM. COLLECTION OF THE ART MUSEUM OF THE AMERICAS, OAS, WASHINGTON, D.C., U.S.A. PURCHASE FUND, 1978. PHOTOGRAPH BY ANGEL HURTADO.

with the Uruguayans Glauco Capozzoli (b. 1929), Luis Camnitzer (b. 1939), and Naúl Ojeda (b. 1939) *(p. 139)*; and with the Venezuelan Francisco Bellorín (b. 1941).

This flowering of graphics in Latin America is highly significant for the resistance it represents to the spectacular effort that was then being made on the international stage to find replacements for traditional art forms, which were held to be "dead." At the Latin American Exhibition of Drawings and Prints held in Caracas in 1967, the Venezuelan critic Juan Calzadilla was clear in his recognition of this point. He wrote: "Art is not dead. The situation is really one of coexistence, side by side, of a variety of concepts. This exhibition, for example, testifies to the continuing relevance of an inherited but living tradition. At a moment when our consciousness of being underdeveloped makes us prone to be dazzled by what is not our own, this exhibition of real works of art by genuine artists comes as a timely reminder that in art it is more important to be authentic than to be fashionable."

It was precisely out of scorn for "fashionableness" that painters and sculp-

• **JUAN ANTONIO RODA**. *LAUGH-TER NO. 6*. 1972. ETCHING 8/20, 64.8 X 48.4 CM. COLLECTION OF THE INTER-AMERICAN DEVELOPMENT BANK, WASHINGTON, D.C., U.S.A. PHOTOGRAPH BY ANGEL HURTADO.

tors turned to printmaking. The case of Juan Antonio Roda (Colombian, b. 1921) *(p. 138)* provides a brilliant example. As a painter he had attained the highest of levels with a series of Christs he did in 1968 and his *Windows in Suba* of 1970. From 1971 to 1976, however, he devoted himself exclusively to printmaking, producing series entitled *Portrait of a Nobody*, *Laughter*, *The Dead Nuns' Delirium*, and *Dog Leashes*. His prints, like those that Lasansky did on the Nazis and their victims, rank among the best produced in Latin America. They mark a break with the concept of uniqueness—of the work which exists solely in the original—and a step toward making art available, through reproduction, to the public of lesser means.

The social aspect of printmaking was recognized by the Cuban revolution from the very first. Strong support was lent to the Print Workshop in Havana, at which a numerous generation of artists received training. The revolution achieved its greatest success, however, in the area of poster-production. It was first promoted by cultural institutions such as the Cuban Institute of Cinematographic Arts and Industries (ICAIC), the National Council of Culture, and the Union of Cuban Artists and Writers, but soon posters were adopted as a means of mass communication with the public. Painters old and young, graphic artists, and

• NAUL OJEDA. *THE LAST SUPPER.* 1977. WOODCUT, 48.2 X 91.4 CM. REPRODUCED BY PERMISSION OF THE ARTIST (ABOVE). **LUIS SOLARI.** *CHARMING ALLEGORY.* 1975. CO-LOR ETCHING AND DRYPOINT, 45.7 X 61 CM. COLLECTION OF THE ART MUSEUM OF THE AMERICAS, OAS, WASHINGTON, D.C., U.S.A. PUR-CHASE FUND, 1978 (BELOW). PHO-TOGRAPHS BY ANGEL HURTADO.

movie-makers engaged in designing wall drawings and posters to serve as strate-gic weapons for bringing about the change of viewpoint required for radical po-litical and social reforms. They achieved their purpose thanks to the artists' good taste and high professional standards, and to their skill at reducing themes to es-sentials. By their appreciation of the nature of the medium and its capacity for instant communication, they carried out a literacy campaign that was as effective in its way as the one waged in the schools. Cuban posters, like those produced in Poland, managed to escape the pitfalls of socialist realism, which is the ruination

of painting, sculpture, and drawing as art. Avoiding ideological excess, the artists produced one of the most significant bodies of work in Latin America—an achievement that was recognized both there and in the United States, by critics such as Damián Bayón and Susan Sontag.

At the same time that printmaking was reasserting its peculiar values and flourishing rather than retreating before the advances of "antimuseum art" or "Systems art," drawing also took on deeper significance. It was not a question of painters or sculptors indulging in drawing as a side line, but of artists devoting themselves to drawing heart and soul. Such was the case with the Mexican José Luis Cuevas *(pp. 132, 141)*, who played a decisive role during the '70s in winning standing for drawing as a medium and in demonstrating its power of communication. Certain artists mentioned in the previous chapter, such as Zachrisson, Carlos Alonso, and Grassmann, showed a new and powerful imagination in their drawings.

Among pioneer efforts worthy of mention are the *Faceless Men*, a series done in Mexico in 1968 by Luis Nishizawa (b. 1920), and the sketches, collages, and montages of the Ecuadorians Guillermo Muriel (b. 1925) and Hugo Cifuentes (b. 1923). The Ecuadorian critic Wilson Hallo rightly considers the latter to have been one of the main contributors to the development of graphic arts in his country, opening the way for young men such as Ramiro Jácome (b. 1948).

Like free-hand drawing, illustration enjoyed new prestige, taking on the political and social significance it had had at the end of the nineteenth century. Good examples are provided by the series in tribute to the singer Carlos Gardel *To the Master, with Love*, done by the Uruguayan Hermenegildo Sábat (b. 1933), and the various series of political drawings done by the Guatemalan Arnoldo Ramírez Amaya (b. 1944) and the Colombian Gustavo Zalamea (b. 1951) *(p. 143)*, whose *Documents of the Planet* date from 1979.

In certain cases, such as those of the Mexican Javier Arévalo (b. 1957), the Peruvian Valeriano (*i.e.*, Pablo Alvarez Valeriano, b. 1957), and the Ecuadorian Nicolás Svistonoff (b. 1945), a talent for drawing went hand in hand with skill in the techniques of printmaking. During the '70s Venezuela and Colombia could boast of draftsmen of exceptional quality—in the case of Venezuela, Alexis Gorodine (b. 1946), Simón Guedes (b. 1948), Jorge Pizzani (b. 1949), Francisco Quilici (b. 1954), and María Eugenia Arria (b. 1956); in that of Colombia, Miguel Angel Rojas (b. 1946), Félix Angel (b. 1949) *(p. 161)*, Ever Astudillo (b. 1948), and Oscar Muñoz (b. 1951). In their compositions line acquired a value of its own comparable to the values of painting. Draftsmen of the rank of María Lino (Cuban, b. 1951), Juan Ramón Velázquez (Puerto Rican b. 1950), and Remo Bianchedi (Argentine, b. 1950), not only confirmed the strength of traditional media but justified rejection of the transformation of art into a public spectacle. The idea that the "object of the art" had fallen into discredit was thoroughly disproved by the endeavors of individuals such as these. Moreover, the relatively modest price of graphics in the market and their public accessibility automatically gave them a "use value" which the partisans of antiart had vainly sought in their

● **JOSE LUIS CUEVAS**. *SELF-PORTRAIT WITH THE YOUNG LADIES OF AVIGNON.* FROM THE SERIES IN TRIBUTE TO PICASSO. 1973. PEN AND INK WASH ON PAPER, 40 X 33.5 CM. COLLECTION OF THE ART MUSEUM OF THE AMERICAS, OAS, WASHINGTON, D.C., U.S.A. PURCHASE FUND, 1974. PHOTOGRAPH BY ANGEL HURTADO.

endeavor to free themselves from the tyranny of the "market value" set by middlemen.

Recognition of art's "use value" was one of the great ambitions of the '70s. Recognition, however, takes on altogether different characteristics depending on whether one speaks of Latin America or the highly industrialized areas of the world. The difference between "use value" and "market value" that existed in the developed countries simply did not apply in Latin America. The crisis existing in the former could not be transplanted to the latter. When an attempt was made in this line, the result was a burst of artificial activity, promoted by entities such as the Center for Art and Communication (CAYC) in Buenos Aires. Thanks to the prestige acquired by draftsmanship and the intercommunication that took place at biennials and other collective exhibitions, graphic artists were able to lessen the distinction between "use value" and "market value," thereby attaining one of the prime objectives of the decade— a closer relationship between artists and the public.

Of the three main lines of activity into which the work of this period can

be divided—the division being made merely for purposes of an orderly sampling of the enormous amount of material available—it is graphics that most clearly illustrates consciousness of the challenge to "directed chaos" that presented itself at the same time in the United States and in Europe. In a very real and original sense, graphics constituted the Latin American version of the "poor-man's art" that was first promoted in Italy and then became one of the passing fashions of the '60s and '70s, taking on the sophistication which fashionableness implies. Multiple prints for those of limited means, the modest production cost of graphic art as compared with painting and sculpture, and the transitory value of posters and wall art had the expected impact on the Latin American public. The "ephemeral mural" done by José Luis Cuevas for the fashionable "Pink Zone" of Mexico City, the *Speedway Museum* promoted by Rafael Bogarín (b. 1946) at El Tigre racetrack in Venezuela, the newspaper reproductions and heliogravures of which the Colombian Gustavo Zalamea made distribution were all planned and executed with the general public in mind. Thus in the Latin American context graphic artists constituted a true avant-garde.

Three of the products of the people-oriented avant-garde merit particular attention: "objects," textiles, and primitive paintings.

Toward the end of the '60s, in the heat of the general break with tradition, a number of artists turned out "objects," employing a variety of materials. The creations presented by the Colombian ceramist Beatriz Daza (1927-1968) in 1966 under the title "The Testimony of Objects" are substantially different from the ceramics done by three women active in Venezuela—those produced from 1967 to 1969 by Tecla Tofano (born in Italy in 1927), those of Seka Severín (born in Yugoslavia in 1923, came to Venezuela in 1960), and the ones turned out in the early '70s by Colette Delozanne (born in France in 1934, came to Venezuela in 1955). All however provide good examples of the increasing lack of definition between areas of artistic endeavor. In Tecla Tofano's violent criticisms of male- and consumer-oriented society one can find elements of both sculpture and political caricature. Seka's pieces are like totems carved from stone. Delozanne engages in nostalgic archaeology, seeking to relink present-day Latin American society to its pre-Hispanic origins. Beatriz Daza's collages of real-life objects lent value to cups and spoons at a time when U.S. Pop Art was bringing such items into discredit. The same search for meaning is evidenced in the boxes of the Mexican Alan Glass (b. 1932). The magical effects they produce derive more from invention than from memory, contrary to the case of the U.S. artist Joseph Cornell. In the Surrealist line, the Mexican Xavier Esqueda (b. 1943) produced in 1968 a series he called *Present Memories*. One of the most original creative artists of the following generation was the Colombian Bernardo Salcedo (b. 1942). In the late '60s and throughout the '70s he turned out the largest collection of boxes and free-form objects in Latin America. He began with white boxes containing fragments of dolls, and went on, first to a series connected with speedways, and then to objects of his own invention that recall machinery and household appliances.

• **GUSTAVO ZALAMEA TRABA**. *STU-DY WITH NARAJANA FRUIT.* 1988. OIL ON CANVAS, 200 X 200 CM. PHO-TOGRAPH FURNISHED AND REPRO-DUCTION AUTHORIZED BY THE "CENTRO DE ARTE EUROAME-RICANO" GALLERY IN CARACAS, VENEZUELA.

José Ramón Lerma, a Chicano born in 1930, was one of the first to turn to a theme which was to become a commonplace in Latin American Pop Art—the Sacred Heart of Jesus. Others who took it up were the Colombian Juan Camilo Uribe (b. 1945) and the Venezuelan Carlos Zerpa (b. 1950). The insistence on this theme and the fact that it crops up even in the work of a U.S. artist of Latin extraction give evidence of the strong pressure exerted by religion in Latin America. The originality of the theme from the viewpoint of Pop Art lies in the fact that it takes as its point of departure not a consumer product but a mass-produced color print.

Objects charged with meaning were also produced by the Brazilian Jonas dos Santos (b. 1947). In his use of "ecological" materials he resembles Frans Krajcberg (born in Poland in 1921, came to Brasil in 1948), but the end product is decidedly fetish-like in effect. This is also the case with the work of his compatriot Tunga (b. 1952). The "objects" made by the Colombian Ramiro Gómez (b. 1949) fall into the same category as the box-books of the U.S. artist Lucas Samaras; Gómez's is the poor-man's version, however, aggressively fashioned from nails, wire, tow, and rubbish.

The number of artists of interest during this period is too great to permit mention of all. As an example of the lively activity in textiles, let us take Mexico, where all sorts of new materials—thread, string, hemp, and other fibers; gold, silver, and other wires—were incorporated into the woven fabric, which might also be enhanced with collages of plexiglas and wood. Androna Linartas (b. 1940), Helga Freund (b. 1942), Tomás González (b. 1942), Ismael Guardado (b. 1942), Aldape Luz (b. 1946), Marcela Villaseñor (b. 1948), Teresa Villarreal Núñez (b. 1952), Maricarmen Hernández (b. 1952), and Víctor Abreu (b. 1952) provide good examples of the new directions taken in Mexican weaving. A not unnatural development in this generation was treatment of textiles as three-dimensional objects, as in the case of the tubes adorned with woven stripes executed by Maricarmen Hernández in 1971. The originality of their invention was firmly asserted and remains unsurpassed.

The most important event of the '70s as regards textiles was the extraordinary increase in the number of weavers: it was a mass appropriation of a means of expression closely linked to handicrafts and to the art of the past. There was unquestionably a willful effort to bring graphics, "objects," textiles, and folk arts into close rapport. Whereas in industrialized countries there was a great divorce between handicrafts and studio art, in Latin America folk inspiration continued to pervade all aspects of daily life, including studio art. In countries with a strong Indian tradition, folk art and relics of the pre-Hispanic past still live on. Even in countries such as Venezuela, in which modernization is far advanced, the folk tradition is preserved in prints, talismans, fetishes, and rites. Poverty and ethnic continuity are responsible for the fact that folk art is more easily visible in Brazil, Mexico, and Colombia than in the countries of the southern cone, in which the rise of the middle class has consigned such production to the provinces.

Folk art covers a vast terrain. It corresponds to a need for self-expression, compensating in part for life's brutal social and economic inequalities. "Primitive" or "naive" painters were busy throughout the '70s. Free of the influence of changing fashion, they provide a positive, many-sided, timeless vision of the world.

Among the pioneers in this line were the Nicaraguan Asilia Guillén (1887-1964) *(p. 145)*, the Honduran José Antonio Velásquez (1906-1983) *(p. 145)*, the Colombian Noé León (1907-1978), the Venezuelan Feliciano Carvallo (b. 1920), and the Colombian Sofía Urrutia (b. 1912). The last-mentioned constitutes a unique instance of a primitive painter springing from the cultural elite. All contributed to increased appreciation of a genre that had found its way into the commercial market thanks to the efforts of the primitives and pseudo-primitives of Haiti. When we come to the primitives born after 1940— Dirceu Carvalho (Brazilian, b. 1942), Joseph Jean-Gilles (Haitian, b. 1943) *(p. 146)*, Julio Sequeira (Nicaraguan, b. 1947), Neké Alamo (Venezuelan, b. 1948)—we find that in nearly all cases we are dealing with works done solely for the artist's own satisfaction, without commercial intent. It is a static art, which permits of no change.

● **ASILIA GUILLEN**. *RAFAELA HERRERA DEFENDS THE CASTLE AGAINST THE PIRATES*. 1962. OIL ON CANVAS, 63.5 X 96.5 CM. (ABOVE). **JOSE ANTONIO VELASQUEZ**. *SAN ANTONIO DE ORIENTE*. 1972. OIL ON CANVAS, 120 X 153.7 CM. (BELOW). BOTH WORKS, COLLECTION OF THE ART MUSEUM OF THE AMERICAS, OAS, WASHINGTON, D.C., U.S.A. PURCHASE FUND, 1962 AND 1972. PHOTOGRAPHS BY ANGEL HURTADO.

In the 1970s, the Solentiname group constituted a case apart. It grew up in the village of the same name on the shores of Lake Nicaragua, under the inspiration of the poet Ernesto Cardenal. It was not a question of setting up a school for primitive painters: the village was as it were a forcing bed in which peasants were persuaded they had talent and provided with the means of expressing it. The results were surprising.

• JOSEPH JEAN-GILLES. *HAITIAN LANDSCAPE*. 1973. OIL ON CANVAS, 76 X 122 CM. COLLECTION OF THE ART MUSEUM OF THE AMERICAS, OAS, WASHINGTON, D.C., U.S.A. PURCHASE FUND, 1974. PHOTOGRAPH BY ANGEL HURTADO.

During the '60s and '70s the international art scene was one big brassy show. In Latin America, however, the first current to evidence itself was willfully marginal in character, purposely antispectacular, and stubbornly devoted to conveying meaning.

Paradoxically, "communication" was also the aim of the "happenings," the Conceptual art, and the Systems art of the period. Art was understood to be a language, with codes to be deciphered, and semiotics was all the rage.

The principal critical confrontation of the period involved a matter of definition: What type of art bows to domination, and what type contributes to liberation? Two tendencies were evidenced in the endeavors to resolve this problem. On the one hand there was art that still took the form of an object produced in a traditional manner and circulated through the established channels of galleries and museums. On the other hand there was art that might take any form whatever but that was *not* to be treated as an object and that rejected both the concept of museums and galleries and the services which they offered. When it came to theory, traditional art was accused of serving the consumer market, and the art that broke with tradition was charged with being anticonsumer and incapable of meeting consumer needs. These, in broad outline, were the premises around which the arguments revolved.

It is difficult to review the period objectively because there is almost no difference between the criticisms made by one side and those made by the other. Critics who defended tradition that evidenced a capacity for renewal were by no means unanimous in their views. Their best-known spokesmen were the Argentine Damián Bayón and the Colombian Marta Traba. The books they published in the '70s differ in tone and objective, though they agree as to the tedium and weakness of the works systematically turned out by the avant-garde and its failure to communicate with the public. The avant-garde line was represented primarily by the Argentine Jorge Glusberg and the Peruvian Juan Acha, who likewise failed to agree with one another. In the '70s Glusberg adopted the strategy of the defenders of traditional art. "The new art," he wrote, "seeks to break the ideological bonds imposed by countries in which wealth and power are concentrated, employing at times the very methodology and language current in those countries, at times utilizing devices entirely its own. There is an undeniable convergence of attitudes with respect to what we might term the strategies of liberation. Though political and social in origin, they are clearly manifested in the cultural and artistic areas." For Marta Traba the artist's capacity for effecting a revolution lies in the substance and effectiveness of his message; for Glusberg, in his capacity for breaking with rules. Both critics concur as to the end result: the revolutionary artist will aid in the liberation process. However, the divergence between them with respect to artistic action was complete. Avant-garde art was produced for the elite; traditional art, circulated through galleries and museums, continued its task of educating the middle classes and sought to broaden further its range of action.

Criticism suffered as a result of this confrontation. In light of the highly bellicose attitude of the avant-garde, the great majority of new critics to come along preferred to devote themselves to research and the history of art in their respective countries. The Venezuelan María Elena Ramos wrote in 1981: "If the artist is to reflect the real nature of our countries and of their inhabitants ('the public,' 'one's fellow men,' 'human beings,' 'active members of society') he cannot indulge in a solitary love affair with his own thoughts, like a person constantly staring at his reflection in a mirror. He must make others the object of his love, and do so effectively." The first Latin American colloquium on nonobjective art was held under the auspices of the Museum of Modern Art in Medellín in reaction to the Coltejer Biennial of 1981. It brought the confrontation between the two critical and aesthetic tendencies into focus, clarifying their points of difference.

To get a clear idea of the situation, one must recall, first of all, the appearance of the nonobjective avant-garde in the U.S. and Europe in the early 1960s. In the U.S. the happenings or performances put on by Allan Kaprow (the first book on the topic, *Happenings, Assemblages and Actions*, was published in 1966) came at about the same time as Tinguely's self-destroying machine *Tribute to New York* (1960) and the destructive happenings that Wolf Vostell staged in Ulm, Germany (1964). The self-destruction process culminated in the bodily sacrifices of the Vienna group and the suicide of Piero Manzoni, the principal European advo-

cate of aggressive acts. Closely associated with the foregoing were acts such as those of Kounellis and Vito Aconcci in which the human body was made an object of degradation, or those of Charlotte Mormann or Yves Klein in which it was rendered the subject of ridicule. These are but two of innumerable types of "body art" and "destructive art." The smashing of luxury items—automobiles, refrigerators, and pianos—obviously reflects the affluence of the societies in which such acts took place. They constituted a reaction to the advertising with which the media bombarded society and to the emphasis placed on selection of the right brand name rather than on the pleasure to be derived from the use of a given product.

The new Latin American critics were quick to see that this situation did not apply to their countries. The Peruvian critic Alfonso Castrillón wrote: "One can understand the succession of manifestations such as poor-man's art, ecological art, body art, happenings, and Systems art as responses to the crisis in sensitivity and the crisis with respect to the object considered as merchandise." Later he asserted: "Juan Acha advanced a theory that could find no acceptance among artists of that time [i.e., the 1960s] because industrialization was still in its beginnings in Peru and therefore modern technology and communications media could not fulfill the role proposed by McLuhan in his utopian visions."

At times the doubts aroused by obvious differences were stated in the form of questions. "Given the marginal character of activity in the nonobjective line—which parallels the activity of the traditional art market—to what extent," the Brazilian critic Aracy Amaral wondered, "can it be considered a desirable and effective factor for integrating the artist into the struggle in which a society such as that of Latin America is engaged? A society in which—as a political commentator has said with reference to Brazil—'80 percent of the population goes hungry and 20 percent represents those in power.'"

The manifold antiart and avant-garde movements which evidenced themselves in Europe and the U.S. during the '60s and '70s had a solid social and economic base on which to operate. It was not a matter of individual novelty, such as the *Merzbau* (the cathedral of poverty) put up by Schwitters in the 1920s in Hannover, Germany, or the bottle of Paris air which Duchamp brought to the U.S. in 1915. The air that Piero Manzoni bottled half a century later represented a general spirit of aggressiveness towards the society in which all creative sectors participate. In Latin America a few solitary figures might be considered forerunners of this rebellion, for example the Brazilian Flávio Rezende de Carvalho (1899-1973), who broke the calm of São Paulo in 1931 with a series of extravagant performances, fashions, and situations expressly designed to shock the public.

One must also keep in mind the Brazilian tradition of body movement to which the critic Aracy Amaral draws attention, a tradition which is expressed in such manifestations as Carnival, the voodoo rites of *candomblé*, and the dance-like type of fighting known as *capoeira*.

In the nonobjective line, Brazil once again showed itself a pioneer. The first group of nontraditional artists, headed by Rubens Gerchman (b. 1942) and

Antônio Dias (b. 1944), appeared in 1964 under the name of "New Objectivity."
During the successive presentations of "Opinion" in 1965-66, the public had its
first surprise encounter with Hélio Oiticica (b. 1937) and his billiard tables with
players absorbed in the game, and with the water-and-stone-filled plastic bags of
Lygia Clark, already mentioned in the previous chapter as an avant-garde pio-
neer. In 1966 Wesley Duke Lee (b. 1931) made his appearance in Brazilian art
with his "rex-time," or hope in avant-garde art, promoted by his own "Rex Gal-
lery and Sons."

It was a spectacle sponsored by the Di Tella Institute, entitled "The
Mess," which stirred up opinion pro and con in Buenos Aires. It made the repu-
tations of Leopoldo Maler (b. 1937) and Marta Minujín (b. 1941) *(p. 149)* and
paved the way for a new generation which thereupon took center stage in Argen-
tina: Pablo Mesejean (b. 1937), Delia Cancela (b. 1942), and Dalila Puzzovio (b.
1942). With them nontraditional art—which at that time had much of the nature
of U.S. Pop Art and happenings—received the stamp of official approval. The
active wielders of the stamp were the Di Tella Institute and the critic Jorge
Romero Brest. Another critic, the previously mentioned Juan Acha, was the in-
tellectual godfather of the Peruvian avant-garde. The MIMUY group was pre-
sented at the Institute of Contemporary Art, which played a role similar to that of
the Di Tella Institute. It induced the young to reject traditional means of expres-

sion; they thereupon proceeded to fill the gallery with garbage and trash. The Peruvian adventure culminated in 1969 with the Conceptual work of Rafael Hastings (b. 1945), who in an exhibit at the Institute of Contemporary Art, showed the course of Juan Acha's development by a display of documents.

Through its imitation of U.S. Pop Art and the satellite position it adopted with respect to U.S. and European Conceptual art—consecrated at the "Documenta" exhibit in Kassel, Germany—the avant-garde succeeded in making a way for itself from one end of Latin America to the other. Few attempts were made, however, to "nationalize" those forms of expression. In 1967 the Bogotá Museum of Modern Art inaugurated an exhibit entitled "Environmental Spaces," at which five young artists—among them Alvaro Barrios (b. 1945), the future leader of the nonobjective trend—were given a whole floor for their presentation. This single experiment featured a maquette executed by a popular artist, so gigantic that it had to be stored on the Museum grounds until one of the walls of the room in which it was to be displayed could be demolished (and later rebuilt, at the Museum's expense). In 1968, however, the Brazilians and Argentines outdid the Colombians. In Brazil a public art month, called "Art in the Street," was organized by the critic Frederico Morais. Participants included Wilma Martins (b. 1934), Wanda Pimentel (b. 1943), Hélio Oiticica (b. 1937), and Roberto Moriconi (born in Italy in 1932, came to Brazil in 1953). This occasion provided further evidence of the social orientation of the avant-garde, which sought to involve a public that was already accustomed to extroverted rituals and spur-of-the-moment spectacles. Oiticica's versatility and ingenuity were demonstrated by his *parangolés,* consisting of mantle-covered bodies which provided lively illustrations for the texts that were included. The populist and critical intent of the Brazilian movement, which was strengthened later by the contribution of groups in the Northeast, set it off from the one in Argentina, which was characterized by sophistication and elements of laboratory experimentation, even in its politically oriented action. In Brazil, violence took the name of "Apocalypopothesis." In Argentina Pablo Suárez (b. 1937) and Roberto Jacoby (b. 1944) initiated dissident action within the Di Tella Institute. Their slogan was "What counts is life." Their most visible achievement was the performance *Tucumán in Flames*, in which they sought to involve the public by calling on the Workers' Federation and the community at large to participate. The scandal-show put on by the Di Tella Institute in 1968 was "Impo-Expo: Buenos Aires Up to Date." It evidenced little in the way of ingenuity and still less in the way of critical judgment.

Paradoxically, the "new objectivity" and nonobjective art produced numerous "objects," such as the "box-poems" which Lygia Pape (b. 1929) turned out in Brazil in 1967, and the novel archaeological book-objects which Jacques Bedel (b. 1947) authored in Argentina in 1968. Objects were also destroyed. They were however of less value than those used by the Europeans in such cases. In 1970, for example, the Brazilian Cildo Meireles (b. 1948) burned chickens alive. In the course of the numerous performances he put on later, he recorded

• LUIS FERNANDO BENEDIT. *THE CAT.* 1969. ACRYLIC ON CANVAS, 47 X 55.9 CM. COLLECTION OF THE ART MUSEUM OF THE AMERICAS, OAS, WASHINGTON, D.C., U.S.A. PURCHASE FUND, 1970. PHOTO-GRAPH BY ANGEL HURTADO.

messages to put in Coca Cola bottles, which were then returned to circulation. The Coca Cola logo served the same purpose for the Conceptual artists as did the image of the Sacred Heart of Jesus for the Pop artists. The Colombian Antonio Caro (b. 1950) won fame by imitating the first syllable of the logo in writing his country's name.

In 1969, with the ideological and financial backing of Jorge Glusberg, the Center for Art and Communication (CAYC) of Buenos Aires began to achieve new prominence. Between that year and 1973, a number of artists affiliated with the institution visited the best-known fashion and spectacle centers of Europe and Japan and countries noted for high technology, where they took up computer art. In 1969 they had made themselves felt in so many places and had sufficient means that they were able to hold an Interdisciplinary Encounter on Body Art at the Pompidou Center in Paris, at which the nucleus of the group, composed of Clorindo Testa (mentioned in the previous chapter), Víctor Grippo (b. 1936), Luis Benedit (b. 1937) *(p. 151)*, Leopoldo Maler (b. 1937), Vicente Marotta (b. 1935), and Jacques Bedel (b. 1947) had already appeared. The traveling exhibition on Systems art in Latin America which circulated at the same time presented works by more than 70 artists, including many from the area of graphics or who had only occasionally ventured into nontraditional activities. In the same year

1969, pressure of circumstances forced CAYC to forsake its international pretensions and adopt the mantle of Latin Americanism, rejecting foreign models and calling for the liberation of oppressed peoples. The use as a slogan of Antonio Gramsci's saying "Truth is always revolutionary" is highly indicative of the sudden change. It was in 1969 too that a large number of artists and critics boycotted the São Paulo Biennial in protest against the excesses of the military dictatorship. This was a more effective act than the *Idle Myths* performance suggested by Ivald Granato (b. 1949) as an answer to the First Latin American Biennial in 1978.

In 1970 Antônio Manuel (b. 1947) put on a corporal performance in Brazil, proclaiming as he stripped off his clothes, "My work is my body." He was continuing a line previously exploited by Oiticica, Lygia Clark, and Ferreira Gullar. At about the same time Emilio Hernández (b. 1940) was presenting photos and "environments" and engaging in Conceptual art processes and ecological explanations at the Culture and Liberty Gallery in Lima. Thenceforth the new forms of expression took their place in museums, and experimental groups multiplied, taking two different lines: they either went into isolation, constituting a hermetic avant-garde that abstained from communication, or they infiltrated folk art, as in the case of Brazil, Mexico, and Colombia.

A majority of the artists who appeared during this decade in Argentina were absorbed into the Center for Art and Communication; among them were Geny Dignac (b. 1932), Jaime Davidovich (b. 1936), Lea Lublin (b. 1929), Luis Pazos (b. 1940), and Carlos Ginzburg (b. 1946). Whatever the political or social message of such performances as were put on, it was blurred into a generalized perception of CAYC-type avant-garde art. The *Tribute to Chief Viltipico*, the last headman of the Humahuacas, presented by Alfredo Portillos (b. 1928), melds with the passion of "Art and Cybernetics" in Buenos Aires. The triumph of the Group of Thirteen at the São Paulo Biennial signaled the victory of "objects" and spectacles over traditional systems. Leopoldo Maler, who presented the spectacle *The Place* in London in 1969, wound up collaborating in 1981 with Marta Minujín in the performance *From Amaru to Barthes*, in which fields and purposes were defined. Involved in the performance were three critics: the Frenchman Pierre Restany, the Argentine Jorge Romero Brest, and the Peruvian Juan Acha. The performance was totally lacking in public participation and support. Its name implied the idea behind it: Tupac Amaru and Roland Barthes were superficial disguises for Latin Americanism and semiotics.

In 1976, CAYC once again undertook a regional role, presenting "Latin America 76" at the Miró Foundation in Barcelona, Spain. The reaction came in 1977 with the announcement of the Benson and Hedges Prize for new Argentine painting, in an attempt to clarify the national scene, for in reality traditional art had not been stamped out by the avant-garde but continued to flourish.

The same recognition of the situation had been achieved in Brazil, more consciously and with greater rapidity, at the Salon for Young Contemporary Art in 1972, at which acknowledgment was made of the coexistence of avant-garde

and traditional studio art. This notwithstanding, there were really important avant-garde manifestations in Brazil in the early 1970s. In 1971, the Rio de Janeiro Museum of Modern Art sponsored the "Activity-Creativity" symposia, at which the leading figures were Lygia Pape, Antônio Manuel, and Ana Bela Geiger (b. 1933). The same year the "Creation Sundays" coordinated by the critic Frederico Morais got the people of Rio and a large number of artists working together in an effort to stimulate invention at the folk level. Two years later the critic Aracy Amaral and the French artist Fred Forest (b. 1933, active in Rio de Janeiro in the 1970s) had the idea for "Sound and You," which was carried out with the help of Radio Pan-Americana. The project consisted in receiving and disseminating reactions and replies from the public. Undoubtedly the capacity for dialogue and the creation of politico-social consciousness displayed by Brazilian critics from Mário Pedrosa to Frederico Morais, together with their concern for communication, is a fundamental factor in the constantly maintained relationship between the avant-garde and the people. The Brazilian critic Ferreira Gullar had a peculiarly acute awareness of the two directions taken by art under the pressure exerted by mass culture. According to him, art either disintegrated before the advance of new images, situations, and actions, or else it sought to identify with mass culture, adopting its methods and resources. In this regard he pointed out the need that knowledge be gained, not through intuitive perception of reality, but through common human experience, since it thereby acquires a deeper and truer power of expression.

Critics in Mexico identified with the avant-garde in its concern for the relationship between art and the people, witness the writings of Rita Eder and Ida Rodríguez Prampolini and the theories developed in the '70s by Néstor García Canclini. In 1971 the Mexico City Museum of Modern Art exhibited Systems art for the first time, giving rise to fears that the avant-garde might become intellectualized in the Argentine manner. Despite this beginning to the decade and the ultrasophistication of the performances carried out in 1972 by the writer Alejandro Jodorowsky and the painter Alberto Gironella (b. 1929), whose *Burial of Zapata* was put on as a happening at the Palace of Fine Arts, just as in the case of Brazil a proliferation of groups assured a variety of experiments and a continuing consciousness of the vigor of Mexican folk culture. The groups of the mid '70s were thoroughly populist in character. There was the "No Group," which questioned art's sacred cows and the advertising and distribution media, giving dramatic presentations similar to Chicano theater. There was the "Pentagon Process," particularly concerned for liberation struggles in Latin America and the fate of those who had "disappeared" because of their political beliefs. The Summa Group painted street murals after the fashion of the Ramona Parra Brigade, active in Chile during the presidency of Salvador Allende, which ended in 1973. The Plastic Research Workshop promoted community-painted murals.

In 1978 the Mexico City Museum of Modern Art sponsored the "New Tendencies" exhibition, at which an effort was made to bring together groups of a more intellectual character: the Intersection Group headed by Moisés

Zabludowsky, concerned with city architecture and urban art; Mónica Mayer, with her project for a wall on which the public could express its opinions in the form of graffiti; Susana Sierra (b. 1942) with her stelae; Ivette Fertes, with "neon in the city." That same year, at the Forum for Contemporary Art, a panel composed of Bostelmann, Dondé, Estrada, and Naranjo discussed the media and the validity of Conceptual art, considerably after similar debates had taken place elsewhere in the world. In 1980 a group called Alternative Forms—likewise composed of Enrique Bostelmann (b. 1939), Olga Dondé (b. 1935), and Rogelio Naranjo (b. 1937)—presented *Life, Passion, and Death* on the basis of their respective pictorial and graphic experiences. The Ajolotes Project directed by the writer Elizondo, who caustically sought to redefine Mexican culture as "Axolotl (*i.e.* salamander) culture," provided a good example of the mingling of the folk element with intellectual satire, as did the project "Peyote and Company."

In Colombia the avant-garde took a position halfway between esoteric isolation and continuing communication with the public, the need for which was clearly felt by individual artists. Among the moderates were Bernardo Salcedo (b. 1942); José Urbach (b. 1940), with important Conceptual work supported by photographs; and Dora Ramírez (b. 1923), and Marta Elena Vélez (b. 1939), with their Pop paintings. The break with traditional art was best typified by Beatriz González (b. 1938) with her demystification of culture in general and Colombian culture in particular. Toward the end of the '70s she turned to large-scale work, divided between enormous canvases in which she reworked Manet's *Déjeuner sur l'herbe*, shower curtains printed with the likeness of President Turbay, and television sets on which the president's face was also repeated for humoristic effect. The esoteric avant-garde in Colombia was promoted by museums at which young critics congregated. The Bogotá Museum of Modern Art sponsored the "Athens Salon," La Tertulia Museum in Cali organized "Art in the Eighties," and the Medellín Museum of Modern Art was responsible for the previously mentioned colloquium on nonobjective art.

The decentralization of art in Colombia favored the simultaneous growth of a number of esoteric movements. The strongest group was unquestionably "The Syndicate," active in Barranquilla from 1976 to 1979. Its leading light was Alvaro Barrios (b.1945), who in 1979 organized the Barranquilla Festival of Avant-garde Art. As was the case with Beatriz González, the target of Barrios' work was European culture, as represented by Raphael, Millet, Marcel Duchamp, and Pollaiuolo. Group 44, also based in Barranquilla, is best represented by Alvaro Herazo's maps and the food-product landscapes of Delfina Bernal. (Both artists were born in 1942.) The cleverness of the code-setting elite was always affected—despite its efforts to the contrary—by the real poverty of Colombian life. Greater authenticity is therefore to be found in the work of the avant-garde artists who reflect that poverty—such as Gabriel Sencial (b. 1947) with the examples of bus art he displayed in 1972, Carlos Restrepo (b.1950) with his sculptures made of wire and toothpaste tubes, Jonier Marín (b.1946) with his Amazon project, Alicia Barney (b.1952) with the industrial waste she gathered

from Yumbo, Inginio Caro (b. 1952) with his wax sculptures—than in the constructions of Sara Modiano (b. 1951) or Mónica Negret (b. 1957).

Thirty years after the first acts of aggression, destruction, or environmental change, similar performances by young Colombians serve but to show how uninformed a "closed-door" country such as theirs can be. The same observation applies to serial photos or photomontages that reflect U.S. experimentation along such lines. The team of Medellín architects made up of Jorge Mario Gómez, Patricia Gómez, and Fabio Antonio Ramírez was in a better situation. Using photos, videotapes, films, and monographs, they aimed at such visionary urban undertakings as the Monument to José Martí or the "Colombianisco Project," in all of which contact was maintained with reality. The naturally "pop" character of daily life in Colombia was an obstacle to attempts at intellectual Pop Art. This explains the failure met by the Argentine Marta Minujín's burning of an effigy of Carlos Gardel in Medellín in 1980, in contrast with the success of Juan Camilo Uribe's prints featuring Bolívar and the miraculous doctor José Gregorio Hernández. The development of social consciousness by young artists led to other experiments: the mural newspapers on occurrences in Colombia executed by Diego Arango (b. 1942) and Nirma Zárate (b. 1936), the *Wrappings for our Institutions* (enormous bags stamped in printer's ink) turned out by Gustavo Zalamea (b. 1951), and Alfredo Guerrero's accusatorial compositions labeled *The Colombian Fatherland Sunk in a Morass.*

When avant-garde tendencies suddenly appeared in countries such as Peru and Venezuela, they seemed even more like imports from abroad than in the cases previously analyzed. New experiments and attitudes cropped up sporadically in Peru during the '70s but had no impact on the public. In 1972 Teresa Burga (b. 1939) presented at the Peruvian-American Cultural Institute a series of clinical self-portraits recording stages of her life as observed over the period of a month. The critic Alfonso Castrillón wrote: "The sudden leap into avant-garde art which took place about 1968 found no echo in our society and evidenced a lack of critical reflection during the production process." This applies to all that followed until the "Sign Countersign Exhibit" promoted by the architects Willey Ludeña and Hugo Salazar in 1979. Attempts at breaking with tradition were ill founded, and invariably outdated. Award of the 1976 National Prize for Plastic Arts to the retablo-maker Joaquín López Antay (1897-1981) was a bold criticism of both the emptiness of studio art and the uncalled-for extravagance of art that broke with tradition. The decision foreshadowed the democratic aims of the nationalistic revolution which General Velasco Alvarado led in 1968.

Kinetic art was dominant in Venezuela in the early '70s and bore the stamp of official approval. The young artist who came along could either play it safe, producing a kinetic picture, mural, or object, or take his chances on some other means of expression. The most important member of the younger generation was William Stone (b. 1945). He headed a brilliant group which numbered among its members Margot Romer (b. 1938), Ana María Mazzei (b. 1941), and Beatriz Blanco (b.1944). In 1973 they promoted three spectacle-exhibitions:

Man's Lost Sensations, presented at the Mendoza Foundation, *Contribution to General Confusion*, and *Skin against Skin*. The last-mentioned—a space complex, designed like the others to arouse diverse sensations of touch, sight, and hearing in the spectator—went on to the Twelfth São Paulo Biennial. However, it was through photography, videotapes, and particularly "Super 8" that the avant-garde standard was snatched from the hands of kinetic artists. Photography was handled with a certain degree of caution. The admirable José Sigala (b. 1940) reinterpreted the U.S. classic tradition; Ana Luisa Figueredo and Ricardo Armas stood out among younger photographers. The greatest contribution of photography to the avant-garde movement was the support it provided for Conceptual art. The work of Claudio Perna (b. 1939) stands out in an extensive range of "mixed techniques" which achieved maximum effect in the production of "Super 8." There were a large number of cinematographers, but only Diego Rízquez (b. 1949) produced critically coherent work, the most notable example of which, *Bolívar, a Tropical Symphony*, came toward the end of the '70s. Working in the mordantly satiric spirit of the "Whale Roof" group, Carlos Zerpa (b. 1950) combined a variety of media in attacking themes such as José Gregorio Hernández, the unbeatable Sacred Heart of Jesus, and Venezuela's oil-derived wealth. The last-mentioned he mocked in the spectacle *Welcome, Mr. Nation*, which concluded with a shower of coins.

Stimulated by the Venezuelan critic Margarita D'Amico, the production of videotapes, "Super 8," comic strips, and performances followed step by step the festivals promoted by Charlotte Mormann and Nam Jum Paik in the United States. Comic strips played a marginal role in these behind-the-times activities. The Mexican Jesusa Rodríguez, Nelson Moctezuma (b. 1949), and Zalathiel Vargas (Mexican, b. 1941) sought however to give new life to the comic strip as an impact-producing vehicle of satiric communication.

Finally, mention should be made of a few figures who invented their own individual forms of avant-garde art, without swelling the ranks of any given group. There were, for example, Vinício Horta (Brazilian, b. 1942), with his "mortuary chapel"; Ana Mendieta (Cuban, b. 1948), with the silhouettes and clay compositions she did in 1972; the Colombian Silvia Mejía (b. 1943), with the exhibit of photographs of hands which she presented in 1978 under the title "Words of Feminine Gender"; the bundles or wrappings of the Chilean Catalina Parra; and the Puerto Rican printmaker José Rosa (b. 1939), with his *Bottles that Sell Us*, a series with strong links to folk art and sayings.

During the 1970s the avant-garde was characterized by "antiart" manifestations and by an aggressive attitude which was immediately neutralized in art centers by the power of the media and establishment institutions. In Latin America, however, the paradox of institutionalized aggression can be found only in Buenos Aires, for the reasons already set forth, and in Venezuela, where the ruling class felt the need to take on a twenty-first-century air. In the rest of the region avant-garde tendencies remained outside the mainstream until they were accepted by museums and presented like any other trend, not as substitutes for

traditional art. From the viewpoint of concrete accomplishment, the avant-garde failed in the objectives at which it aimed: it brought about neither the death of art nor the demolition of institutions. It had no critical impact, since it had lost all contact with the public whose feelings it was supposed to arouse. Understanding of its message remained the privilege of a small elite. In cases in which it did not lose sight of society but played rather the role of an irreverent iconoclast, it brought a breath of fresh air and a new appreciation of the creative power inherent in the people. In these instances it has a legitimate place in the history of the development of modern Latin American art.

The third line of artistic production in the 1970s is represented by traditional uses of accepted media and firm confidence in symbolic language's power of communication. Here it is impossible to draw a clear dividing line between young artists born after 1940 and those who preceded them. More than in previous decades renewal was a matter of local circumstance. In the case of Buenos Aires, for instance, it can be measured by the degree to which the artist came into confrontation with the Center for Art and Communication. In Colombia studio art was dominant and maintained an unbroken line of communication with the public. Nonobjective and avant-garde art was relegated to a place on the periphery. In Venezuela kinetic art retained a position of preponderance. However, the strength of the art market was such as to permit simultaneous activity along new and traditional lines, including graphics, since buyers could be found for everything, at least up to 1983.

We repeat that the persistence of traditional media of expression amid imitations or adaptations of avant-garde imports has a "behavioral" value. The "behavioral" idea was strong in the '70s. The Documenta exhibitions in Kassel, Germany, and the Venice Biennial, at which European novelties were much in evidence, gave "behavior" a very precise meaning: the artistic object was supplanted in importance by the creative act or the impulse that led the artist thereto. "Behavior," understood as action, concerned itself with creating situations (necessarily ephemeral in nature, despite the fact that they might be captured on film) or with leaving evidence of the process which led up to the act of creation, there being no particular interest in the creation itself. However, long before this term became a buzz word among opinion-shapers in the avant-garde, the lines of work in which Latin American artists engaged can be viewed as "behavior" provoked by the 180° turn in aesthetic concepts, the new burden of ideology imposed on the avant-garde, and the exactions of the cultural industry.

As regards aesthetics, the Latin Americans who defended painting, sculpture, drawing, and printmaking and continued in their practice lent support to the placement of values within a historical framework. They categorically opposed the new "aesthetics of deterioration," in accordance with which all axiological considerations were rejected in favor of change and transitory situations.

They were also called to respond to the strong ideological influence of the media—to the illusion of a single, worldwide culture, achieved by transfer to the third world of the symbols associated with highly industrialized countries. In

their response the Latin Americans emphasized in one way or another their regional character, rejecting concepts of foreign origin and exploiting the possibilities afforded by local cultures.

Opposition to the cultural industry was relatively easy. The danger foreseen by the sociologists of the Frankfurt school, that the artist might be taken over by industry and alienated from art, had little application in Latin America, owing to the weakness of industrial organization in that part of the world.

The two principal determinants of Latin American "behavior" were a sense of history and a will to communicate with society. In 1980, when artists in the U.S. and Europe once again proclaimed the need to give their work a social value, the significance of Latin American behavior 20 years earlier became readily apparent.

There was considerable development along abstract lines during the period under consideration. One notes the contribution of such young artists as the Brazilians Márzia Barroso do Amaral (b. 1943) and Adriano d'Aquino (b. 1946); the Paraguayan Enrique Careaga (b. 1944); Alberto Icaza Vargas (b. 1945, active in Costa Rica); the Colombians Alberto Uribe (b. 1947), John Castles (b. 1946), Edelmira Boller (b. 1940) and Ronny Vajda (b. 1954). The last-mentioned was responsible for the most important sculptural work since Negret and Ramírez Villamizar. One notes also the knots and flat stones of the Argentine Fabriciano Ramos (b. 1944), and the hard-edge compositions of the Peruvian Ciro Palacios (b. 1943). All brought a refreshing note of novelty, limited, however, by respectful observance of geometric precepts in painting or sculpture.

In Venezuela, where interest had centered entirely on kinetic art, the new activity in the geometric-abstract area succeeded in attracting the public to painting such as that produced by Guido Morales (b. 1946), Jorge Veliz (b. 1949), Diana M. Villamizar (b. 1949), Christine Malcuzinsky (b. 1951), Pedro Piña (b. 1953), Julio Pacheco Rivas (b. 1953), and Alejandra Daini (b. 1957). Jorge Pacheco Rivas provides a perfect example of the trend toward less mechanical forms of art as he moves from Surrealist concepts of space to highly imaginative free-form constructions.

The great surprise of the '70s as regards the geometric-abstract area was the mass turn of young Mexicans toward a form of expression that had previously been the province of solitary pioneers such as Gunther Gerzso (see the previous chapter) or Rodolfo Zanabria (b. 1930). Their work was characterized by interest in color fields and adoption of hard-edge techniques. Such is the case with Arnaldo Coen (b. 1940), Hersúa (b. 1940), Ricardo Regazzoni (b. 1942), Benjamín (b. 1943), Francisco Moyao (b. 1946), Ignacio Salazar (b. 1947), Sebastián Roberto Real de León (b. 1950), Carlos Agustín (b. 1952), Omar Gasca (b. 1952), Susana Campos, and Alejandro Herrera (b. 1955). The last-mentioned was one of a group of young geometric-abstract artists from Oaxaca who were strongly influenced by Gerzso and Donis.

Another important aspect of Mexican Neogeometry was its connection with sculpture and architecture. Important precedents were set by the sculptures

of the Path of Friendship designed for the Olympic Games of 1968 and Angela Gurria's Usumacinta River project. In 1979 the Center for Sculptural Space was opened in the Mexican capital's University City. Helen Escobedo, Mathias Goeritz, and Manuel Felguérez were among the established artists participating; Sebastián, Silva, and Hersúa, among the newer figures. The critic Rita Eder characterized the ensemble as part urban, part ecological: "An enormous sea of wrinkled lava is surrounded by 64 smooth, 3-by-4-meter modules. It has the attraction of ancient stone circles and exudes the monumental spirit of pre-Hispanic architecture. Nonetheless, it represents a modern concept of space." It is interesting to note that the decade of the '70s, which began with a work that might have been conceived by the Pharaohs, the "Mexico of the Year 2000" project, of which Siqueiros' Polyforum was a part, concluded with the Sculptural Space, an undertaking in which the air was cleared of official ideology and the bad taste of the ruling class was thoroughly repudiated.

A tendency developed during the '70s which remained within the bounds of Neogeometry but permitted of certain poetic touches and sought for more indirect or elliptical modes of expression. The Brazilian critic Roberto Pontual labeled it "Lyric Abstraction" at the exhibition he organized for the Rio Museum of Modern Art in 1978 after engaging in extensive research and collecting works from throughout Latin America. The tendency evidenced itself in Mexico in works of great versatility and good taste, as in the output of such artists as Beatriz Zamora (b. 1935), Rafael Zepeda (b. 1938), and Gabriel Macotela (b. 1954). Other interesting figures were Ismael Martínez Guardado (b. 1942), José Luis Serrano (b. 1947), Kiyoto Ota Okuzawa (born in Japan in 1948, came to Mexico in 1972), Francisca Sutil (b. 1952), Federico Amat (born in Barcelona, Spain, in 1952, but active in Mexico), Susana Sierra (b. 1942), and Agueda Lozano (b. 1944). Similar to the work of the last-mentioned is that of the Nicaraguan Ilse Manzanares. All these helped the advance toward modernization, shaking off the bonds imposed by the Muralist School and the figurative painting that had succeeded it, so that complete freedom of expression was at last achieved.

Various types of Lyric Abstraction were developed in Colombia by Ana Mercedes Hoyos (b. 1942) in her works of the late 1970s, Ana María Rueda (b. 1954), Hugo Zapata (b. 1945), and Alvaro Marín (b. 1946). The work of the last-mentioned is similar to that of the Puerto Rican abstract landscapists Wilfredo Chiesa and Colo.

Wherever the Lyric Abstraction tendency manifested itself—as in the work of the Ecuadorian Mario Solís (b. 1940), the Uruguayan Ney (b. 1943), the Brazilian Cláudio Tozzi (b. 1944), and the Cubans Richard Rodríguez and Rafael Vadía (both born in 1950), and in the compositions done in the '70s by the Peruvian Martha Vértiz—one can recognize a desire for symbolic communication which transcends the purely visual message of the Neogeometric artists. The organic atmosphere, the presence of nature as a remembered or conceivable landscape, the delicate intromission of graphic signs, the notes and touches that have no relation to rational thought—all these serve to link the Lyric Ab-

• **LUIS CABALLERO**. *DARK NIGHT OF SAINT JOHN OF THE CROSS.* 1977. LITHOGRAPH 13/60, 29.2 X 43.2 CM. COLLECTION OF THE INTER-AMERICAN DEVELOPMENT BANK, WASHINGTON, D.C., U.S.A. PHOTOGRAPH BY WILLIE HEINZ.

straction of the '70s to the worldwide growth of ecological groups, though to be sure there is no cause-and-effect relationship between the two. One must acknowledge also that in Latin America the ecological movement did not take on the dramatic character of a crusade to save humanity that it had in the highly industrialized countries. It consisted more in an awareness of the need to preserve flora and fauna (including isolated Indian tribes) that were on the way to extinction, and a consciousness of living in a realm of nature whose wild beauty has not yet been destroyed.

The impossibility of drawing a clear line between artists born before and after 1940 applies also in the figurative area, whatever the tendency taken—realistic, hyperrealistic, or surrealistic. In 1970, just as in previous decades, Latin American realism kept its distance from the spectacular hyperrealism that characterized the U.S. return to figurative painting. It also viewed with distrust the appearance toward the end of the '70s of the ultravanguard in Italy, Germany, and the United States, preceded in the last-mentioned case by the "brutalism" of the Chicago groups and the mural work of the Chicanos on the West Coast. The U.S. ultravanguard differed from its European counterpart in that it incorpo-

rated marginal groups, particularly the Puerto Ricans in Manhattan who had been responsible for the graffiti in the subways 15 years earlier. There were but a few isolated representatives of the ultravanguard in Latin America: the Cuban Luis Cruz Azaceta (b. 1942) *(p. 162)*; the Argentine Osvaldo Romberg (b. 1938), the reference here is to his relatively recent work, done around 1980; and the Mexican Alejandro Colunga (b. 1948), whose fable-like work of the late '70s, inspired in national myths, exudes a brute force far superior to that of the European ultravanguard of the 1980s.

Several artists show how far Latin American realism can go by a concentrated effort that is outwardly manifested in perfectionist painting, for example Gregorio Cuartas (Colombian, b. 1938), Carlos Revilla (Peruvian, b. 1940), Gonzalo Morales (Costa Rican, b. 1945), and the Brazilian Gregório Correia. In this context the human figure constitutes a silent spectacle, to be read much as a landscape, witness the work of Teresa Morán (Mexican, b. 1939), Darío Morales (Colombian, b. 1944), and Héctor Giuffré (Argentine, b. 1944). In contrast with this essentially quiet realism we find work of a more dramatic character. Thus a religious atmosphere of suffering and penance pervades the extraordinary compositions of the Colombian Luis Caballero (b. 1943) *(p. 160)* and the sculptures of

• **FELIX ANGEL**. *MAN ALONE.* 1974. PENCIL, CRAYON, AND TEMPERA ON PAPER, 50 X 70 CM. COLLECTION OF THE ART MUSEUM OF THE AMERICAS, OAS, WASHINGTON, D.C., U.S.A. PURCHASE FUND, 1974. PHOTOGRAPH BY WILLIE HEINZ.

the Venezuelan Carlos Prada (b. 1944). In his painting the Venezuelan Edgard Sánchez (b. 1940) successfully meets all dramatic challenges, as does the Colombian sculptress Beatriz Echeverri (b. 1938) in her treatment of the human body.

Realism finds a third form of expression in the grotesque. The sources from which this trend derives are many; among others one can recognize vaguely the hand of such masters as the Colombian Fernando Botero, the Englishman Francis Bacon, and the Dutchman Karel Appel. It is local reality that supplies the basic material, however—the deforming effect that Latin American society has on individuals, acts, and situations. Among the representatives of this trend are the Argentine Hugo Sbernini (b. 1942), Antonio Moya (born in Spain in 1942, active in Venezuela), the Venezuelan Alirio Palacios (b. 1944), the Nicaraguan Dino Aranda (b. 1945), and the Colombians Jorge Mantilla Caballero (b. 1946) and Francisco Rocca (b. 1946). Ugliness and deformity continue to crop up throughout the '70s, treated in a variety of ways by figures such as the Colombian María de la Paz Jaramillo (b. 1948) and three artists born in 1949: the Argentine Jorge Alvaro, the Colombian Félix Angel, and the Venezuelan Anita Pantín. Colombia has been particularly prolific in artists in this line, owing doubtless to the stimulating example of Fernando Botero. The variations run a wide gamut, from the figures tied up and hanging by their feet painted by Sonia Gutiérrez (b. 1947) to the huge, flat figures of Alberto Sojo (b. 1956) and the

gesturalism of María Teresa Vieco (b. 1952). In the three-dimensional field we have the rag sculptures of Lilia Valbuena (Venezuelan, b. 1946) and the cut-out metal silhouettes of Abigail Varela (Venezuelan, b. 1948), which recall those of her compatriot Beatriz Blanco (b. 1944). All constitute disquieting representations of the human figure.

Disquietude can also be felt in landscape painting. One can note it in the work of the Argentine María Helguera (b. 1943), with her dislocated rooms, the Venezuelan Ana María Mazzei (b. 1941), Jorge Seguí (born in Argentina in 1945 but active in Venezuela), Nicolás Amoroso (born in Argentina in 1944 but active in Mexico), the Argentine Miguel Angel Bengoechea (b. 1945), the Venezuelan Francisco Quilici (b. 1954), the Mexican Saúl Villa (b. 1958), and a number of painters from Oaxaca, Mexico, most notably Filemón Santiago (b. 1958) and Felipe de Jesús Morales (b. 1959).

The divergent paths taken in figurative painting were in many cases a matter of individual choice. Some artists took pleasure in combining objects and color fields, or in developing a color field to the fullest extent of its possibilities, as was the case with Julio Larraz (Cuban, b. 1944) and Eduardo Tamariz (Mexican, b. 1945). The somber chromatic atmosphere of pool halls presides over the work of the Colombian Saturnino Ramírez (b. 1946). Américo Castilla (Argentine, b. 1942), Adrián Pujol (Venezuelan, b. 1948), and in particular Antonio Barrera (Colombian, b. 1948) paint calm, loosely composed landscapes with the same energy that Edgard Silva (Colombian, b. 1944) produces tightly constructed ones. Such diverse elements as suns, eggs, fragments of birds, and machine-like forms appear in the work of Roberto Huezo (Salvadoran, b. 1947), Carlos Aresti (Chilean, b. 1939), and Eduardo Berroeta (Chilean, b. 1946). Closely drawn, sharply outlined figures distinguish the compositions of the Colombian Heriberto Cogollo (b. 1945).

The Latin American hyperrealist tendency is marked by strong, sensitive concern for covering the gamut of reality. This is evidenced in the work of a long list of young painters and graphic artists. Carmen Aldunate (Chilean, b. 1940) draws Renaissance women with the same preciseness that the Colombian Dioscórides Pérez (b. 1950) investigates the culture of the past. The Peruvian Humberto Aquino (b. 1947) and the Argentine Mónica Meira (b. 1949, active in Colombia) give their attention to simple everyday objects.

Javier Restrepo (Colombian, b. 1943), Bill Caro (Peruvian, b. 1949), and the Colombian Beatriz Jaramillo (b. 1955) deal more aggressively with urban life, painting interiors, wretched-looking housefronts, and town squares. The Colombian Oscar Muñoz (b. 1951), one of the most notable draftsmen of his generation, does pathetic scenes of rooming houses and slum dwellings, portraying their inhabitants in strong chiaroscuro.

A large number of young artists born in the '50s or just before continue to believe in realism: the Colombian Carlos Lozano (b. 1950), the Venezuelans Henry Puerta and Azalea Quiñones (both born in 1951), the Mexican Enrique Guzmán (b. 1952), the Colombian Mariana Varela (b. 1947), the Dominicans

Alberto Blass (b. 1949) and Sum Prats (b. 1959), and Enrique Estrada (Mexican, b. 1942), the outstanding figure at the Young Painters Salon in Mexico in 1980.

As regards Surrealism in the 1970s, in a sampling of fully realized talents mention might be made of the Mexicans Tomás Parra (b. 1937) and Juan Calderón (b. 1938) and the Argentine Alicia Carletti (b. 1946). In Carletti's works, in which disproportionate values are assigned to component elements, one can detect a descendant of René Magritte, with his rooms invaded by fruits. The Venezuelan Emerio Darío Lunar (b. 1940) provides a fascinating example of the convergence of professional and folk art with his strange images, representative of the best in Surrealism.

Venezuela produced at this time a number of artists who excelled in original ways. Ender Cepeda (b. 1945), Henry Bermúdez (b. 1950), and Felipe Márquez (b. 1954) invented extraordinary bestiaries. One may also mention Carmelo Niño (b. 1951), Gabriela Morawetz (born in Poland in 1952 but active in Venezuela), and Francisco Cisneros (b. 1956). The arrival in the country of the Polish printmaker Mieteck Detiniesky (b. 1938), coinciding as it did with Alirio Palacios' return home after a stay in Detiniesky's country and the resumption of artistic activity by Jacobo Borges, had a strong influence on efforts to carry figurative painting to the limits of the possible.

In the '70s the Mexican Xavier Esqueda (b. 1943) invented what the critic Xavier Moyssén called "Pop Surrealism" in the series the artist entitled *Eclipses* and *Generous Mirrors*. At the same time the Brazilian João Câmara Júnior (b. 1944) was doing surprising allegories of national life.

In the case of some artists belonging to earlier generations one notes new developments, inspired by the times. Such was the case with the Uruguayan Horacio Torres (1924-1976) and his female nudes, the Brazilian Mário Gruber (b. 1927) with the notable series of hands and puppets he did in 1976, and the Argentines Delia Cugat (b. 1930) and Sergio Camporeale (b. 1937), who, on resuming painting, enriched the Surrealist and hyperrealist areas with works of surprising perfection and semantic richness. Artists of continuous evolution, such as the Argentine Antonio Seguí (b. 1934) and the Uruguayan José Gamarra (b. 1934), contributed ironic imagery to the art of the '70s.

The foregoing represents but a sampling; there were many other artists of comparable rank. Their numbers were too great and the quality of their work too high for the unfortunate idea of the death of art to prosper in Latin America. Comprehension of, and receptiveness to, art have not varied substantially. Given the stagnation in political and social development, economic recession, rising public indebtedness, retreat in the field of human rights, and the loss of illusions of development that accompanied the crises of the '80s in Mexico, Brazil, and Venezuela, artists found their market limited to a small circle of collectors. The art boom of the '60s (which unquestionably preceded the boom in literature) was over; sights were lowered to more modest levels. After the worldwide exuberance of the '60s came the let-down of the '70s and a settling of accounts. This together with the oil crisis and the shifts of power that it brought about have served to

increase Latin America's traditional anomie. Nonetheless, though they have found themselves as the result of unfavorable circumstances relegated to the rank of merely regional heroes, artists as individual creators have kept up a constantly rising rate of production.

· · ·

It is true that Latin America is responsible for no original "ism" in the twentieth century. Mexican Muralism, despite its energy and novelty, did not transform the language of plastic expression in a fashion comparable to U.S. Abstract Expressionism, Spanish Informalism, English Pop Art, Italian "poor-man's art," or German Conceptual art. However, thanks to its firmly held aim of maintaining communication with the public via visual messages charged with meaning, it has gradually produced an "image bank," a reserve of real importance to the region and of considerable potential value for the rest of the world.

Paralleling this bank, whose images consist in reconstructions or renovations of imported models, is another bank, whose stock is composed of folk art, the work of the least-favored sectors of society. It represents an area of life in which the symbols derive primarily from religion and superstition; it is particularly rich in countries with large numbers of mestizos and mulattoes. It is responsible for the preservation of media and processes proper to handicrafts; it favors an expansion of the art market toward what the Peruvian critic Mirko Lauer calls "a turn toward the masses by the bourgeoisie possessing a medium level of information, refinement, and culture." This two-pronged activity—professional art on the one hand and folk art on the other—is characterized by the social orientation which is a constant in modern Latin American art. Knowledge of art therefore helps in understanding and analyzing Latin American societies.

Artists give direction to our hopes, tear away the veil of our illusions, and communicate our defects. The essence of artistic creation lies in the unveiling of mystery. This has been the task to which succeeding generations have dedicated themselves. In the case of the Spanish-speaking countries there is a common bond of language, tradition, and history, their bond to Brazil being one of geography and social and economic development.

Like Africa, Latin America is a divided block, but a block just the same. Consequently, despite controversy about the matter, it is permissible to speak of Latin American art, or of art produced in Latin America, as an element for defining a culture that cannot and will not be confused with others.

ARTIST INDEX